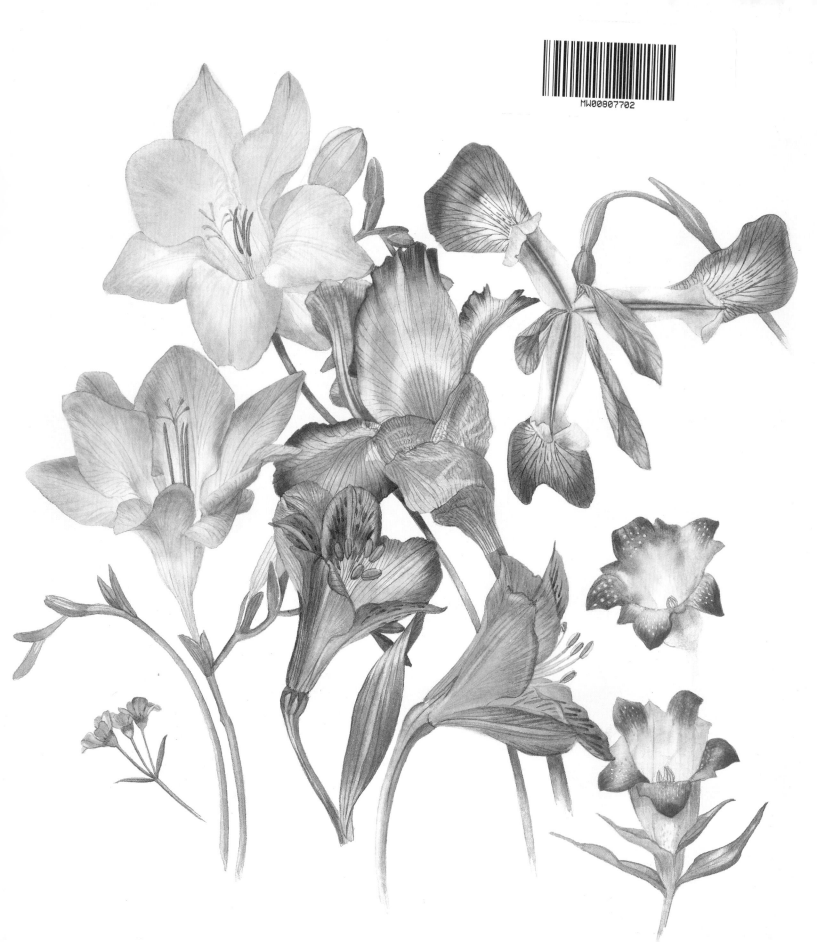

MW00807702

Billy Showell's
Botanical Painting in Watercolour

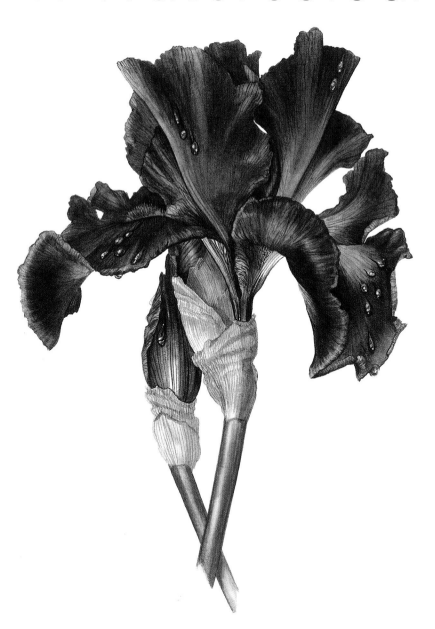

First published in 2016

Search Press Limited
Wellwood, North Farm Road,
Tunbridge Wells, Kent TN2 3DR

Reprinted 2016, 2017 (twice), 2018, 2019 (twice),

2020, 2021, 2023

Text copyright © Billy Showell 2016

Photographs by Paul Bricknell at Search Press Studios
Photographs and design copyright
© Search Press Ltd, 2016

Photograph of the author courtesy of Roddy Paine

All rights reserved. No part of this book, text,
photographs or illustrations may be reproduced or
transmitted in any form or by any means by print,
photoprint, microfilm, microfiche, photocopier,
internet or in any way known or as yet unknown,
or stored in a retrieval system, without written
permission obtained beforehand from Search Press.
Printed in China

ISBN: 978-1-84448-451-5

The Publishers and author can accept no responsibility
for any consequences arising from the information,
advice or instructions given in this publication.

Suppliers

If you have any difficulty obtaining any of the
materials and equipment mentioned in this book,
then please visit the Search Press website for details of
suppliers:
www.searchpress.com

You can see and learn more about Billy's paintings and
the techniques she uses at www.billyshowell.com

Publishers' note

All the step-by-step photographs in this book
feature the author, Billy Showell, demonstrating
botanical painting with watercolours. No models
have been used.

Dedication

For Mum, Dad, and Edith and Walter Cook, my mother-
and father-in-law, who encouraged me to exhibit my first
paintings. Also thank you to Edith, for getting me hooked
on watercolour.

Acknowledgements

Thank you to Katie French for her help and support
throughout the writing of this book, and thank you to
all my students and botanical painting friends who are
immensely supportive and encouraging. Finally, thank
you to Search Press for giving me the opportunity to
make this book.

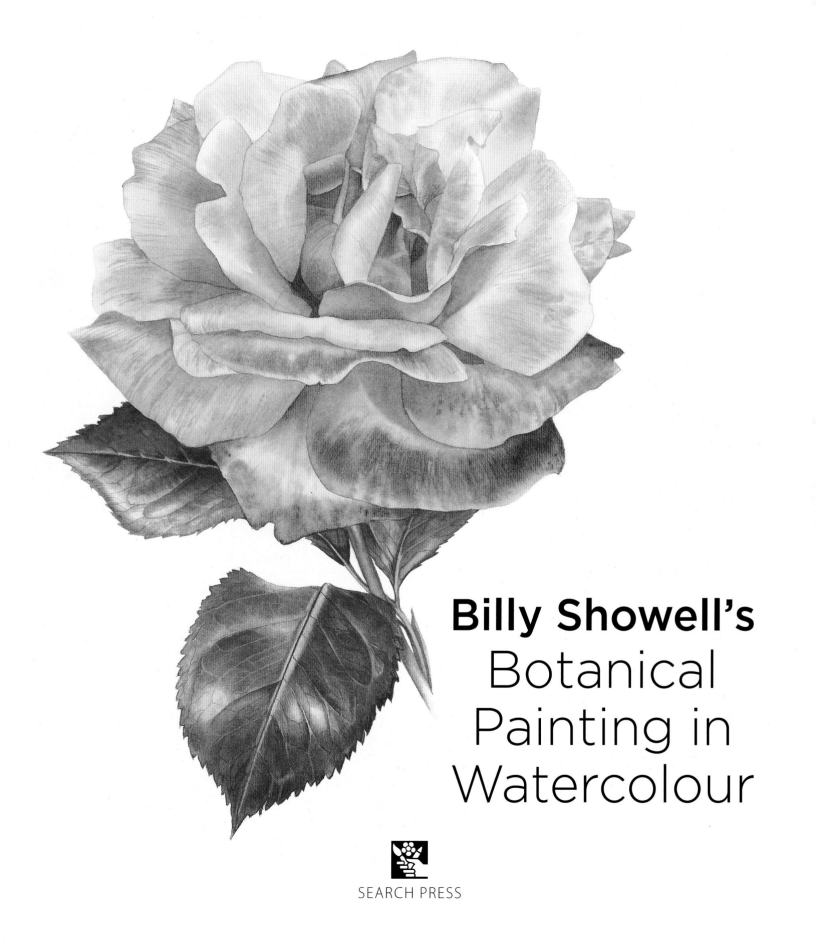

Billy Showell's
Botanical
Painting in
Watercolour

SEARCH PRESS

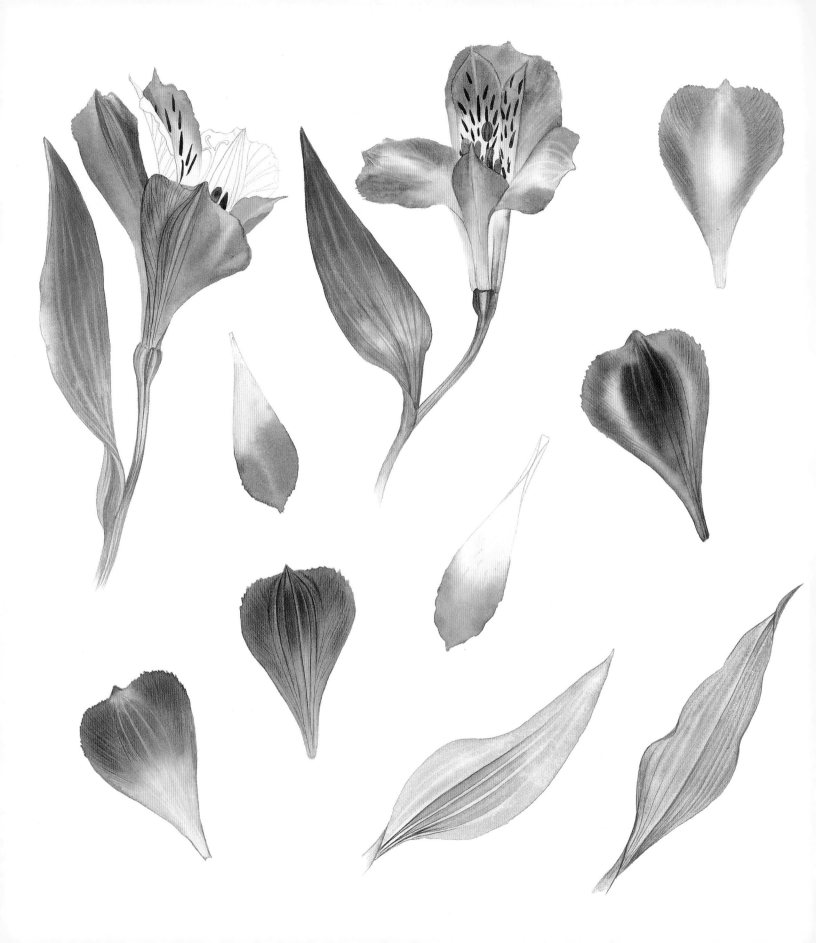

Contents

Introduction

In this book I hope to offer you a myriad of useful hints and tips about painting my way. These have been gathered from listening to advice from other artists since I was a child; practising and indeed learning from many mistakes; and having little eureka moments over my years of painting in watercolour.

Botanical illustration is steeped in tradition and has therefore acquired certain myths about what or what not to do; my way of painting is botanical painting, which is subtly different from illustration. While retaining botanical accuracy, I can play around with composition formats and create a painting as opposed to a formal layout or plate.

Regarding technique, my mantra is 'if it works, use it'. I like to use modern materials and try out different combinations of colours without the heavy historical 'dos and don'ts' restricting my process. When it comes to enjoying painting, there are no rules. I always say to students, do your research and find out what is required for exhibitions or art societies and follow their guidelines if required, then you can be sure that what or how you are painting will be acceptable to the judges. But if you are painting for you, then in my opinion anything goes.

Remember, if something I share with you in this book works well, then pass it on to someone else. Every time a tip gets shared it is open to a new interpretation and possibly improvement. Sharing makes you feel good, too.

Some of the techniques I use may contradict the historical rules of botanical watercolour, but they work for me and you can pick and choose which work for you. Remember: practice, planning and perfection are the keys to success. I call these the 3Ps, and they will help to keep you on track. Reading about how to paint is beneficial, but it is no replacement for practice and playing with the paint. Planning some time in which to paint and planning out your pictures will help you save paper and time, and perfection comes with knowing your tools and the paint and paper well.

If this all sounds daunting it is not meant to be. Celebrate the improvements in your painting, as well as all the little successes along the way. If something beautiful happens then let it be, and aim to replicate your success.

Anemones on a tea-stained background.

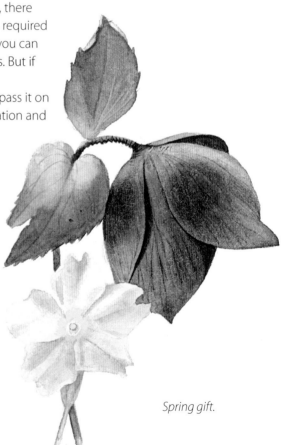

Spring gift.

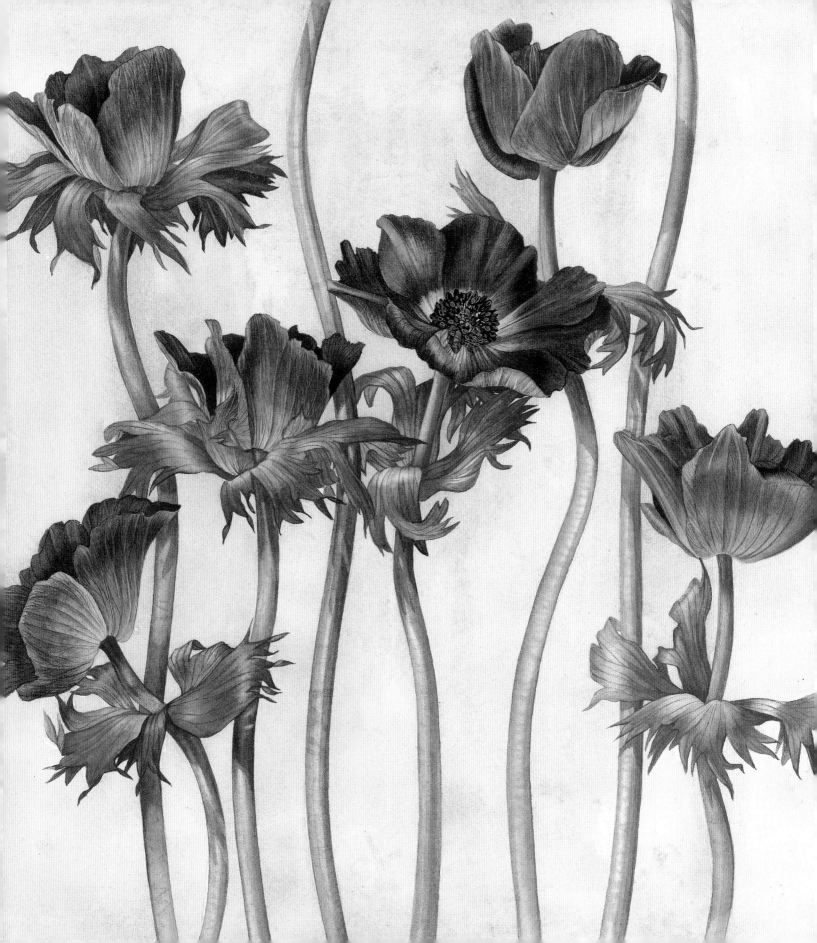

Materials

Botanical painting requires quite specific materials. Some of these are universally used and some are a matter of preference. In this book I will recommend the materials I use, though there are other options that you should research. Only buy the essentials initially, then add to your basic kit as you progress.

My 'desert island' minimum kit would be the three primary colours French Ultramarine, Sennelier Yellow Deep and Rose Madder Lake; a no. 6 pointed brush; and a block of Fabriano Artistico hot-pressed paper. You can mix a broad colour palette from these three primaries and any additional tubes of paint you buy will be a bonus.

A large china plate makes an excellent surface for mixing your colours on until you are able to invest in a mixing palette. Old brushes can be used to mix paint, and most people own a pencil for drawing with. For a water container, use any large vessel with a wide base that cannot be toppled easily.

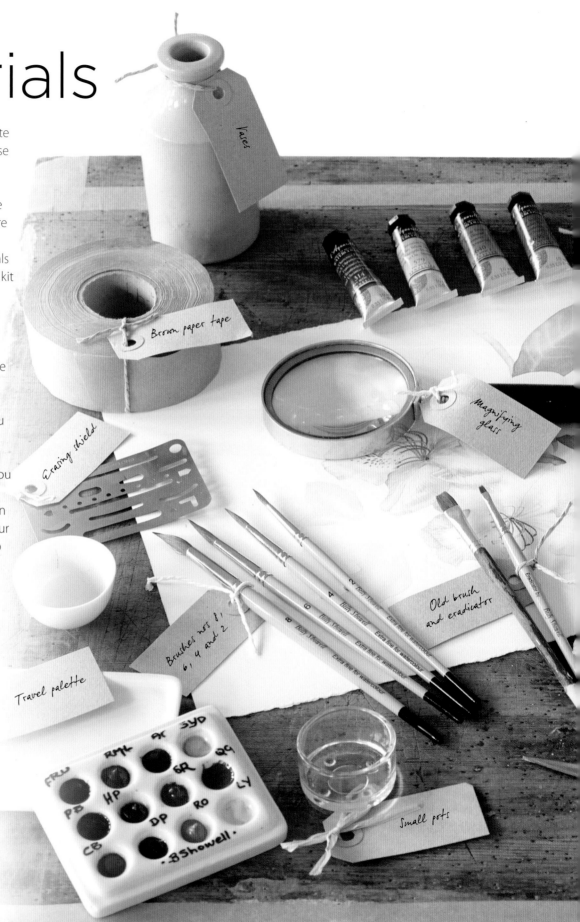

Vases

Brown paper tape

Magnifying glass

Grazing shield

Old brush and eradicator

Brushes nos 8, 6, 4 and 2

Travel palette

Small pots

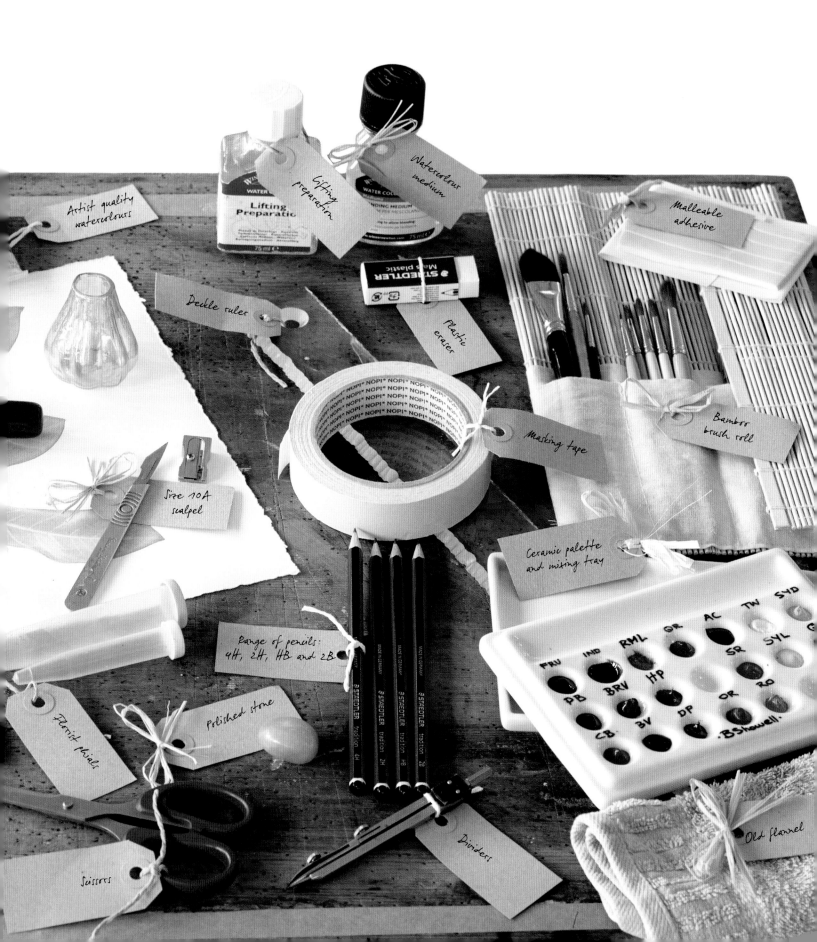

Artist quality watercolours

Lifting preparation

Watercolour medium

Malleable adhesive

Deckle ruler

Plastic eraser

Masking tape

Bamboo brush roll

Size 10A scalpel

Ceramic palette and mixing tray

Range of pencils: 4H, 2H, HB and 2B

Florist phials

Polished stone

Dividers

Old flannel

Scissors

Paper

There are many different types of watercolour paper, and it is important to know what type of paper to buy. I use Fabriano Artistico hot-pressed, 100 per cent cotton paper, either 640gsm (300lb) or 300gsm (140lb). This is a very smooth hot-pressed paper and is very resilient to corrections. It is available in bright white, which has a slight blue tinge, or traditional white, which has a cream tone. My personal preference is for the traditional white.

Buying paper

I would advise you to buy a single sheet of paper at a time so that you can see whether that particular paper suits you. Make sure you write down the make, weight and finish for future reference.

Once you find a paper that works well for you, buy a block of it. A block is a pad of paper that is stuck down round all the edges, apart from one corner or section that is left unstuck. The paper is kept flat and you paint on the top sheet. Once your painting is complete, remove it carefully by sliding a blunt knife between the two top sheets at the unstuck corner or section and release the top sheet. You then continue to paint on the next sheet and so on. The only difficulty with this is that you may want to start a new painting before the first is completed. If you choose to remove the top sheet before the painting is finished, it may cockle up. Don't worry if this happens. Simply follow the advice on stretching a finished painting on pages 186–187.

Which is the right side of the paper?

There is a great deal of unnecessary worry about which is the right side of a piece of paper for painting on. With Fabriano Artistico I use the side on which you can read the watermark, which is visible at one end of the large single sheets, though with other papers this is not always the case.

One way to find out which is the right side is to support the paper from underneath and allow it to flop down on either side of your hand. Turn the paper over and repeat. Whichever way the paper flops most easily, the top surface is the right side of the paper.

You can often feel the difference between the right and wrong side: the right side of the paper should feel smoother. If in doubt, ask your art supplier. With blocks of paper, the top of the top sheet should be the right side, but I would always lift the pad from the card backing and check which side feels smoother.

Tip

If you use traditional white paper and you wish to produce prints of your work, you will need to inform your printer that the paper colour should be scanned as 'white' so that the cream tone is not picked up.

Tip

Don't turn the paper over. I have found that the side with the watermark allows me to paint with ease and enjoyment whereas the opposite ruins my experience and leads to frustration and disappointment.

To stretch or not to stretch

I rarely stretch my watercolour paper before I paint. Stretching prevents paper from cockling when it gets damp, but if, like me, you don't use a great deal of water in the background of your painting, it's rarely a problem. Stretched paper needs to be glued down to a board while you are painting, but I prefer to keep the paper free and be able to move it around as I paint, allowing me to work with the natural curve of my hand. If you use very heavy 640gsm (300lb) paper, it does not require stretching to keep it flat.

You can, if need be, stretch your finished painting quite easily, so there is no need to do it beforehand. Guidance on how to stretch watercolour paper is provided on pages 186–187.

Tip

Students often end up with many sheets of paper with one study in the middle of each. I recommend that you use all of the paper, placing the first study to one side if it is small so that you can fit further studies on the same sheet later on. If a painting goes wrong or is unfinished, use the remaining paper for further small studies of the same subject or others related to it.

Portfolio

You will need a good art bag to keep your paintings flat and free from harm until they are ready for framing. Keep on-going paintings in acid-free plastic sleeves otherwise the surface of the paper will get damaged as you slide them in and out of the portfolio; the pieces of paper actually become rougher where they rub against each other, and this will affect the painting process.

Sketchbooks and notebooks

I always take a tiny notebook with me wherever I go. I use it to record colours and to keep a note of ideas wherever I travel, ensuring I always have a record of those inspirational moments.

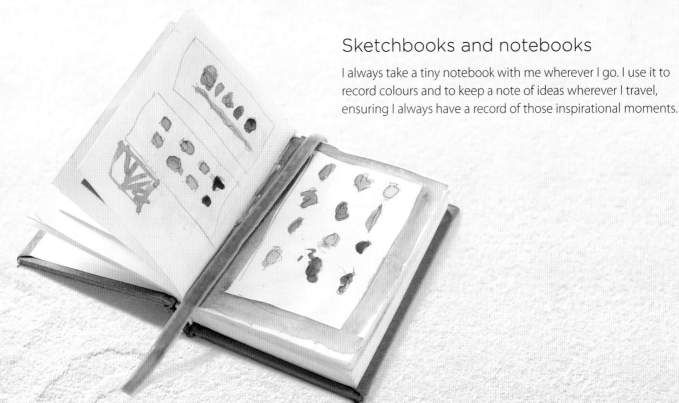

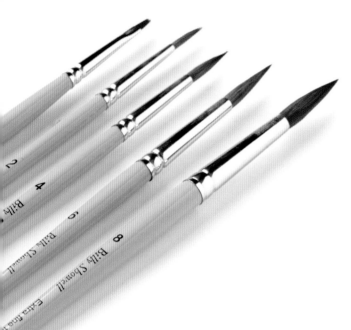

Paintbrushes

Over the years I have worked mainly with sable brushes. Although you can use man-made fibre brushes, remember not to sweep the paper too often or the hot-pressed surface will get damaged. I have used predominantly a no. 6 and no. 4 round fine-tipped brush, but as I have started to paint a greater variety of subjects I have started also using a no. 2 brush for very small plants, a no. 8 for very large plants, and of course my little man-made fibre eradicator brush for the removal of any mistakes.

 If you are starting out, a good starter pack would be a no. 6, a no. 2 and an eradicator. This would give you a set that would cope with most sizes of subject, though if you are anything like me you will want the whole set in order to be prepared to paint absolutely anything.

Water container

Choose a large pot with a wide base to contain your water; jam jars can be toppled too easily. This metal plant pot is excellent and looks good too.

Old mixing brush

Tip

I use an old, cheap, flat synthetic brush for mixing my colours. It takes the strain off my best brushes, which now last longer, and allows me to mix really strong colours in large quantities. Being synthetic the brush doesn't hold onto all the colour but leaves it on the palette, which is very useful indeed!

Brush roll

A bamboo brush roll will hold your brushes tidily and allow them to dry off gently, keeping them in pristine condition. I always tell my students to throw away the tiny plastic tube that covers the tip of a new brush; replacing it can catch a hair and damage it, and storing it wet inside the tube (worse still, from licking) will eventually cause the brush to deteriorate. This type of roll will hold all the brushes you need plus some pencils, so everything is in one place.

Paints

A full list of the colours that I use is on page 140. The twelve that I use most often are predominantly transparent colours. They are made by Sennelier and are available as a set (see opposite), though all the colours are made by other paint manufacturers too, including Winsor & Newton. Sennelier paints contain honey, which I find makes them smoother and keeps them softer for longer. Always use artist quality watercolours as they give the best results. Student quality paints are cheaper but do not spread as well and produce disappointing results.

Note

A conversion chart for Winsor & Newton and Sennelier paints is available on my website.

Mixing palettes

The mixing palette I use in my studio is a rectangular ceramic tray. For travelling I have discovered these handy two-piece ceramic sets. As well as the primaries I can take small samples of the paints I use rather than the whole set of tubes. I have a larger version of the travel palette as a clean spare for use in the studio or garden. I have marked the initials of the colours onto the palette with a permanent marker, so that I get to know my colour names.

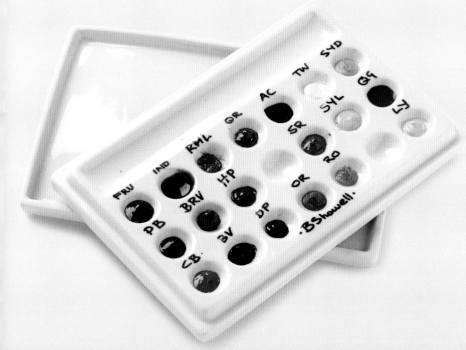

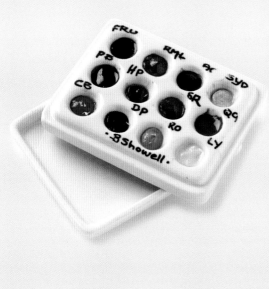

13

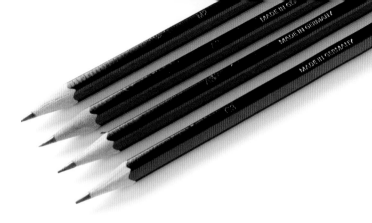

Pencils

4H, 2H, HB and 2B are the pencils I use for drawing and making notes, but a full range of the H pencils through to the Bs is required if you are going to do tonal pencil drawings.

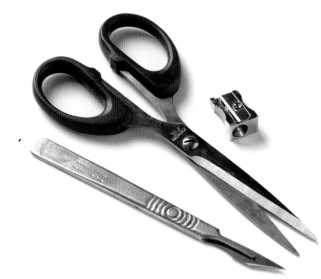

Scissors, scalpel and sharpener

A pair of scissors is very useful for cutting paper as well as plant stems. A good sharpener is necessary for keeping your pencils sharp. If yours continually breaks the leads, replace it with a new one.

I use a scalpel size 10A for sharpening my pencils and for cutting paper or board. It is also useful for plant dissection, the removal of stubborn marks on the paper (see page 86) and for picking out tiny, sharp highlights (see page 65).

Masking fluid

Masking fluid is a rubber solution that you apply to dry paper. It hardens and is used to protect the area it covers from being painted. It is especially useful for protecting areas of fine detail. Apply it with the applicator provided, or use the handle of your brush. Never use the bristles, as it will destroy them. There are many types of masking fluid on the market. The one I use has a blue tinge when dry, making it clearly visible on the paper. Runnier versions are easier to apply than thicker ones.

Erasing shield

This is a metal plate with a variety of different shapes cut into it. It allows you to protect your drawing and erase small, precise areas of graphite.

Malleable adhesive and eraser

Malleable adhesive can be rolled gently over a finished outline drawing before painting to remove the excess graphite (see page 30). A plastic eraser is used to remove your pencil outline once the subject has been mapped in with colour. It is soft on the paper and can also be sliced to create smaller erasers for getting into small areas.

Deckle ruler

This is used for creating a decorative torn edge to the paper. It is not essential but is fun to use and very effective (see page 188).

Observation tools

I use a magnifying glass for looking at really fine detail on a plant. A measuring rule is essential for measuring and drawing plants accurately, and is also useful when mounting or framing your work. Dividers can also be used for measuring plants. Though not essential, they are ideal for gauging the size of complicated structures (see page 26).

Set square

A set square is essential for getting a true corner or angle on your paper before tearing a decorative edge, or for squaring the edges of your painting before mounting or framing.

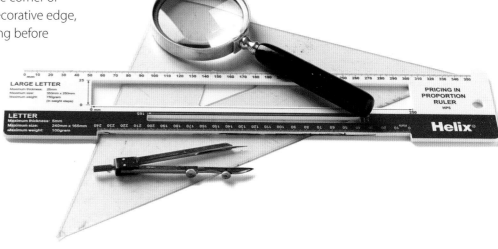

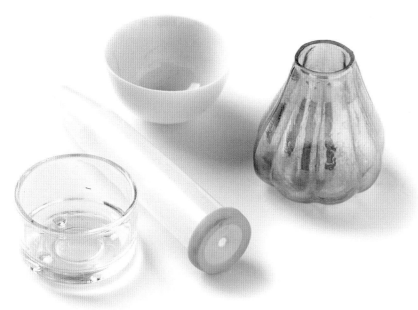

Small mixing bowls and phials

I have a selection of little glass tea-light holders and ceramic dishes for mixing up large amounts of a specific colour or squeezing out a little fresh colour away from the main palette.

Mini vases are useful for keeping small flowers and leaves fresh, or for preserving the odd flower head that has become detached from its stem. Florist's phials are extremely useful for keeping cut flowers fresh and mobile (see page 20).

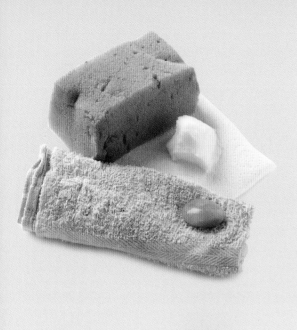

Sponges and cloths

I use an old cotton flannel as a dab pad (an absorbent pad to wipe your brushes on while painting). It is kinder on your brushes than paper towel and is reusable. Have some paper towel handy too, though, as it can be used for mopping up spills and for occasionally dabbing the painting (see page 56). If you intend to stretch your paper, you will need an old medium-sized bath towel and a large sponge for thoroughly wetting the back of the paper.

Magic eraser block

This was a well-kept secret but is now used widely by artists. It is a cleaning sponge that can be used damp to remove stains or stubborn marks from your finished work (see page 84). Use a make that has no bleaching agents in it otherwise it may cause long-term damage to the paper.

Polished stone

Use a polished stone to smooth out over-worked areas of your painting or smooth out paper where a mistake has been removed. Always place a piece of paper towel over the part you are working on to avoid creating a shiny surface.

Lifting preparation

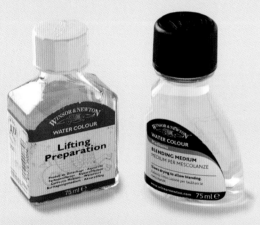

This is a clear fluid that you paint straight onto an area of your paper. Once dry, it will permanently protect the paper from staining. This allows you to paint over an area and lift out the highlights to reveal the white paper underneath, even after the paint has dried. However, it is only suitable for small areas.

Blending medium

Add this to your paint to make it dry more slowly and spread further. I like to experiment with this, and use it for large washes of colour.

Tape

Masking tape is very useful for holding down your paper, stabilising your plant material, and so on. Gummed brown paper tape is used for stretching paper (see pages 186–187), and I also use brown cloth tape for mounting and framing work.

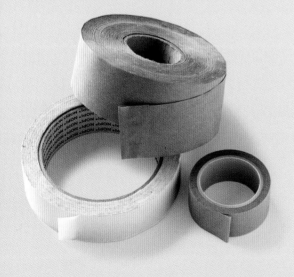

Facing page:
Tea Rose
Tea roses with a tea-stained background.

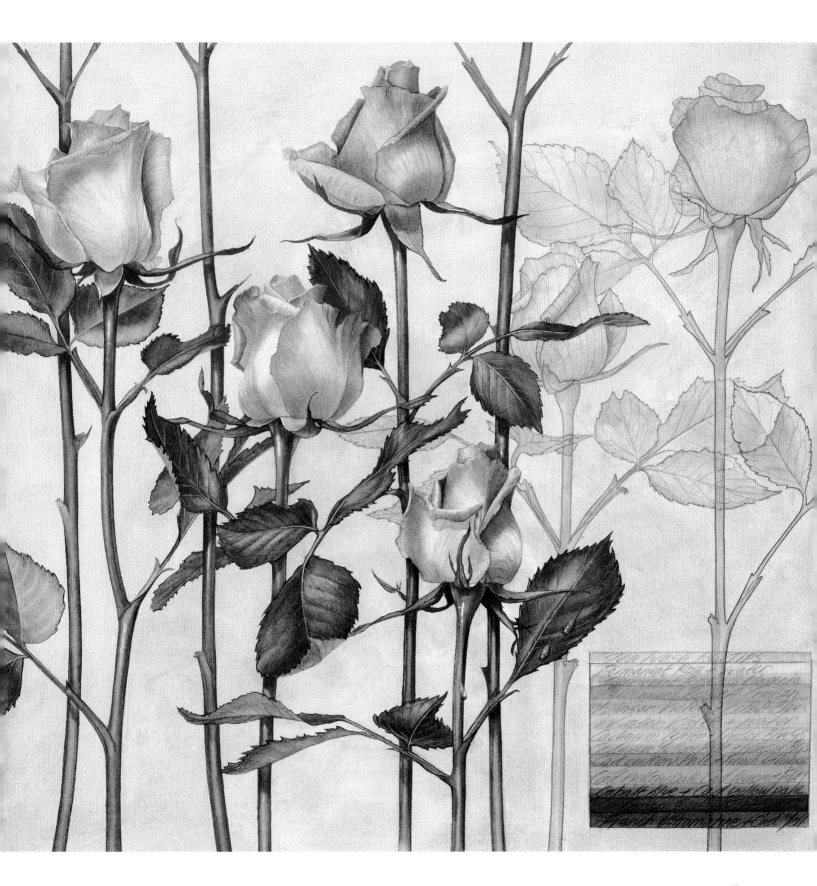

Getting started

Choosing your subject matter is not an easy task, and at this point I would encourage you to choose a flower or fruit that you love the look of. Painting is easier if you like the subject, so banish the 'empty wine bottle and an orange' type of painting and make a study of your favourite plant. I adore painting from the fresh, live plant, as you can turn it round and study it carefully with a magnifying glass. You learn to work fast, but if you want a static image to work from, then take some photographs of the subject from different angles and work from those once your flower or fruit has withered. Keep the subject fresh as long as you can to match the colour and detail more accurately.

Research how to care for your plant. Useful information on how to keep cut flowers alive is provided on pages 20–21, and florists' websites or magazines are also a good source of tips and advice on this subject. Invest in a good digital camera; if your flower is fading it is useful to have a record of it. I use a small digital camera and then upload the photographs to my computer. I occasionally print out the images but prefer to work straight from the computer screen as this gives more light and depth.

Gather together everything you need so that your painting time is as stress free as possible. Try to find a space in your home where you can lay out your materials and leave them out ready for when you have the time or the inspiration to paint. Packing them away each time will be tiresome and may put you off just grabbing a few minutes of quality painting time now and then.

Getting in the right frame of mind

Once set up, say to yourself, 'let's see what happens' rather than 'I must start and finish the piece now'. If you put too much pressure on yourself it will cramp your creativity. Don't underestimate the importance of practice – jumping straight into a painting and expecting to produce a masterpiece without practising the skills can lead to disappointment.

How to lay out your workstation

I am fortunate to have studio space, but as I am often teaching there I find my workstation frequently gets moved about. I therefore have a specific way of laying it out so that each time I paint, it feels familiar and above all comfortable. Paints, water and your dab pad should be on the right if you are right-handed and on the left if you are left-handed. The light source is best positioned on the opposite side to your dominant hand so that you do not have to work within the shadow cast by your hand. I like to work with a window to my left and a lamp for when further drama is required. I use my lamp to light the paper or the subject, or both if I can, but experiment and find out what works for you.

Daylight will be more truthful for colour mixing but you can always mix near the daylight and then paint by lamplight. I believe there should be no rules except the ones that make sense for you and make it easier for you to paint, so discard the rule book if it seems too rigid and follow your own instincts.

Have all the tools you will need to hand but not in the way, and give yourself space to move the work around and so that you can avoid splashing paint onto your painting. Make sure you have a supply of paper towel and clean water just in case of any spillages.

Working from life

Keeping fresh items fresh

Looking after your plant material is essential to prolonging the time you can observe it. Photographs are great, but for me there is nothing like the real thing. Obviously, if you are working on a subject that is out of season then there is no choice but to use a photograph, but here are some tried-and-tested tips for keeping things fresh.

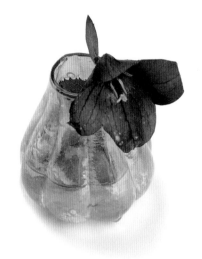

Keep small flower heads in water in small vases and store them in a cool dark place overnight.

Preserving your plant material

1 Try to cut your flowers early in the morning when the sap is rising and put them directly into water.
2 Cut the stems at a 45-degree angle, preferably beneath the water to prevent air bubbles getting into the stem.
3 Crush the end of any woody stemmed plants to help the plant take up water.
4 Don't remove thorns from roses.
5 Most flowers like water at room temperature (preferably rain water) but bulb flowers, for example tulips and daffodils, prefer ice cold water.
6 Keep the water clean by changing it daily.
7 A light misting of water helps delicate blooms stay firm.
8 Blanch the end of wild flower stems in boiling water for five minutes before putting them in a water phial or vase.
9 Store blooms in a cool, dark place overnight or in between painting sessions.
10 Snip off the ends of the stems as they turn brown.
11 Always choose the healthiest specimens from the florist. Rose heads should be firm and able to withstand a light squeeze. If they are soft or browning at the base of the flower, they will not last.
12 Semi-opened flowers can be encouraged to open by gently placing cotton wool between the petals overnight.

Phials are also a good way of transporting and preserving plants, and holding them in a steady position, but transfer them to a vase overnight to prevent them drying out.

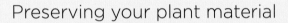

Preserving cut fruit with lemon juice

Cut fruit can be prevented from going brown by rubbing them with lemon juice. The lemon juice prevents oxidisation, which creates the brown colour on the surface. Whole fruit can be kept fresh in the fridge or a cool, dark room overnight, in between painting sessions.

1

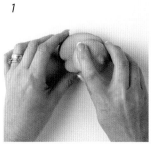

2

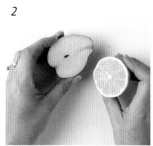

3

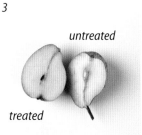

untreated

treated

Tip

In between painting sessions, keep dissected plants on a thick base of wet paper towel inside a sandwich box in the fridge. This won't work for exotics, as these flowers will brown very quickly if stored at low temperatures.

Preserving a cut flower

Large buds may open during the painting process. Some flowers, such as tulips, are particularly susceptible to this. To keep them closed during the painting process, use fine, double-sided tape twisted into a sticky string and gently wrapped around the flower head, or use cotton thread gently tied around the bud as shown below.

Pricking the stems of tulips can keep them straight, but don't leave the pin in the stem.

Tip

It is a good idea to keep snipping small pieces from the bottom of the stem to ensure the stem continues to take up water.

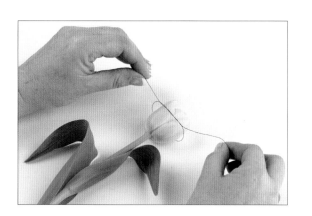

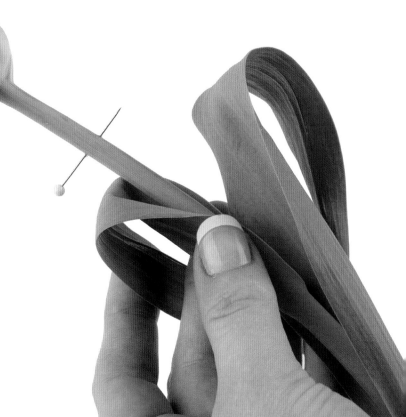

Observation

It is always advisable to get to know the plant you are painting before you start. We often make assumptions about the structure of a plant, but to really understand your subject and depict it accurately, I would aim to spend a good half an hour or so taking notes on details such as the veining pattern, the markings, how the petals or leaves are attached and so on. The checklist on the right will provide useful guidance on what to look out for.

Pressed flowers

I have recently started pressing some of the flowers and leaves from my garden. I lay them between several sheets of paper towel and then place them beneath heavy books. I find that the patterns and veining on the petals and leaves provide very good reference once the specimen has passed. You can add these little captured memories to your sketchbooks when completely dry.

Using a magnifying glass

I find that having a magnifying glass to hand is very useful for understanding the very fine detail on a plant, and how the subject is connected to and growing from the stem and root. I certainly would not advise using it continually without advice from your optician. Close observation is very tiring on your eyes so make sure that you rest them intermittently throughout the day.

Key questions to ask yourself

How wide are the stems?
Are the stems even all the way up or do they thicken in certain areas?
What is the arrangement of the leaves on the stem?
Do the petals fall into a set design?
Are the petals/leaves all the same length or colour?
Are there hairs on the plant and where do they start and finish?
Do the leaves twist?
Are the petals fused before the split and curl back?
Do the stems bend or curve?
Is the vein patterning light or dark or a different colour?
How many petals are there and do they all fit the same pattern?
Does the base of the stem get paler as it emerges from the leaves or bulb?
How do the various parts connect to each other and can you show that somehow within your painting?
Is there a particular angle that gives the onlooker more information about the plant?

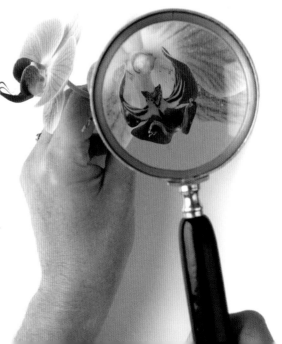

Leaf rubbing

If a leaf is tough enough you can take a rubbing of the veining. I use the underside of the leaf to take the rubbing from, and use a 2B pencil rubbed over a piece of tissue or tracing paper. The rubbing can then be used for reference and you can even cut it out and curl it to see how the veins lie on a curve or twist. It's fun to do too and will help you observe the size and tapering of the veins more easily.

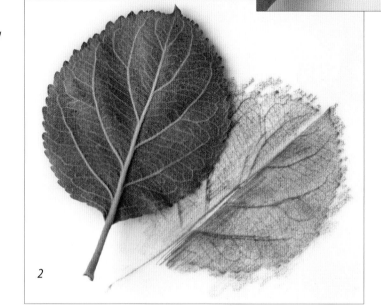

1 Lay the leaf face down on a sheet of paper and lay tracing paper or tissue paper over the top. Rub over the leaf gently using a 2B pencil.

2 Your finished tracing also provides a good reference if your leaf dries out or dies before your painting is complete.

Guide marks

When you are painting something detailed or complicated, you could mark the subject with a tiny dab of paint. Use this as your reference point so that if you get lost in a maze of pattern you can find your way back to the mark and work outwards again.

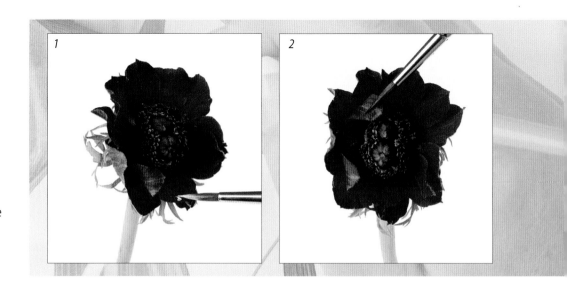

1 When counting petals, mark the starting petal with a dot of contrasting paint. This method can also be used to provide a useful reference point when drawing multi-petalled flowers too.

2 Use a clean paintbrush to carefully move the petals to one side when counting them.

Dissection

Dissection is not essential but it is fascinating, and can offer a valuable insight into the structure of a plant. If you are a confident artist and are looking for a new challenge, dissection can offer you an interesting variation on your usual approach to composition, as shown in the painting opposite.

Start with a simple plant and experiment to see which angle provides you with the most relevant and useful information. Plants usually die off very quickly once dissected, so have your sketchbook ready and make little annotated drawings to help record what you see. Photographs are extremely useful too, if backed up with notes. See page 21 for advice on preserving dissected plants.

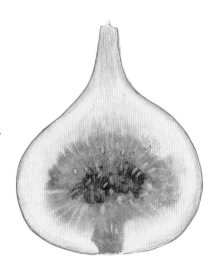

Dissection of a hollyhock flower

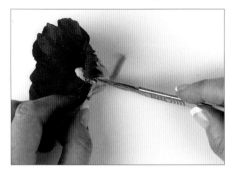

1 Insert a sharp knife or scalpel into the side of the flower head and push the blade through the middle of the flower to the other side. Make sure the blade passes through the pistil. Cut down towards the stem.

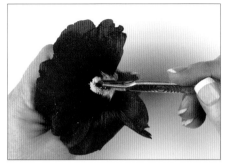

2 Re-insert the blade into the middle of the flower and cut upwards through the pistil.

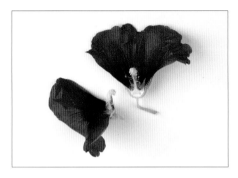

3 Continue to cut through the rest of the flower, until it is in two halves.

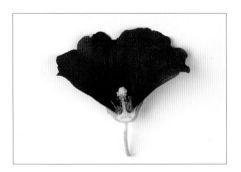

4 Choose the better of the two halves and leave this half intact.

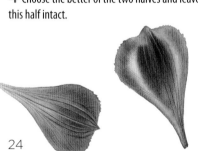

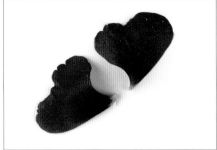

5 Remove the petals from the other half, leaving the sepals attached to the flower centre.

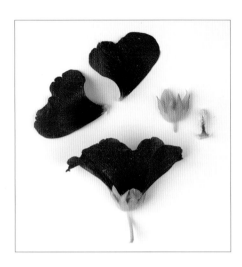

6 Separate the sepals from the flower centre. Lay out your flower's component parts for careful observation.

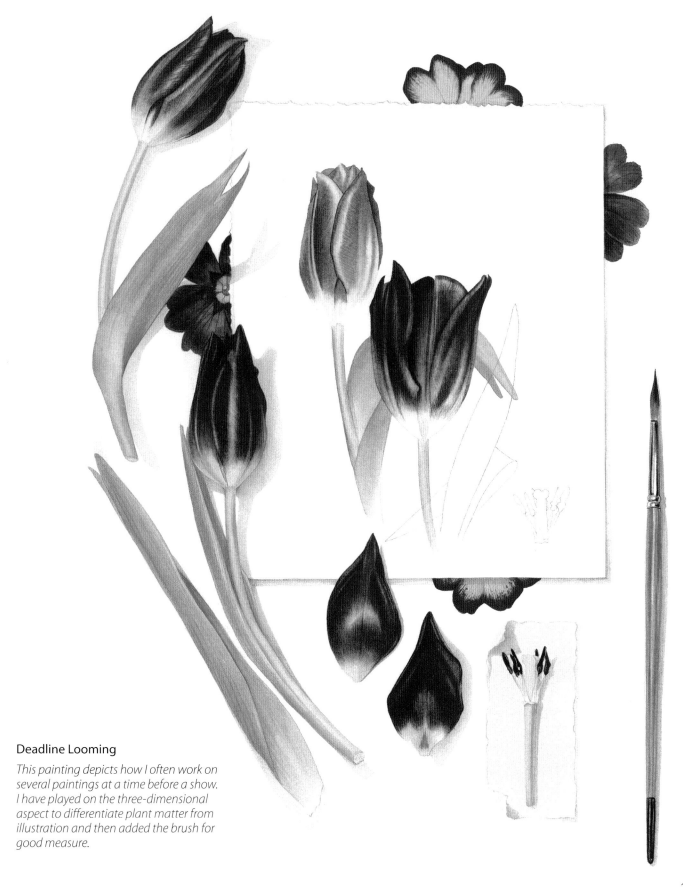

Deadline Looming

This painting depicts how I often work on several paintings at a time before a show. I have played on the three-dimensional aspect to differentiate plant matter from illustration and then added the brush for good measure.

Measuring

Using dividers or a pair of compasses to measure is an art in itself. They are used to take measurements in a two-dimensional plane, and the easiest way to achieve this is to imagine that a pane of glass exists between your dividers and the plant and rest the points of the dividers on the 'glass'. Directly you tilt the dividers you are measuring in three-dimensions, and your drawing will be distorted. If you are enlarging or reducing the image, mark the measurements onto paper alongside a ruler and then multiply or divide by the appropriate enlargement or reduction factor.

1 Use a pair of dividers to measure the width of a flower before drawing.

2 Transfer the measurement to your paper to aid accurate drawing. It is very easy to accidentally enlarge or reduce the size of the flower as you work, so keep checking the measurements throughout the painting process.

Tip

Always lay fresh flowers on a piece of tissue paper or paper towel to avoid marking your painting.

Foreshortening

Keep the dividers vertical and resting on your imaginary sheet of glass when measuring the width of a foreshortened flower. If you tilt the dividers in the direction of the flower, your measurement will be of the actual width rather than the foreshortened width.

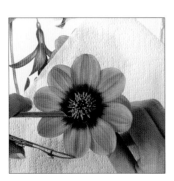 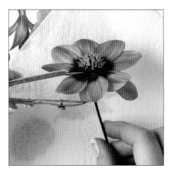

1 Measuring the length of a petal will not give you the foreshortened measurement.

2 Keep the dividers vertical then tip the flower away from you and measure the petal length. Transfer this measurement to your drawing.

Facing page: filling a page with studies can be a great way to test your composition skills. Gather items together and lay them on a sheet of white paper. Enjoy the process of deciding on the best arrangement.

Tip

You can also use a piece of card to measure the width of your flower – simply hold the card up to the flower and mark both ends with a pencil.

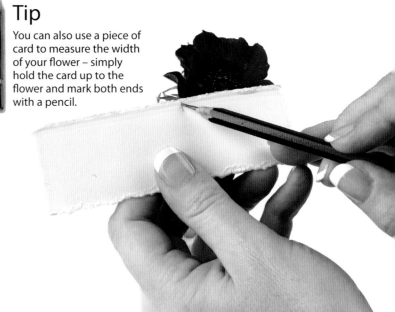

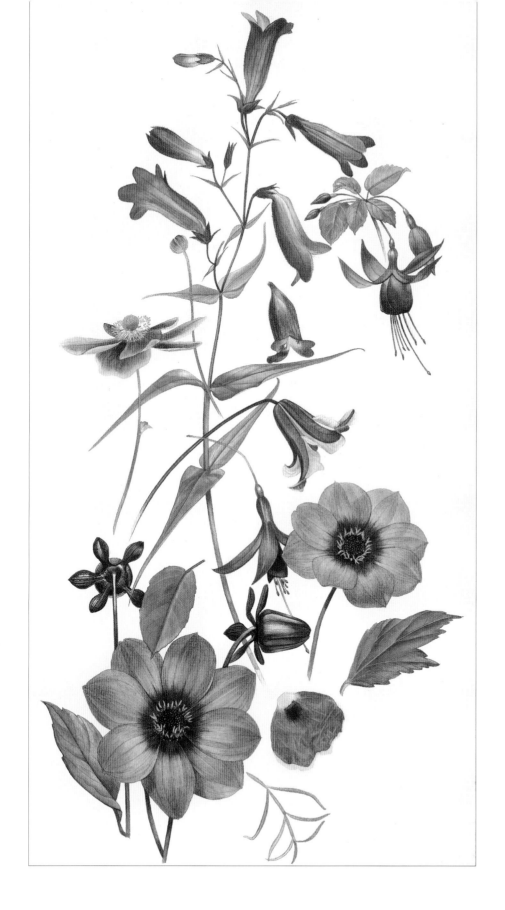

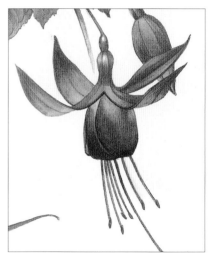

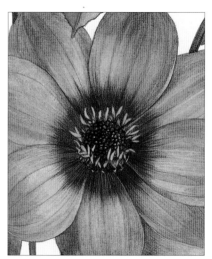

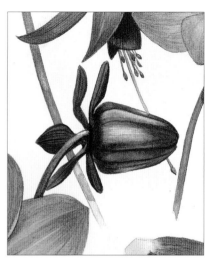

Drawing

Seeing shapes

All my paintings start with a drawing. I like to begin by looking and truly observing: this is the first step to enjoying your art. Sadly, a great many people think they can't draw and convince themselves that they can't be taught; however, with a little knowledge and some practice I believe that we can all draw well. It is simply a matter of training yourself to look and then look again.

In many respects, drawing is the first stage in really understanding a plant. When you draw the elements that make up a flower, fruit or vegetable, you become absorbed in the detail and will increase your knowledge of the nature of the plant.

The idea of educating yourself about the detail in the world around you while enjoying creating an image of it is the reason I love botanical painting. As in the poem *Leisure* by William Henry Davies, 'no time to stop and stare' suggests that our lives are poorer if we cannot take the time to truly rest and look.

I mostly draw and paint my subjects actual size, which I believe is the best way to start as you can then measure easily and draw accurately. Working from a photograph, while sometimes necessary, can lead to distortion of one or two of the plant parts. If you are aiming for accuracy, you should make notes on the measurements or even take cuttings to press.

So, drawing is where we will start, and if the drawing is good then we are part way to a beautiful study.

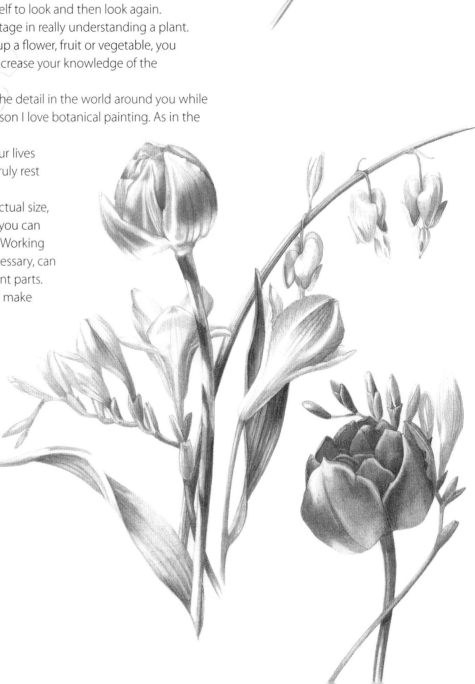

Identifying basic flower shapes

Start by observing the basic, simple shape of the plant, for example a cone, a bell or a triangle. You may feel you just want to draw the plant and don't need to start with a shape, but believe me, it is extremely helpful and can actually speed up the whole drawing process. By lightly sketching in the main shapes, you can get a feel for the whole plant.

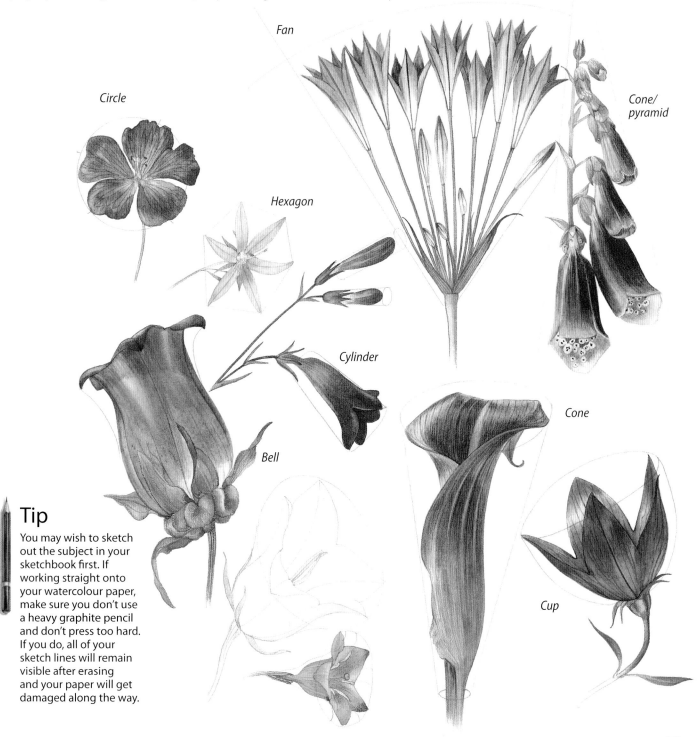

Fan

Circle

Cone/ pyramid

Hexagon

Cylinder

Cone

Bell

Cup

Tip

You may wish to sketch out the subject in your sketchbook first. If working straight onto your watercolour paper, make sure you don't use a heavy graphite pencil and don't press too hard. If you do, all of your sketch lines will remain visible after erasing and your paper will get damaged along the way.

Another way to identify the basic shapes of a plant is through measuring points. Here is a longiflorum lily. I began by marking the tip of each petal onto the paper and then drew in the angles between each petal tip all around the opening of the flower. To accurately observe the angles, I offered my pencil up to the flower as shown in the drawing on the facing page. The pencil allowed me to see the angles more clearly.

Once all the angles and points were marked in, I drew in the petal edges. Keeping the pencil in place for a moment allows me to observe the negative space contained within the petal edges and the pencil. This makes it easier to draw the shape, thus achieving a more accurate depiction of the petal placement.

Notice that the flower opening creates a geometric shape that is dependent on the quantity of petals. As it turns away from you, this shape will become squashed and narrow; as the flower turns to face you, the shape will become fuller and more symmetrical.

All these drawings are done with a 2H pencil and then lightened before painting. Avoid using HB pencils, as these are quite soft and become permanent beneath the first washes of colour.

Lightening a drawing

If your drawing is too heavy, lighten it by rolling malleable adhesive firmly over the surface to lift off the excess graphite. I have used this method for many years, and it works beautifully.

Making notes and analysing a plant before painting the final piece is good practice if you are a beginner. On this page I have made several annotated drawings and painted both sides of a petal to familiarise myself with the subtle changes in colour and pattern.

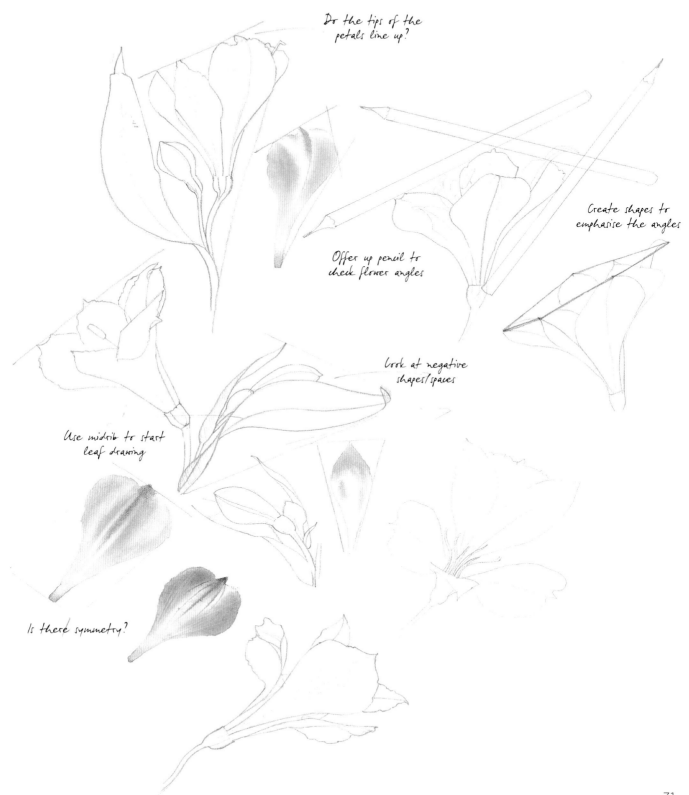

Do the tips of the petals line up?

Create shapes to emphasise the angles

Offer up pencil to check flower angles

Look at negative shapes/spaces

Use midrib to start leaf drawing

Is there symmetry?

Drawing leaves

Leaves terrify some botanical painters, as they can make or break a plant painting. The secret to drawing leaves is the continuation of the main vein or midrib through the centre of the leaf. If this appears broken or misplaced then the true representation of the leaf structure is lost. In nearly all my drawings I start with the main vein. I do this by imagining I can see through the leaf and that the veins and edges of the leaf are all that is visible.

Simplifying leaves and foreshortening

In the illustrations below I have coloured the main vein in green and the outside edges in blue and red. Once these lines have been established, I can then draw in the leaf surface, represented here by the yellow line. I then remove the unwanted pencil lines represented by the dotted lines. The shaded areas help you to see which part is the top of the leaf and which is the underneath. This technique is really good for depicting foreshortened leaves and petals.

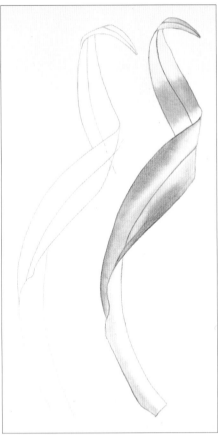

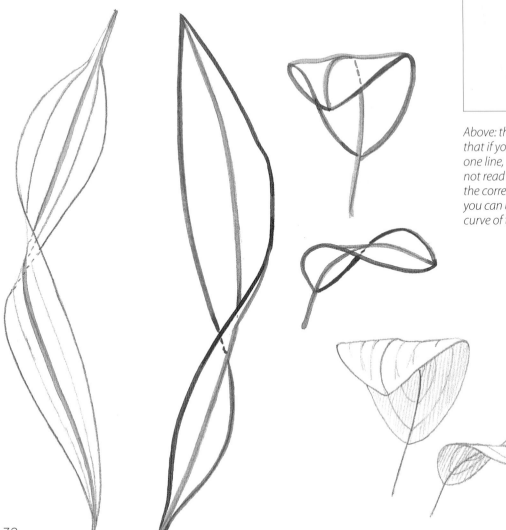

Above: the drawing on the left above shows that if you don't draw the main midrib in one line, then the two halves of the leaf will not read as one. The leaf on the right shows the correct position of the midrib and how you can use a mid-tone grey to depict the curve of the leaf.

Transparent drawing

This method of drawing requires you to imagine you can see right through the objects you are drawing. As with the leaf drawing on the facing page, it is often a more accurate way to get the positions of the edges in the right place. When painting plants with many flowers or fruits, it is relatively easy to draw the foreground shapes first, then fit the background shapes around them. But if you draw all the shapes in at the beginning, then the angles will be true and the study more accurate.

Start by practising this process with simple shapes like the grapes and then progress onto more challenging shapes.

In the study below, drawing transparently means you draw each grape complete, rather than just the parts that are visible. This ensures the shapes and arrangement of the grapes are accurate.

Tip

When drawing, try to leave your mistakes on the paper. Once rubbed out, you may easily repeat the same mistakes again, but if you leave them in place you can more easily adjust your lines to the correct position.

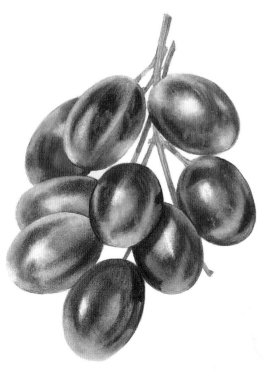

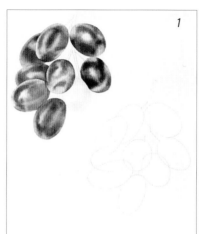

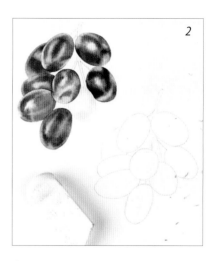

1 Draw the bunch of grapes, with each fruit complete.

2 Use an eraser to remove the parts you don't need. Put back any lines that you have removed by mistake.

Tip

Leaving the erasing till the end of the drawing will avoid distressing the paper. Be aware that different papers respond to erasing in different ways. I use Fabriano Artistico paper, which is highly resilient to erasing. Arches paper is softer and will be easily damaged through using an eraser, so be careful.

In this study you can see the combination of transparent leaf drawing and seeing through the leaf to obtain the correct position of the tulip stem. Elements of the design can then be painted in stages, removing the pencil as you progress.

Observing negative spaces

You can improve your
drawing by observing the
negative spaces between
the various elements of
the plant. Your brain will
not recognise these as
familiar shapes and will
therefore work harder to
observe the plant correctly,
resulting in a more accurate
drawing.

In this painting I have
identified some of the
negative shapes with
diagonal pencil shading.
You can see that the
shapes are more
irregular and therefore
less familiar. Draw these in
first and then build the plant
around them.

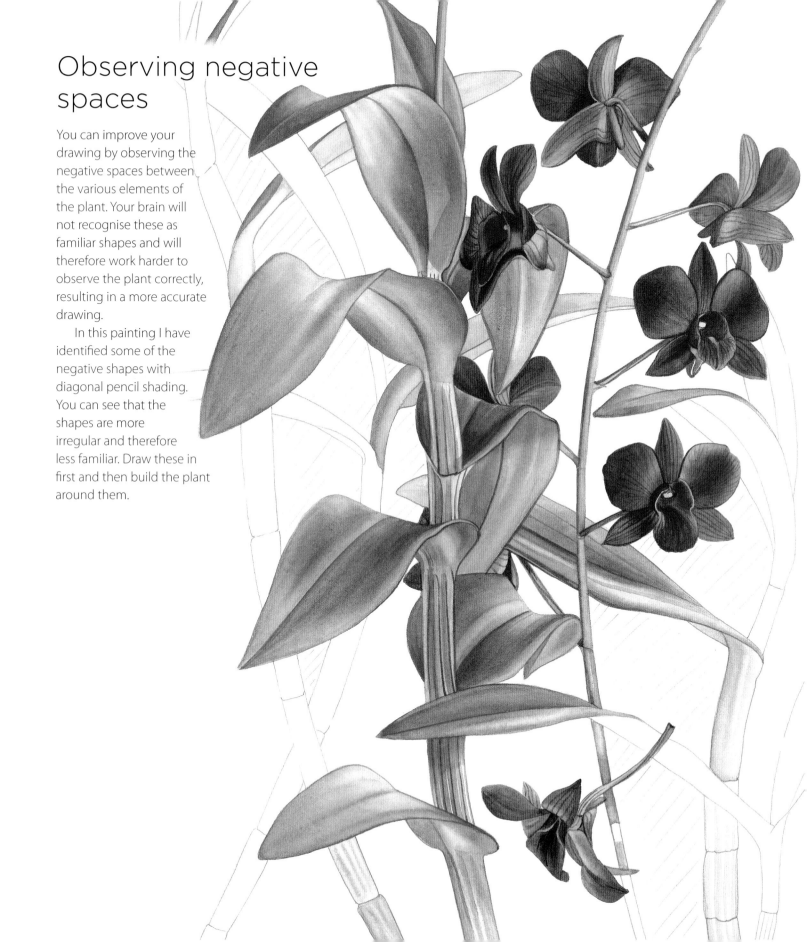

Trace back method

This is a method of transferring a drawing to your watercolour paper. It can be used to transfer a tracing from a photograph or from a study in your sketchbook, or to copy a drawing from one page to another.

In the demonstration below I have used the trace back method to repeat a field study on a finished painting. It is worth mentioning here that this method should not be used to copy another artist's work onto your own to reproduce or sell, as this would be a breach of copyright, but it is a fabulous way of copying your own drawing onto a painting to allow you to position it perfectly in a composition.

1 Trace over the drawing using a sharp 2H pencil.

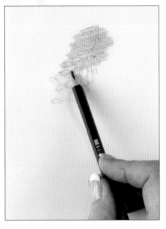

2 Turn the tracing over onto a sheet of paper and shade evenly over the back of the drawing using a 2B or HB pencil.

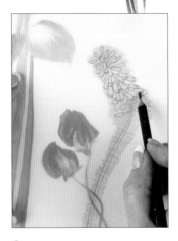

3 Place the shaded side down onto your painting, positioning it accurately. Working methodically, draw carefully over all the lines of your drawing using the 2H pencil.

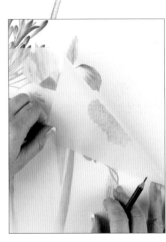

4 Holding the paper firmly in place, carefully fold back the tracing to make sure every part of the drawing has been transferred.

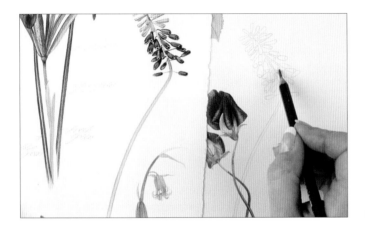

5 Remove the tracing, and correct and strengthen the drawing, using the original painting for reference.

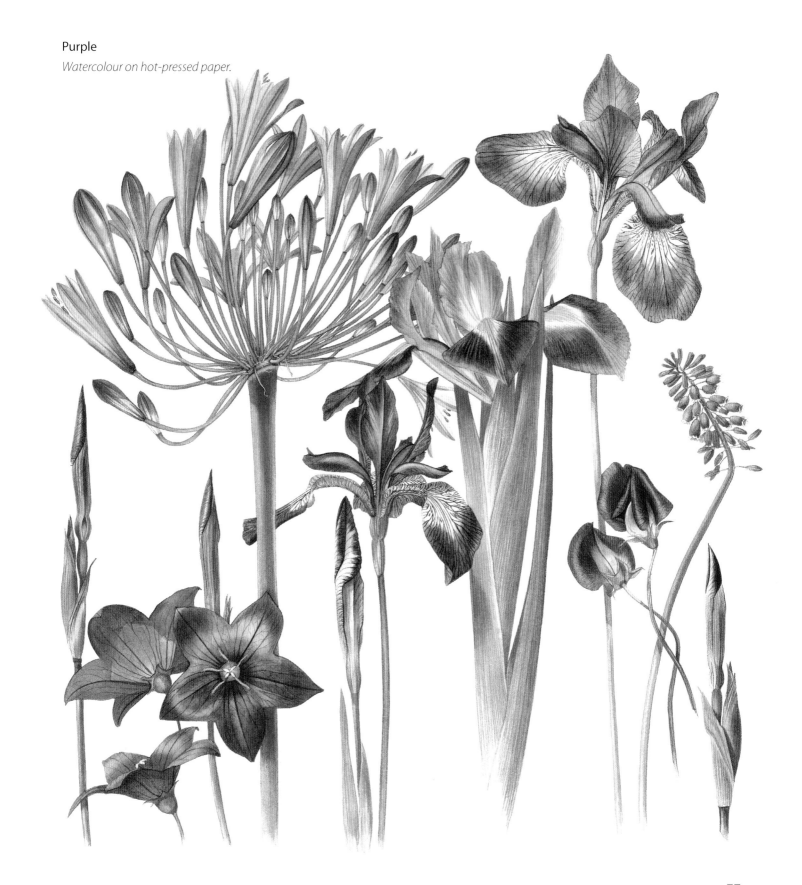

Purple

Watercolour on hot-pressed paper.

Observing pattern and shape

One of the most beautiful forms in nature is the spiral design of some plants such as pine cones, seed heads, sunflower seed patterns and flowers like echinacea. The spiral follows a mathematical pattern identified by a sequence of numbers known as the Fibonacci sequence, 1, 2, 3, 5, 8 and 13 and so on, each new number being the sum of the two previous numbers (Leonardo Fibonacci was an Italian mathematician born in 1170).

It is also amazing that the Fibonacci number sequence is seen throughout nature, from the number of petals on a flower to your own body, for example two hands and five digits, each with three sections.

There are of course exceptions to the rule but even these living designs, I am given to believe, can be explained by other number sequences. The point of knowing all this as a painter is to aid observation and precision in your drawing. By recognising the pattern within a form or in the arrangement of the leaves, you should be able to create a drawing that is both beautiful and accurate.

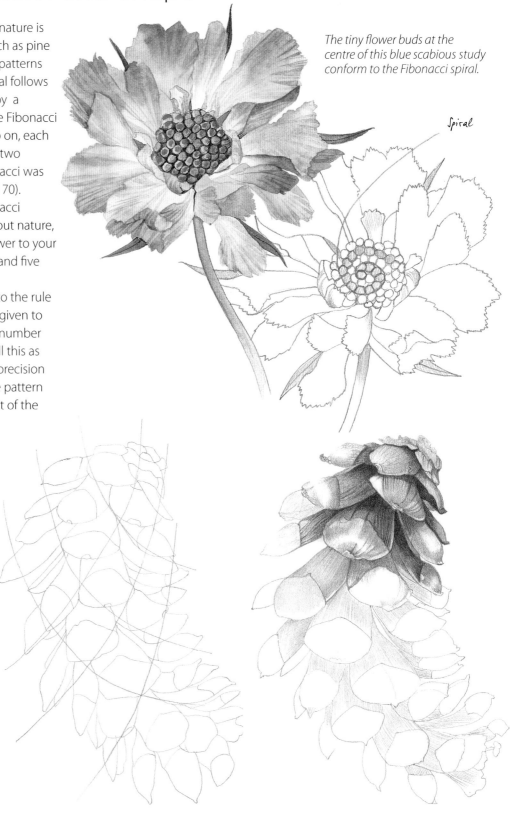

The tiny flower buds at the centre of this blue scabious study conform to the Fibonacci spiral.

Spiral

Line drawing and tonal sketch of a pine cone. On the pine cone you can clearly see the sweep of the spiral pattern decreasing towards the top of the cone.

Symmetry

The beauty of symmetry in nature exists from the start of life in cell division and multiplication. However, it is often not quite perfect and most plants will have subtle differences between each of its apparently identical halves. Flowers, for example, may appear symmetrical, but look closely and you may discover that the patterning, although evenly balanced, is quite different on each side.

Symmetry, however, is a useful tool to use when drawing your subject. You can, for example, use tracing paper to draw out one side of your flower and then fold it in half to trace off the other matching side. Bear in mind that you will have to return to the actual plant to observe the subtle differences between the two sides and make any small adjustments.

You can also use symmetry to check your drawing, for example by measuring the petals with dividers and comparing one side of the flower with the other to see whether those on both sides are the same length and width.

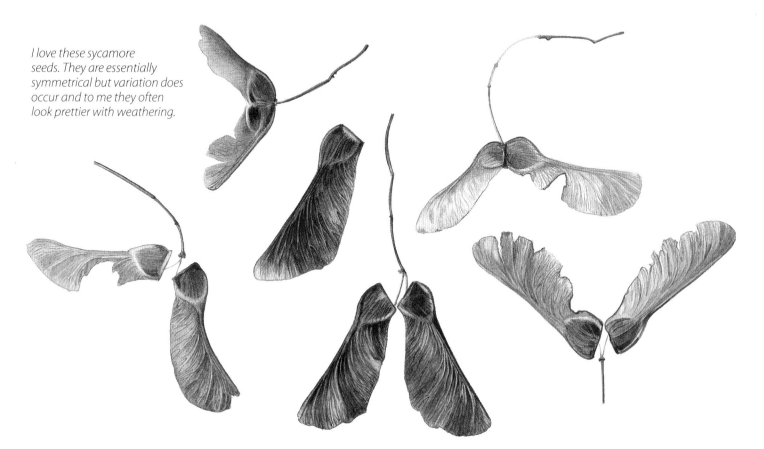

I love these sycamore seeds. They are essentially symmetrical but variation does occur and to me they often look prettier with weathering.

Tone

As part of my preliminary studies, and as an alternative medium to watercolour, I will often make a tonal study of my subject. This is a very useful and enjoyable thing to do; it teaches you to truly observe the depth of tone in a subject, and the highlights and reflected lights on surfaces.

Begin by practising the basic pencil positions shown opposite.

 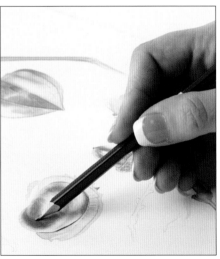

For detail, hold the pencil upright and use the tip of the lead.

For shading, hold the pencil at a shallower angle and use the edge of the lead.

Creating a tonal drawing

If you wish to study the tonal values of your subject before you start a painting, a few tonal exercises like this are invaluable. Use a well-sharpened pencil and, throughout the drawing process, keep the pressure on the pencil light. Before shading, turn the pencil on its side and scribble onto a spare sheet of paper to soften and curve one side of the lead.

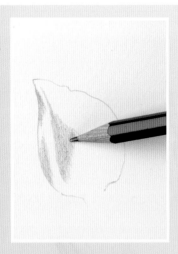 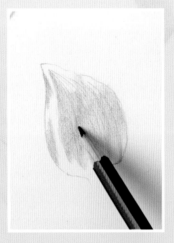 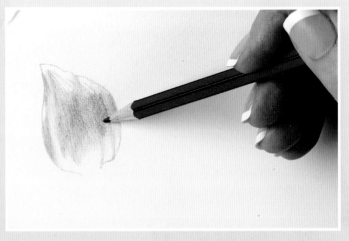

1 With the tip of a 2H pencil, use fine, elliptical lines to begin your initial drawing.

2 Add further light shading using the side of an HB pencil. Work in small, delicate, elliptical movements.

3 Define the deeper shadows using a 2B pencil. For the darker detail, such as scoring the veins, use a 4H.

Using an erasing shield

I have owned an erasing shield since I was a student, and although I don't use it very often, it's an excellent tool for erasing a highlight and keeping a sharp edge to one side.

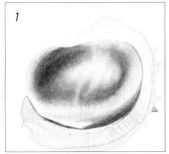

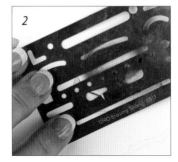

1 Decide where additional highlights are needed on your drawing.

2 Find the shape on your erasing shield that is nearest to the one you want and position it carefully over the drawing.

3 Use an eraser to remove the pencil marks that lie within the shape.

4 Carefully lift off the shield, revealing the highlight underneath.

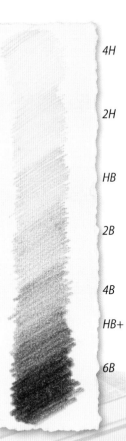

4H

2H

HB

2B

4B

HB+

6B

This strip shows the degrees of darkness achieved with each grade of pencil.

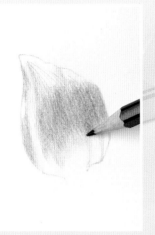

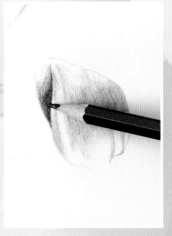

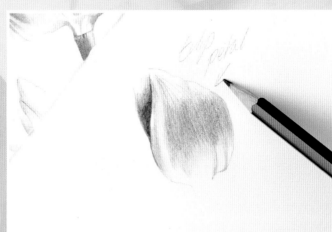

4 Smooth over the 2B graphite by shading again with a 4H pencil. This process is known as burnishing.

5 Using a 3B pencil and a little more pressure, shade up to the lighter edges to create more definition.

6 Annotate your drawing for future reference using a 4H pencil.

Tonal painting and graphite combined

Ever since art school I have loved this combination of grey watercolour tone with graphite over the top. This combination suits my work very well, as I can achieve immediate softness through the use of the watercolour, and then, when it is totally dry, I can build up the tone and detail over the top in pencil.

Start your tonal painting by making a mid-tone grey with French Ultramarine, Sennelier Yellow Deep and Sennelier Red. Water it down progressively to create four tones, as shown below. Keep the mixes well stirred otherwise the colours will separate.

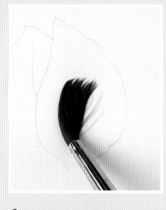

1 Glaze the area with water.

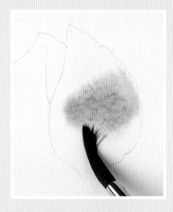

2 Lay on the mid-tone shadows.

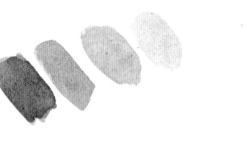

3 Use a clean, damp brush to lift out the light.

4 Allow to dry then map in the adjacent darks.

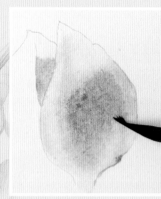

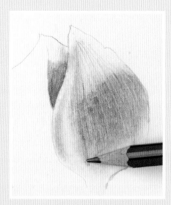

5 Glaze the painting again and deepen the darks.

6 Once the main tones are in place and dry, go over the top with graphite to put in the detail.

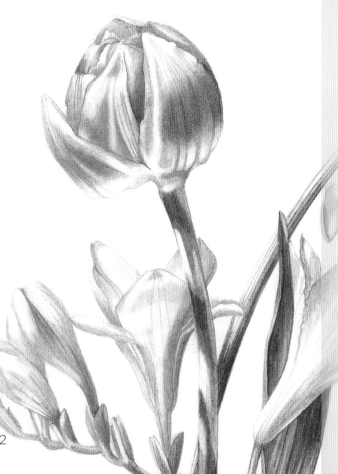

Effect of light on tone

When I am painting I often work with a lamp to help create strong shadows, and also to get the light and shade to aid me in creating form. I spend some time adjusting the lamp to obtain just the right balance to achieve form but also to give enough light to enhance the subject. You can try a tonal study first to see if you have the balance correct.

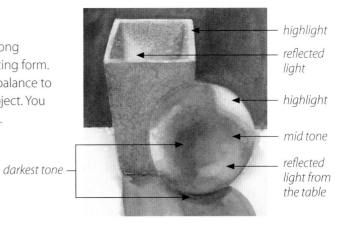

highlight

reflected light

highlight

mid tone

reflected light from the table

darkest tone

On this tonal sketch I have indicated the different areas of light that you need to identify to create a three-dimensional effect. Remember you can get reflected colour too.

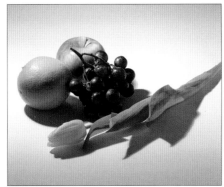

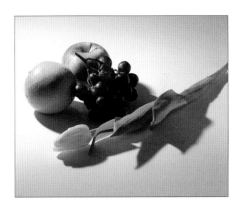

Here the light is too cold and strong, so all the shadow on the orange is pushed to the edge and the flower is washed out.

Here the shadow on the orange wraps around the belly of the orange, aiding the creation of the ball shape. Notice the yellow and green reflected in the shadows.

Here the light is further away and the shadows are longer, but there is not enough light on the grapes and they are lost in the darkness.

Effect of light on colour and texture

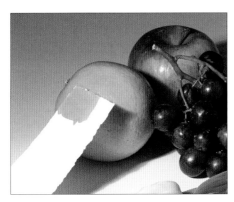

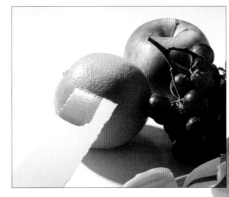

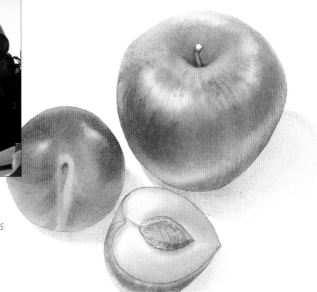

If the light is too soft, the texture and highlight on the orange are lost and the colour you use would be very flat too.

With more dramatic lighting, both the highlight and texture are enhanced allowing you to play with deeper washes and textured glazes.

Using a brush

Getting to know your tools and using the correct tool for the job is imperative. Some brushes will hold too much paint, some not enough. Some will split, and some poorly made brushes will have rogue hairs or be too blunt for fine work.

A good brush takes all the stress out of painting. It will sweep beautifully and deliver the paint with ease, then mop it up softly. With a gentle twist of the brush on the palette it should gather to a point for smaller areas and detail. If looked after well, a good brush should last for years, and getting the most out of it will become second nature to you.

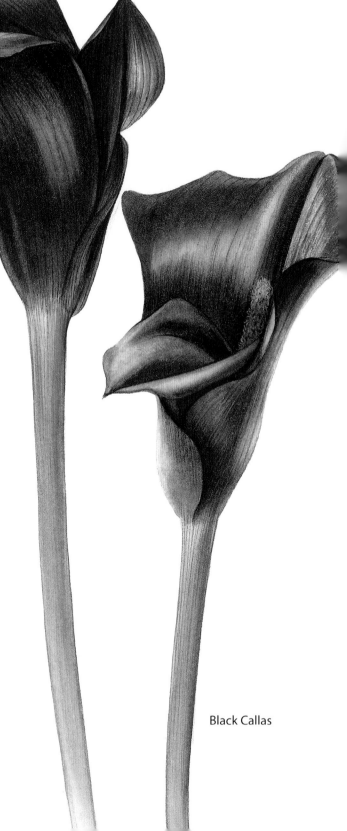

Caring for your brush

- Always remove the plastic tube your brush arrives in and throw the tube away. The tube is only there to protect it on its journey to you from the factory. Wash your brush in clean water and store it in a brush roll. The hairs can then dry freely.
- Never lick your brush. The enzymes in your mouth may hasten the deterioration of the brush hairs.
- Never use your best watercolour brush with any other type of paint.

How to hold your brush

For detail, grasp the brush around the ferrule and hold it upright. Rest your fingers gently on the paper for support, and paint using the very tip of the brush.

When applying a wash, hold the brush further up the handle and use the side of the brush to sweep colour onto the paper. Rest the side of your hand on the paper for support, if you want to. Place a clean sheet of paper beneath your hand to avoid damaging the painting under it.

Black Callas

Basic brushstrokes

Knowing what marks you can make with your brush is essential. With confidence, you may only need a couple of sweeps of your brush for small petals or leaves, therefore economy of stroke is good to master. It is also beneficial to the paper as the less you sweep the brush on the surface the more likely it is to remain undamaged.

Learning different brushstrokes

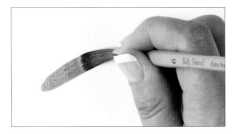

To obtain a broad sweep of colour, use the full width and length of the brush head.

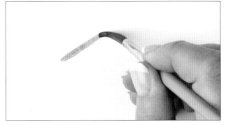

For a finer band, raise the angle of the brush and apply less pressure to the brush head as you move across the paper.

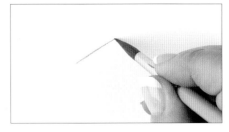

An even finer line can be painted by raising the angle still further and using just the tip of the brush to apply the paint. Practise these steps regularly to obtain confidence with the brush.

Lifting out colour

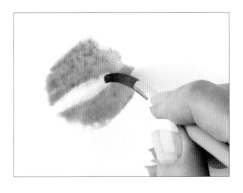

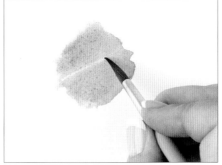

Creating leaf and petal shapes

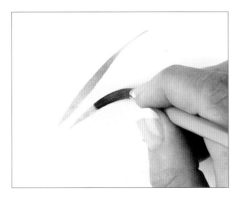

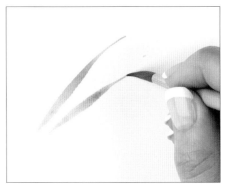

Tip

Hold the brush lower down the handle for more controlled work, and higher up the handle for looser work.

To lift out colour, sweep a clean, damp brush through a puddle of colour. For lifting out a broad band of colour, use the full width and length of the brush head. For a narrower band, increase the angle of the brush and use just the end of the head, twisted into a point.

Tip

As the puddle dries, the sharper and brighter the line you can achieve.

For fine leaves and petals, the rule is 'point, push and lift'. Start at the base of the leaf with the point of the brush. With a smooth motion, push downwards to widen the stroke as you work towards the middle of the leaf, then gradually lift the brush off the paper to create the tip.

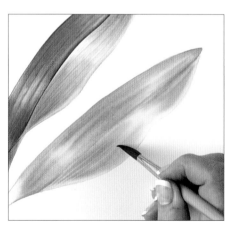

My favourite brushes (from top to bottom): eradicator, and nos 2, 4, 6 and 8.

What size brush to use

Different size brushes are not always essential. I often paint an entire study with one no. 6 brush. However, having a selection of brushes means that one brush does not get over-worked and each size brush will have properties that suit a particular purpose.

Using a no. 8 brush

A no. 8 brush is expensive to buy but it will hold a large amount of water or colour. It will sweep elegantly over the surface of your painting without stressing the paper while still delivering a large amount of colour. Look after it well and it should last a lifetime.

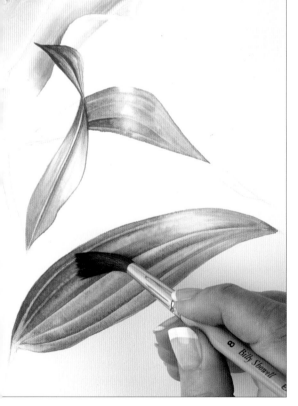

Laying a glaze over a large area using the full width of the brush head.

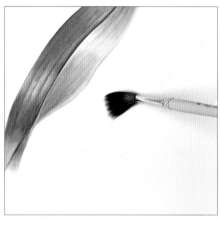

A shape can be filled with a clean water glaze by loading a no. 8 brush with water and applying it in a single stroke using the full width of the brush head.

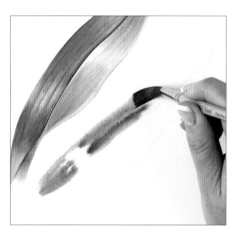

A no. 8 brush will hold a lot of colour, making it ideal for filling large areas with colour.

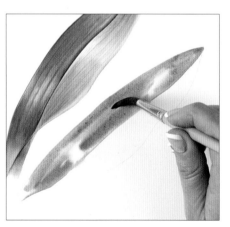

The colour can be lifted out using the flattened point of the brush.

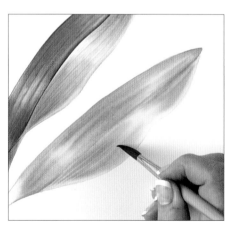

Fine lifting can also be achieved using the tip of a no. 8 brush.

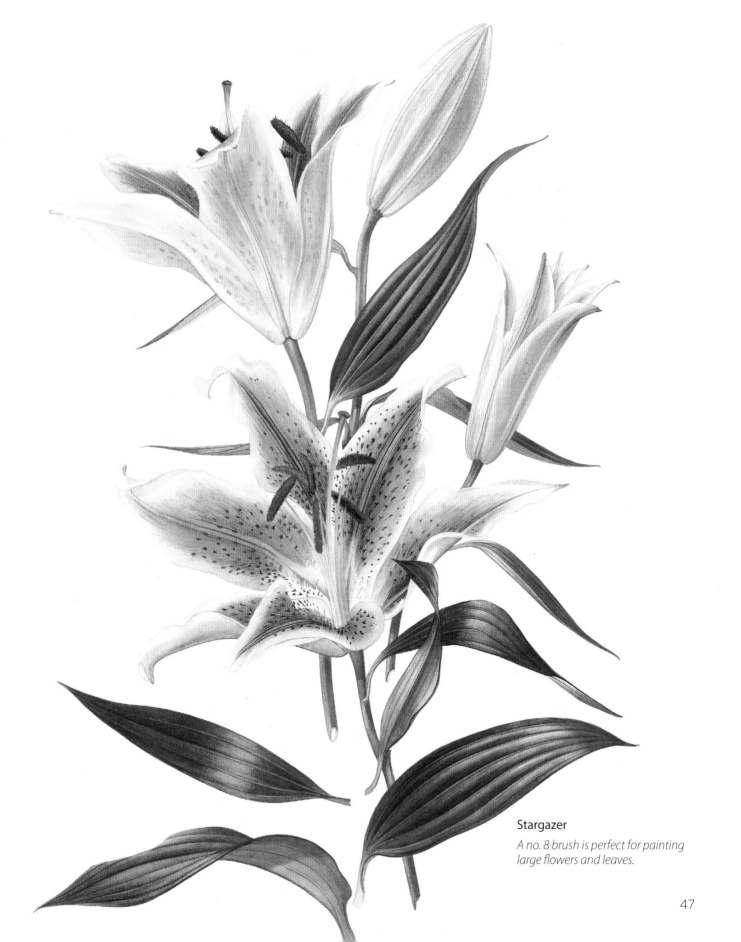

Stargazer

A no. 8 brush is perfect for painting large flowers and leaves.

Using a no. 6 brush

A no. 6 brush is my favourite size of brush to use, especially one with a fine point. It is perfect for glazing and dropping in colour and, as well as that, the fine point can tidy up edges, reveal detail and lift out colour. This rose was painted entirely using one no. 6 brush.

Applying a glaze or colourwash

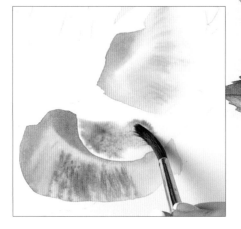

1 Lay a glaze or colourwash over the petal using the body of the brush.

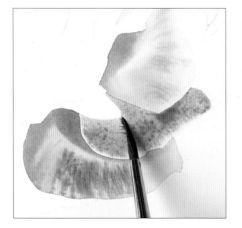

2 Use the tip of the brush to tidy the edges. Repeat this process until you have achieved the desired depth of colour, allowing each layer to dry before applying the next.

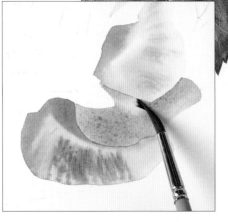

3 Lift out the light using a clean, damp brush to define the shape of the petal.

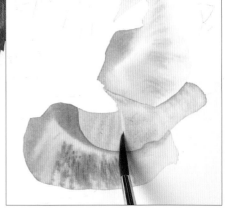

4 Use the tip of the brush to lift out the finer detail and texture.

Sweeping in colour using wet-in-wet

The no. 6 brush is also excellent for large leaves that have long pockets or ridges, for example this hosta leaf. Sweep on colour in large drifts and then lift out light for the highlights and veins. The fine point is then perfect for adding the tiny pocket details along each section. This size brush is also very good for dry brushing.

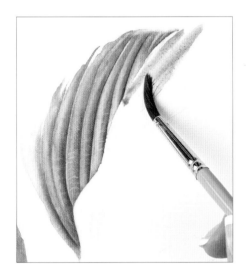

1 Wet the area with water and then sweep in colour using the wet-in-wet technique.

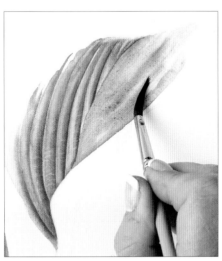

2 Clean the brush and, with a damp brush, lift out the light areas.

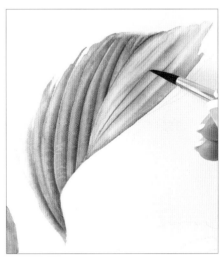

3 Allow to dry, then paint on the creases and detail using the tip of the brush.

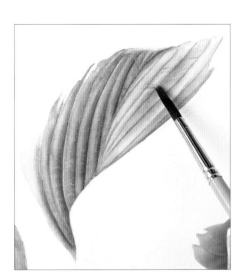

4 When dry, flatten the end of the brush and add texture using the dry-brush technique.

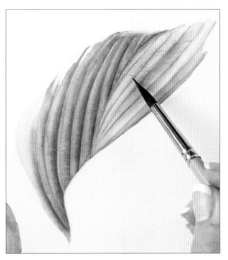

5 Tidy up at the end by using the tip of the brush to refine the veining and detail.

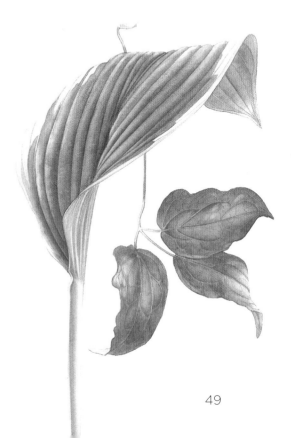

Using a no. 4 brush

The no. 4 brush is an elegant size suitable for painting most small plants. You can achieve a small petal with just one or two strokes of this brush. It holds and delivers just the right amount of paint, and endless fine hairs can be painted on a stem without having to go back and forth to the palette for a refill.

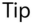

Tip

Make a page of tiny flowers to familiarise yourself with your brush and how you can best use it.

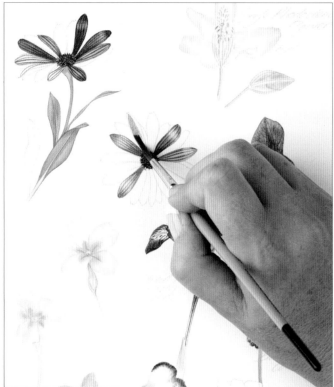

The no. 4 brush is perfect for pushing, lifting, then lifting out a highlight. Use the tip of the brush to draw in fine veins.

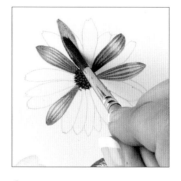

1 Push the colour on to the flower.

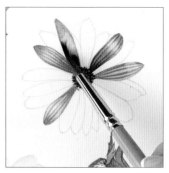

2 Lift the colour off to create highlights.

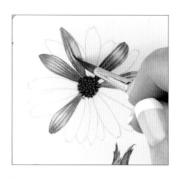

3 Use the tip of the brush to draw in the fine veins.

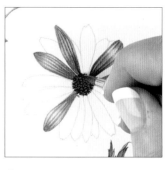

4 Darken the base of the petal.

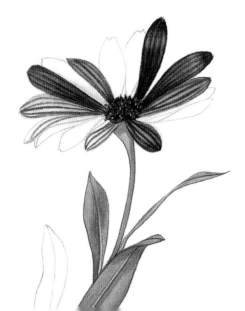

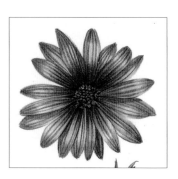

5 Use the fine tip of the brush to draw in the detail on the centre.

6 The finished flower.

50

Using a no. 4 brush to paint a berry

The no. 4 brush holds just enough colour for painting small fruits, and is perfect for lifting out small highlights and mapping in the fine details and stems. When painting berries, you ideally want to retain the white paper where there is a highlight. Use the no. 4 brush to deposit strong colour around the light, and keep the highlight and edges clean and soft by wiping these areas clean with a damp brush.

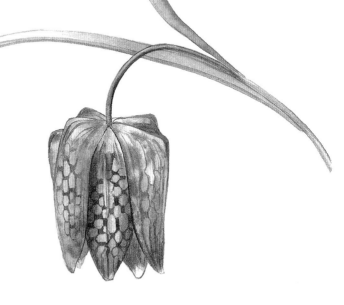

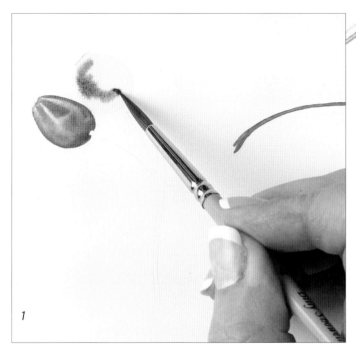

The delicate pattern on this snake's head fritillary was painted using a no. 4 brush.

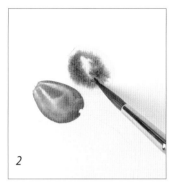

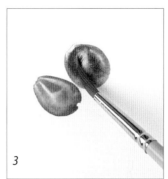

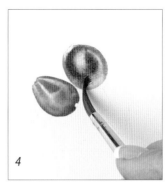

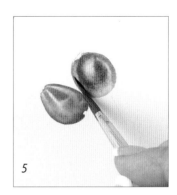

Begin by glazing the berry with water, then drop in colour either side of the highlight (1, 2). Clean the brush and wipe it through the highlight to soften the edges of the two areas of colour (3). Lift out more light using the flattened side of the brush, allow to dry, then continue to build up the colour (4).

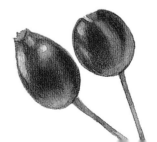

Using a no. 2 brush

I have only recently started using a no. 2 brush but have found it perfect for painting the finest of details and the smallest of flowers. It is especially good for the minute veining on mature leaves. You need to fully load the brush, twist it on the palette while pulling it towards you and then lightly touch the tip of the brush on your painting dab pad. This prevents the brush from making heavy marks on the first application. Keep your brush vertical at all times and use the finest hair on the tip of the brush.

To add fine veins to a leaf, twist the end of the brush to a very fine point and use the last hair on the tip of the brush.

Painting small petal shapes

The no. 2 brush is excellent for painting tiny flowers. Two to three sweeps with the tip of the brush will establish the first glaze of one small flower on a grape hyacinth; two strokes will establish one petal on a daisy (see page 53 opposite). Just watch that the ferrule of the brush (the metal end) doesn't have any droplets of water on it or they could slip down the brush onto the painting when you least expect it.

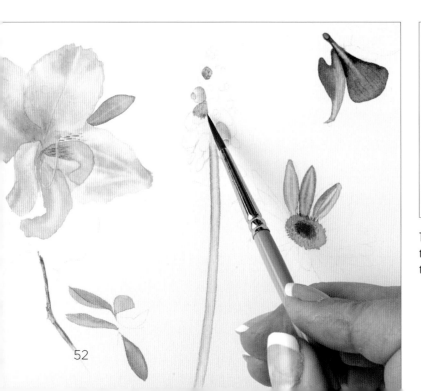

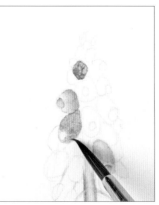

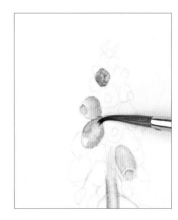

There is no need to wet the area first. Just lay on the colour, lift out the highlights, then, working in very small areas, use the tip of the brush to apply the colour. Tidy the edges and lift out further highlights.

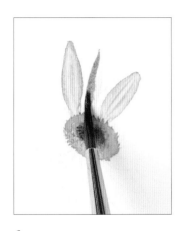

1 Sweep colour on one side of the petal.

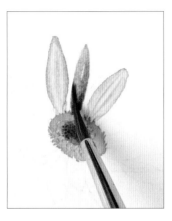

2 Swiftly sweep colour on the other side.

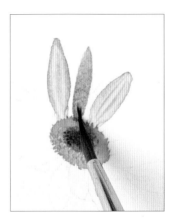

3 Blend the two sides gently.

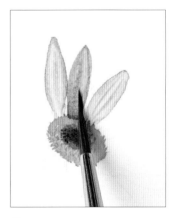

4 Lift out the highlights with the damp tip of the brush.

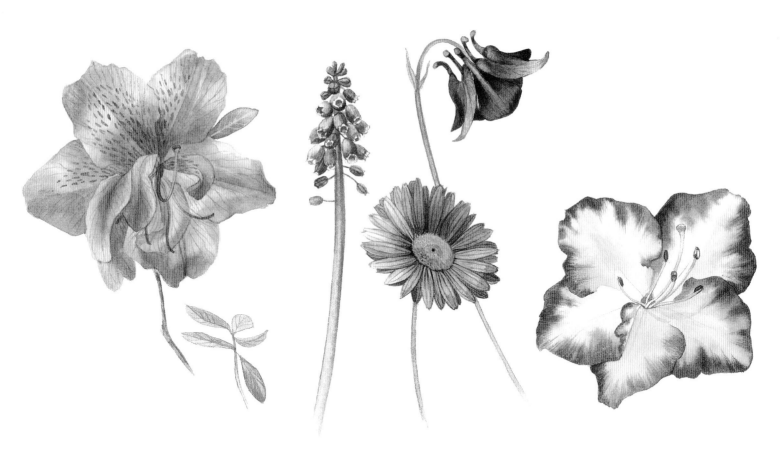

Pink and blue make a pleasing combination, and small flowers like these can be used to create a border-style painting. Try adding small leaves to embellish the design.

Painting techniques

When you first start painting, you may be tempted to skip the techniques section in a book and think to yourself, 'I don't need to read this; surely you just start painting and see how you go?' This can work for some painting styles, but botanical painting requires an understanding of how to control the paint, so in this section I will show you a few ways of doing just that.

Doodling with the paint will help you gather confidence with the medium, but while you are playing with the paint try out these techniques and adapt them to your way of painting.

Wet-in-wet

This technique forms the basis of all my painting. It is by far the most important technique to perfect. Too much water and the paint slips to the edge. Too little water and the glaze will dry out before you drop in the colour, leaving an uneven effect. If the water glaze is just right, the paint, when dropped in, should spread out with a lovely soft, cloudy edge.

I use a wide range of techniques to achieve a primrose leaf. Start with something simple and build up to more challenging plants.

Tip

If the colour doesn't spread into a water glaze, then either the water glaze is too dry or you are using inferior student quality paints.

Laying the first wash for a leaf

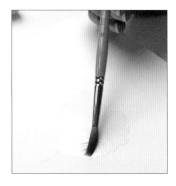

1 Wet the brush and lay a clear water glaze over the shape. Cover the area evenly, being careful not to go beyond the edges of the shape. The water glaze should glisten evenly, so spend time getting it right.

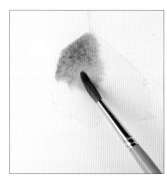

2 Start to drop in the colour – it should have a soft 'cotton wool' edge as the paint starts to spread.

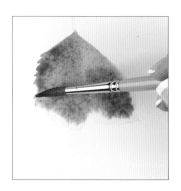

3 While the paint is still wet, form the serrations by laying the point of the brush on the edge of the leaf and pulling back into the wet paint.

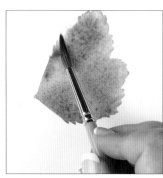

4 Turn the paper to work on the other side of the leaf. Leave to dry. Repeat this exercise until you feel confident to try other techniques on a leaf that is still wet.

Lifting out

Once you have mastered the wet-in-wet glaze, you should practise lifting out. Here you will need a settled but still glistening wet wash of paint. You then use a clean, damp brush to mop out colour to reveal a highlight.

Again, practise this until you are familiar with how wet the paint needs to be and how dry the brush needs to be. After every lift of paint, clean and lightly dry your brush before you mop again, so that you use a clean, damp brush for each highlight.

Tip
To lift out colour, your brush should be drier than the paint on the paper.

Lifting out the highlights on a leaf

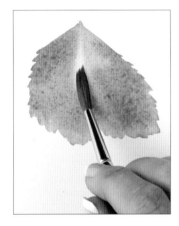 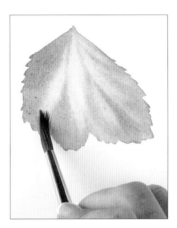 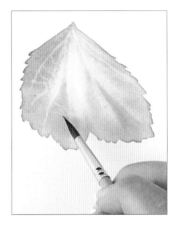

1 Use a brush that is very slightly damp, press firmly on the wet paint with the side of the brush and lift it off cleanly.

2 Repeat for each of the highlights.

3 To lift out the fine veins, wait until the paint is almost dry, then use the tip of a slightly wet, pointed brush to lift out the veins.

4 As the paint dries, you will achieve progressively finer lines. If nothing happens then the paint has dried, or the green glaze is too wet.

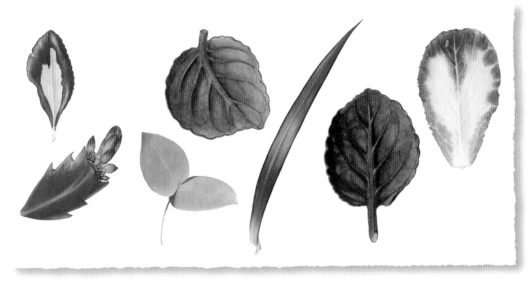

Variations in leaf design are almost as complex as those in flowers. When you find a challenging leaf, add it to an on-going study, then use the mid-tone colour to add little shadows, just for fun.

Dabbing out colour

This is a fun technique, but I only use it for complicated crushed or folded petals. The random effect created is perfect for the natural crushed surface on a poppy petal. You can also use this technique for creating a random soil effect at the base of a plant.

Tip

Use a very strong mix of colour for the first wash so that you don't have to add more colour over the top to darken it. With an initial dark wash you will get good, strong contrasts of light and dark in the pattern.

1 Glaze the area with water and drop in a strong mix of red, using the wet-in-wet technique (see page 54).

2 While the paint is still wet, add dark purple at the base of the flower so that the two colours merge.

3 Dab the paint just once with a scrunched-up piece of paper towel.

4 Lift the paper towel away.

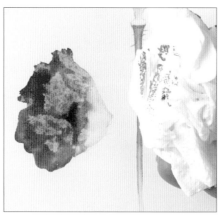

5 Repeat another couple of times, using a new piece of paper towel each time to avoid re-depositing colour onto the painting.

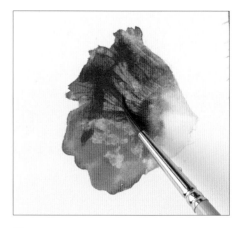

6 Allow to dry thoroughly, then work with the highlights you've lifted out to make the folds in the petals.

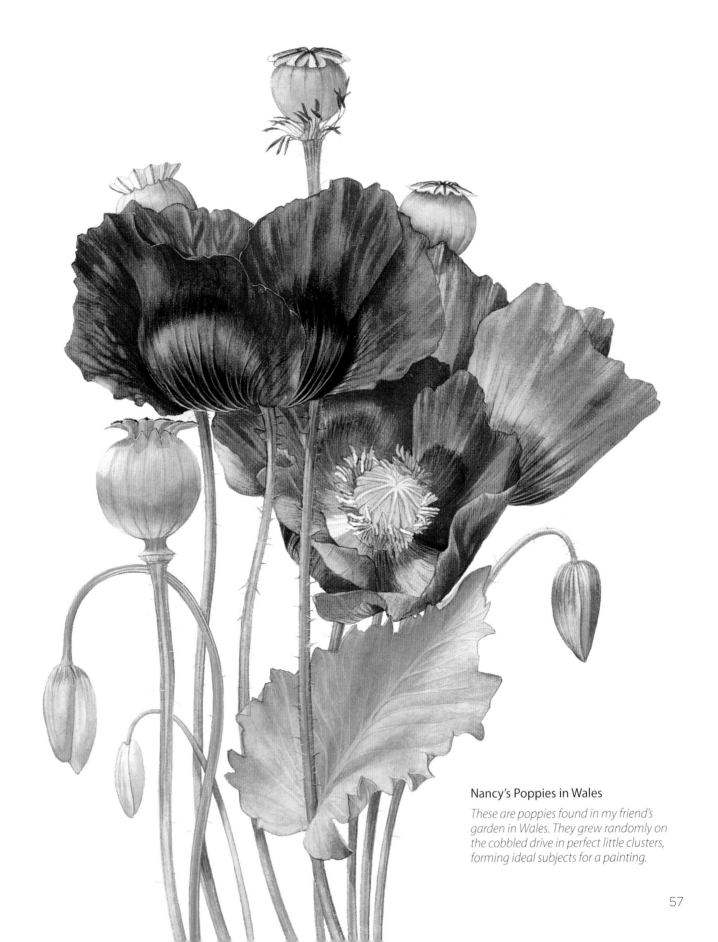

Nancy's Poppies in Wales

These are poppies found in my friend's garden in Wales. They grew randomly on the cobbled drive in perfect little clusters, forming ideal subjects for a painting.

Wet-on-dry

This is the technique of applying wet paint to dry paper. It is used to build up colour or to add detail, pattern or texture in small, easily controlled spaces.

Building up the colour and adding detail to a leaf

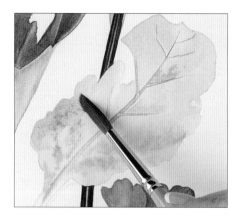 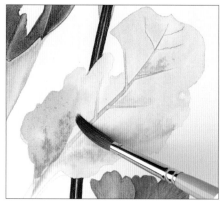 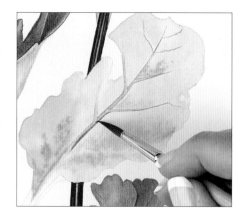

1 When the first layer is completely dry, apply some extra colour to the area you wish to deepen.

2 Quickly soften around the colour with a clean, wet brush to add a wet area around the edge of the paint. This will avoid hard edges.

3 Use this technique to deepen fine areas. When completely dry, paint a fine line to one side of a pronounced vein, then soften to one side with a clean, damp brush.

Dropping in colour

This technique allows you to create further pattern over the top of a dry painting. It works well for autumn-weathered or variegated plants.

You can repeat the process of wet-on-dry followed by dropping in colour in layers, as long as you allow each layer to dry thoroughly before applying the next.

Facing page: leaves offer a chance to perfect veining techniques and play with colour mixes to depict the many shades of green.

Adding pattern to a leaf

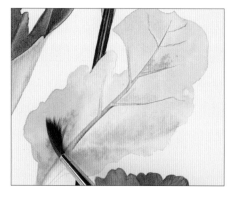 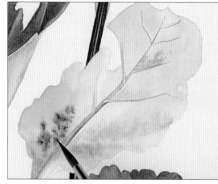

1 Glaze over the area with water. Extend the glaze beyond the area you wish to add pattern to.

2 Drop in colour by touching the water glaze with the tip of the brush.

3 Soften in and around the colour if necessary to create the shapes you want, and soften away any edges or watermarks. Allow to dry.

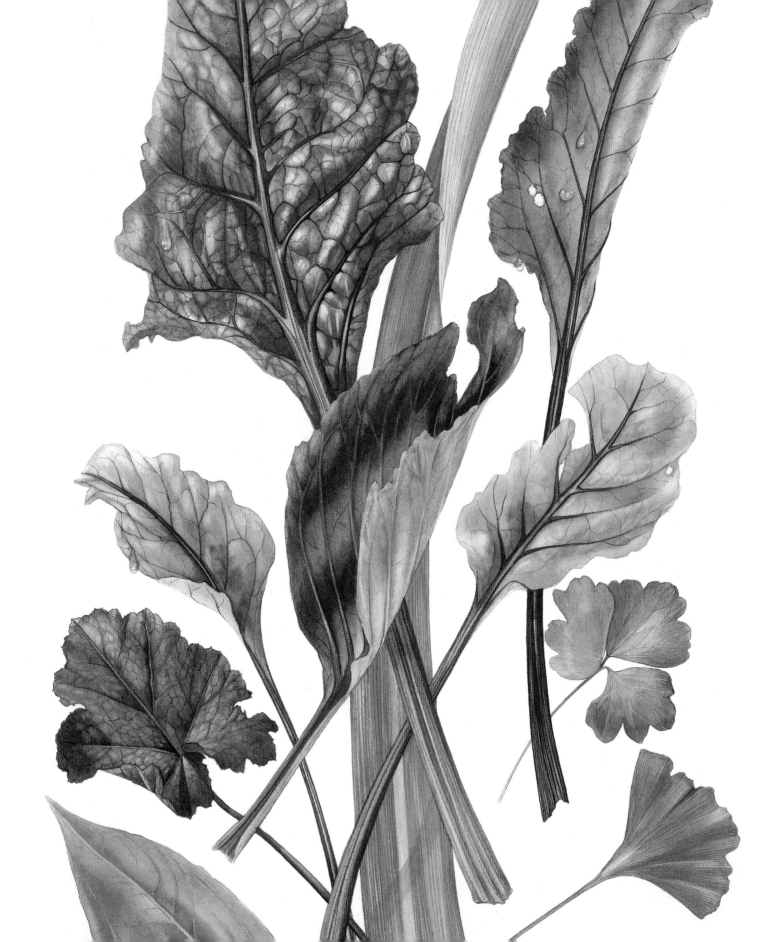

Dropping in water to create pattern

Once you have created pattern using the wet-on-dry technique, you can add further texture by gently dropping in tiny drops of water into the settling colours. The water will push the colour outwards, creating a spotty effect.

Painting an autumn leaf

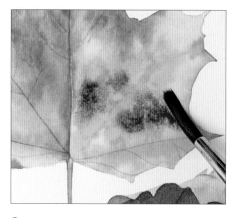

1 Glaze the area with water, then pick up the colour and dab it into the glaze with the point of the brush. Lift off the brush and allow the colour to spread.

2 Repeat with a second colour, allowing it to spread and mix freely with the first colour. Then repeat again with a third colour.

3 Allow the colours to settle, then soften the edges of the colour with a clean, damp brush.

4 Use a clean brush to sweep away any colour you're not happy with.

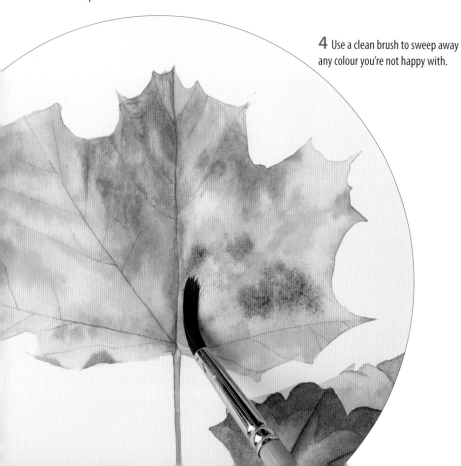

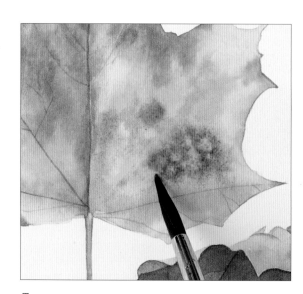

5 Drop water into the wet paint to create texture.

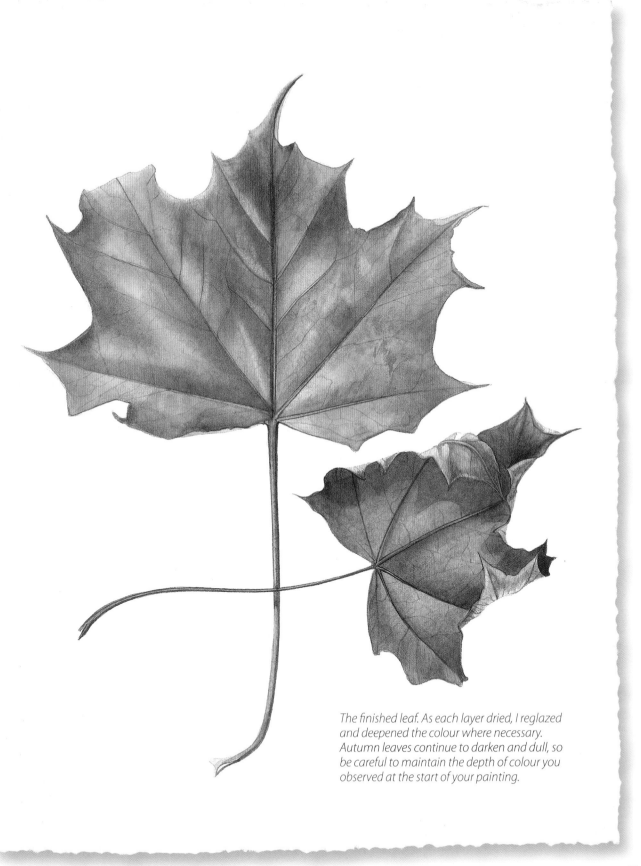

The finished leaf. As each layer dried, I reglazed and deepened the colour where necessary. Autumn leaves continue to darken and dull, so be careful to maintain the depth of colour you observed at the start of your painting.

Colour blending

Moving on from the wet-in-wet technique with
one colour, you can develop this further by having
two colours ready and then dropping them in at
the same time. Be careful not to stir up the colours
together too much or the glaze will get muddy. Also,
try out new combinations on a spare sheet of
paper first.

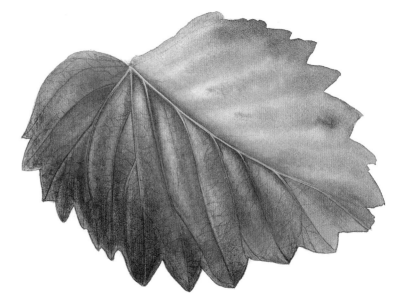

Painting a two-tone (variegated) leaf

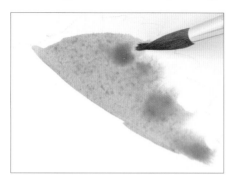

1 Glaze the whole of one half of the leaf with water,
then apply the first colourwash.

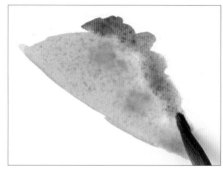

2 Clean the brush, and immediately apply the
second colour.

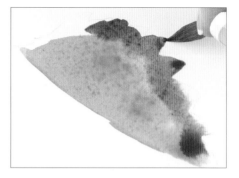

3 While the two colours settle, pull the colour out
into points to define the edge of the leaf using the tip
of the brush.

4 Clean the brush then gently soften the area where
the two colours meet. Clean your brush in between
each sweep.

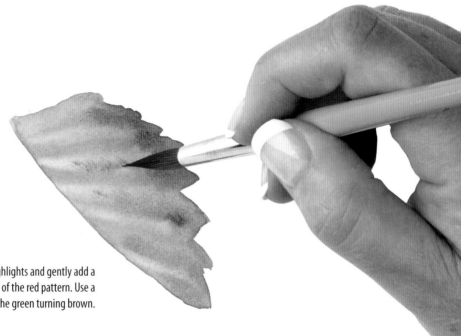

5 If the glaze is still wet, lift out the highlights and gently add a
little of the second colour to create more of the red pattern. Use a
drier mix of red to prevent the green turning brown.

Colour blending by overlaying glazes

This is an alternative technique for getting colours to blend seamlessly. The secret to this is to allow the first glaze of colour to dry thoroughly before reglazing with water and laying the second colour into the remaining space.

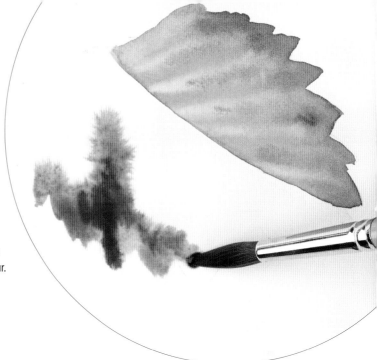

1 Glaze the whole of the other half of the leaf, and drop in the first colour.

2 While the paint is settling, define the leaf edges using the tip of the brush.

3 Just in case the colour moves too fast, control the spread of the paint by using a clean, damp brush to push the colour back into the areas you want to be red. Allow the paint to dry thoroughly.

4 When the first colour is completely dry, glaze the whole area with water once again, including the red area. Make sure you glaze exactly the same area as before.

5 Take the water right up to the edge of the first colour. Don't go over the edge, or you will end up with double edges.

6 Pick up the second colour on the brush and drop it in next to the first.

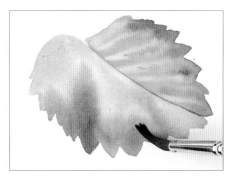

7 Carefully soften the area where the two colours meet using a damp, flattened brush. As it settles, lift out the highlights. Allow to dry thoroughly.

Using blending medium

Blending medium helps the paint you have mixed up travel further and stay wetter for longer. I use it when I am painting large areas. It takes a little while to get used to the feel of the paint, but it is very useful when evaporation time is against you.

Painting a long, slender leaf

The following demonstration shows how much more you can achieve on a large leaf using blending medium. Begin by mixing your colour, then add a loaded brush of the medium and stir it into the colour.

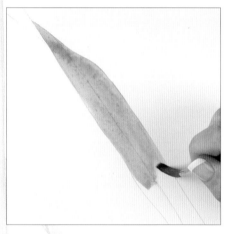

1 Glaze the area with water and apply the paint as normal. Start at the tip of the leaf and move down towards the stem.

2 Soften away any hard edges using a flattened, clean, damp brush.

3 Clean and dampen the brush and lift out the highlights.

4 While the paint is still wet, tidy the edges of the leaf using the tip of the brush.

5 The paint should still be wet enough to add in extra colour and detail, such as deepening the green towards the central vein.

6 There should also be time to lift out the colour along one side of the vein using a clean, damp brush.

Scratching out

This is a technique that you would use only at the end of a painting or on completion of a particular part of a painting. The idea is to pick out or scratch out the colour to reveal a tiny spot of the bright, white, clean paper underneath.

Scratching out a sharp highlight

Once your painting is completely dry, use the sharp tip of a scalpel to flick off a tiny bit of the surface of the paper. Flick in one direction only, then use the blade tip to flatten the paper surface. You could then polish the area flat with a piece of paper towel and a polished stone (see page 82).

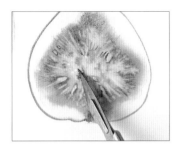

Picking out the tiny wet highlights in a juicy fig.

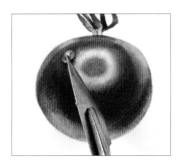

Revealing the sharp light on a water droplet on a tomato.

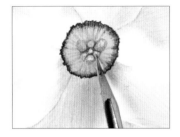

Picking out the highlight on the tops of the daffodil's stamen.

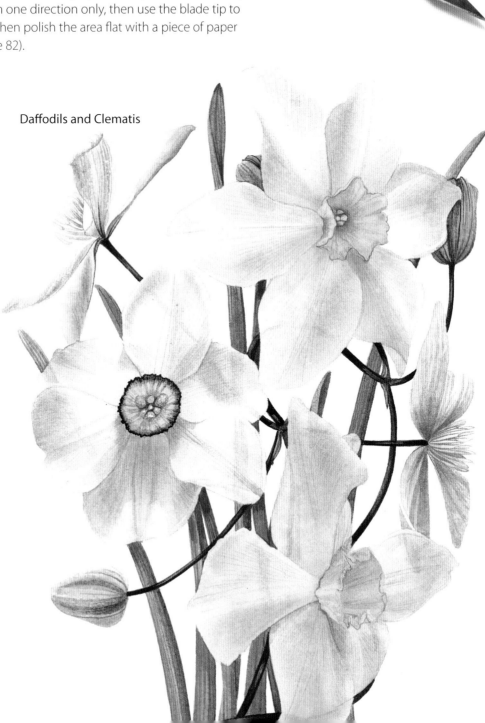

Daffodils and Clematis

Deepening colour

This uses the wet-on-dry technique to really darken an area of your painting without glazing the whole subject. The demonstrations below show how you can deepen two areas, leaving a highlight in between.

Deepening the colour of a leaf with separate glazes

If sufficient drying time is left in between stages, the following method can be repeated two or three times. Once you have applied two or more glazes, you need to be bold to strengthen the colour further.

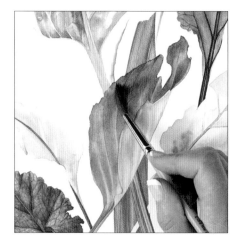

1 Glaze with water an area that is larger than the part you want to darken. This will avoid hard edges.

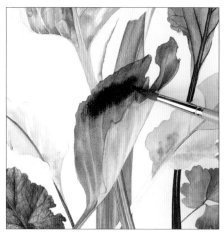

2 Pick up the colour, roll the brush into a point and very lightly lay on the colour. Avoid over-working the colour – allow it to settle naturally on the wet glaze.

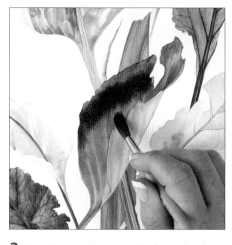

3 Clean the brush, flatten it (as for dry brushing) and gently tease out the edges of the paint into the surrounding water glaze. Leave to dry.

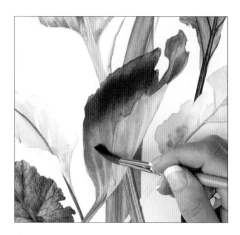

4 When the leaf is completely dry, glaze with water from the highlight down towards the stem.

5 Apply another band of colour, leaving a highlight above.

6 Soften the colour as in step 3.

Fine colour building (with the tip of the brush)

Use this technique when you need to build up colour but don't want to keep wetting the paper. It is especially good for small areas of colour. You can simply apply small strokes of colour and leave them as they are, or gently soften over the fine brushmarks with a slightly damp brush.

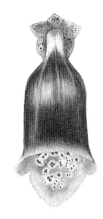

Build up strong colour with lots of tiny brushstrokes and different combinations of colours.

Building colour on a foxglove flower

1 Over your existing washes, very gently feather the paint towards the highlight using the tip of a no. 2 brush. Do not press too hard, and keep the brushstrokes as close together as possible.

2 Allow the paint to dry, apply another layer of colour and repeat the process.

3 If you wish you can soften gently over the paint with a clean, damp brush. Wipe the brush clean intermittently to avoid redepositing as much of the paint as possible.

4 To avoid dragging colour into the highlight, always soften away from it.

Building colour on an onion

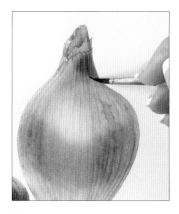

1 Lightly feather the brush and add a strong mix of colour to a dry background.

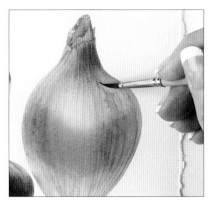

2 Repeat the process lower down. This way you can deliver the paint in between the highlights and the veining.

The completed onion.

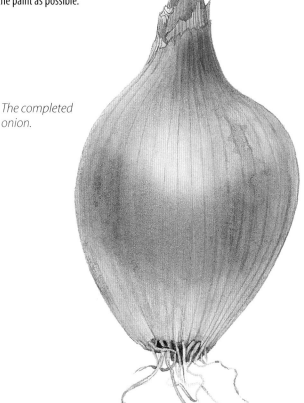

Adding shadow

Sometimes the addition of a shadow over the top of a finished study can give it depth and a more three-dimensional appearance. In the following demonstrations I will give you a number of tips that I have developed throughout my time as a painter.

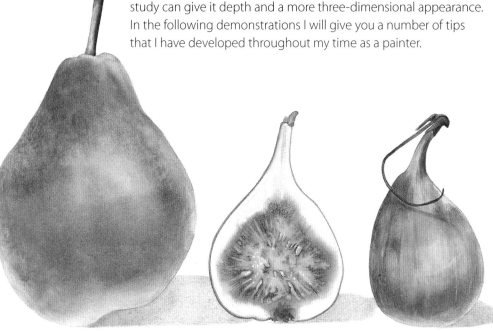

Shadow colour mix

The colour mix that I use for many of my shadows consists of a basic mid-tone grey, to which I add some of the local colour. The basic mid-tone mix I use is predominantly blue, for example Ultramarine Blue, to which I add a touch of a mid red such as Sennelier Red and a warm yellow, for example Sennelier Yellow Deep. I then add a little of either the colour of the subject or that of an adjacent object that has reflected onto the main subject. Just add the local colour to the watered-down mid-tone grey and keep it stirred in between applications.

Adding surface shadow to a green pear

In this example I have added surface shadow to a pear. In my shadow mix I have added more blue and yellow to the mid-tone grey, though for speed you could add some of the green mix used for the pear.

Tips

The deeper the shadow the stronger the mix.

Always try to apply the shadow to a water glaze, and add it all in one go; don't disturb the initial wash or it will dry streaky.

1 Using a small palette, mix a tiny amount of Sennelier Yellow Deep and Phthalocyanine Blue with the standard shadow mix.

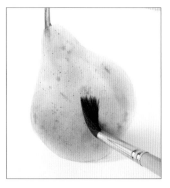

2 Glaze the finished pear with water, using a no. 6 brush.

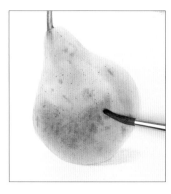

3 Fill the brush with colour and sweep it onto the shaded area of the pear.

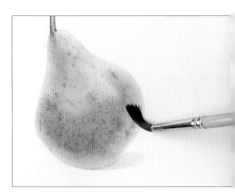

4 Use a clean, damp brush to mop up the colour where you don't need it. Keep an eye on it while it dries and sweep away any watermarks.

Adding shadow to a pale petal

In this example the shadow is very pale. Be careful to keep the mix fresh; if it looks dirty on the palette then it will look dirty on the painting.

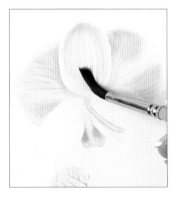

1 Prepare the shadow mix, then apply a clean water glaze to the area where you wish to add shadow. In this case, I have used a very pale mix of the mid-tone shadow colour.

2 Pick up the colour and drop it gently into the shadows. Soften the edges, making sure the colour doesn't spread outside the area of shadow.

Adding a light blue shadow to a pale petal

Occasionally the shadows from bright daylight appear as a pale blue shade, so I sometimes add just a pale wash of light blue instead of the mid-tone grey. It is very effective, and brings a little bit of the garden light into the painting.

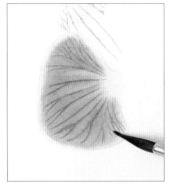

1 A watered-down mix of Cobalt Blue can work well for a shadow. Begin by glazing the whole area with water.

2 Drop in the blue shadow and soften, as described above.

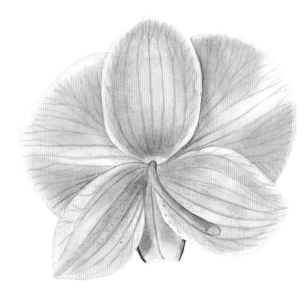

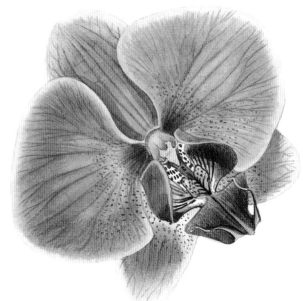

Life-size orchid studies. To keep the veining and shadows subtle they have been sandwiched in between washes of colour as I have worked up the flower.

Adding shadow to yellow plants

Getting light shade into yellow plants can be difficult because if you add the shadow at the end you will most likely end up with a heavy, dirty-looking effect. Start with three puddles of colour: the standard mid-tone shadow mix, a green mix of Lemon Yellow and Phthalocyanine Blue, and a lilac mix of Blue-Violet.

1 Begin by glazing the petal with clean water.

2 Drop in the colour where you can see the shadows, starting with the mid-tone mix.

3 Next, drop in the green mix where you see cooler shadows.

4 Finally, drop in the lilac mix for the warmer shadows.

5 Once all the shadows are dry, glaze over with a lemon wash and then drop in the deeper yellows.

6 Mop out the highlights where you need them.

Tip

Don't make your shadows too pale or they will fade too much during the drying process.

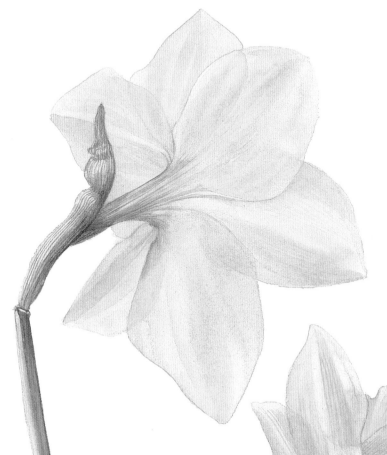

Adding cast shadows

If you choose to add cast shadows, use a lamp to angle light over the subject so that you get the size, shape and tone of the shadow correct. Either paint the cast shadows or shade them in with graphite – either is effective, and sometimes a combination of the two can work well. Play, experiment and see what looks best.

I usually use a mid-tone grey mix for shadows cast onto a white background, as though the subject were sitting on a white cloth.

Tip

If you plan to exhibit your painting, check the rules of the exhibition to make sure cast shadows are allowable.

Adding a cast shadow under a plum using pencil

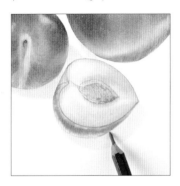

1 Using the elliptical shading method on page 40, build up the shadow using a 2H pencil.

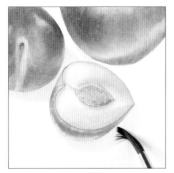

2 Add a clean water glaze over the top of the pencil to remove the graphite shine. This is a good way to obtain an even shadow without risk of the wash going wrong.

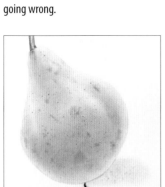

3 Soften the edge of the shadow with a clean, damp brush.

4 Repeat the process to darken the shadow.

Adding a cast shadow under a pear using paint

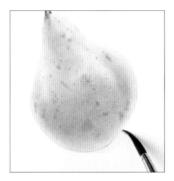

1 Start at the base of the fruit and glaze the shadow area with water.

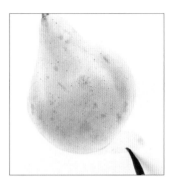

2 Use a gentle touch, and fill the area of the shadow with the shadow mix.

5 If necessary, use a piece of paper towel to soak up the colour at the edges of the shadow to stop it spreading.

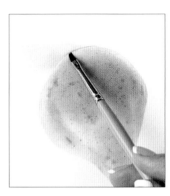

6 Remove the line that forms under the fruit using an eradicator. Turn the paper so that you are working from the edge of the fruit outwards.

Controlling the spread of paint

There are occasions when the spreading of paint is a nuisance, so it is good to know how to control it.

Using a piece of card

With all the best intentions, it is very hard to avoid tapping the brush over the edge of an area when applying fine detail within it, such as the fine veins on a petal. This technique is simple yet so effective, that you will wonder why you have never used it before.

Using paper towel

I always have a roll of paper towel to hand just in case of spills or paint landing accidentally on my painting from my hand or sleeve. It is also a useful way of controlling the spread of paint.

Sometimes an area is too small to glaze just half of it, so I prefer to glaze the whole area, sweep on the paint and then quickly lay the paper towel along the edge on which I want to control the spread. Press your finger along the folded edge to ensure all the moisture has been removed.

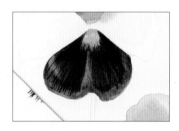

1 Lay a piece of card along the edge of the petal and paint on the veins, continuing the lines onto the card.

2 Carefully remove the card. This method ensures the veins reach right to the edge of the petal.

1 Apply the shadow mix to one half of the petal. Leave an uneven edge along the centre of the petal.

2 Fold the paper towel in two and press the folded edge along the centre of the petal.

3 Remove the paper towel, revealing a defined edge to the shadow along the centre of the petal.

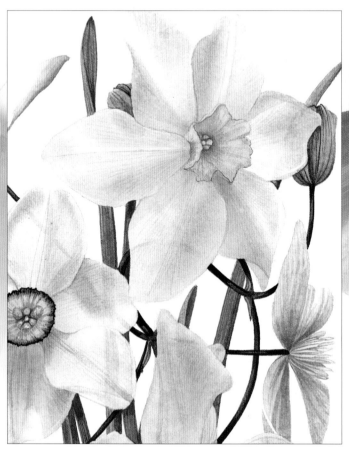

Section from 'Daffodils and Clematis' (page 65), showing the finished flower.

Using masking fluid

Masking fluid is used to preserve the white paper while freely painting over the surrounding area. It should always be applied to dry paper and allowed to dry thoroughly before painting over it. Never use your best brush to apply masking fluid, as you risk destroying the hairs. Instead of a brush, I use a masking fluid bottle with an applicator tip. For more delicate marks such as very fine lines, I use the pin from the lid of the bottle to tease out the fluid.

Adding holes to a nibbled hollyhock leaf

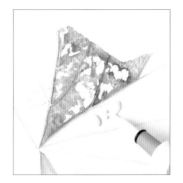

1 Apply masking fluid to the areas where you don't want paint. Allow it to dry.

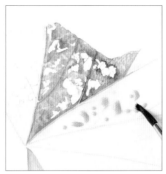

2 When the masking fluid is completely dry, glaze the whole area with water.

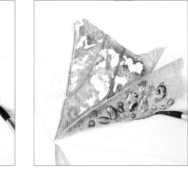

3 Drop in the colour, flicking it over the top of the masking fluid using a no. 6 brush. Allow the paint to dry.

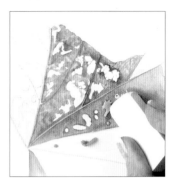

4 When completely dry, rub off the masking fluid using an eraser. Some people prefer to use their fingertips, but make sure your hands are clean and dry.

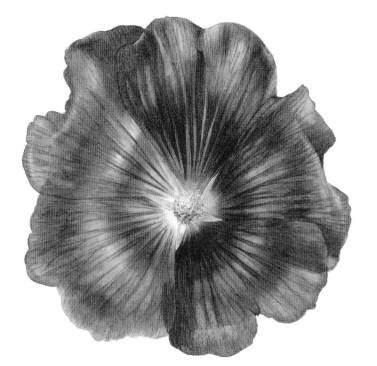

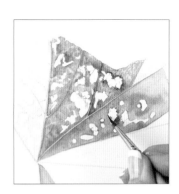

5 You will be left with gaps in the painting where the masking fluid had been applied.

6 Add fine detail, and define the edges of the holes if required using a no. 4 brush.

Using lifting preparation

Lifting preparation protects the paper by preventing paint from sinking in to it. It allows you to lift or wipe out highlights even after the paint has dried. I use lifting preparation only on small, complicated areas, and when I am using staining watercolours, in other words colours that leave a tint on the paper when dry. It works very well for strawberries and other red fruit with bright highlights.

The lifting preparation is painted neat onto the area and allowed to dry before adding colour. I have found it performs best when applied three times, each application being given time to dry before adding the next.

Tip
Never dip a watery, wet brush into the bottle of lifting preparation, as over time it will get watered down and be less effective.

Adding highlights to a rose using lifting preparation

1 Apply three layers of lifting preparation to the paper, positioned approximately where you are going to paint. Allow each layer to dry thoroughly before applying the next.

2 When the final layer is dry, lightly draw in the flower over the top.

3 Lay a clean water glaze over the top of the flower.

4 Drop in colour very gently and, with a fully loaded brush, let it spread gently on the paper.

5 Allow the paint to dry thoroughly and sweep a clean, damp brush on the area to lift out the highlights. You won't see the highlights until after the next step.

6 Lay a piece of white paper towel over the painting and dab it gently with your finger.

7 Remove the paper towel and the areas you dampened will be lifted away, revealing the white paper underneath.

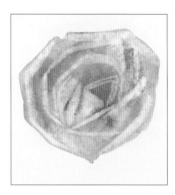

8 Continue to add the remaining highlights using the same method.

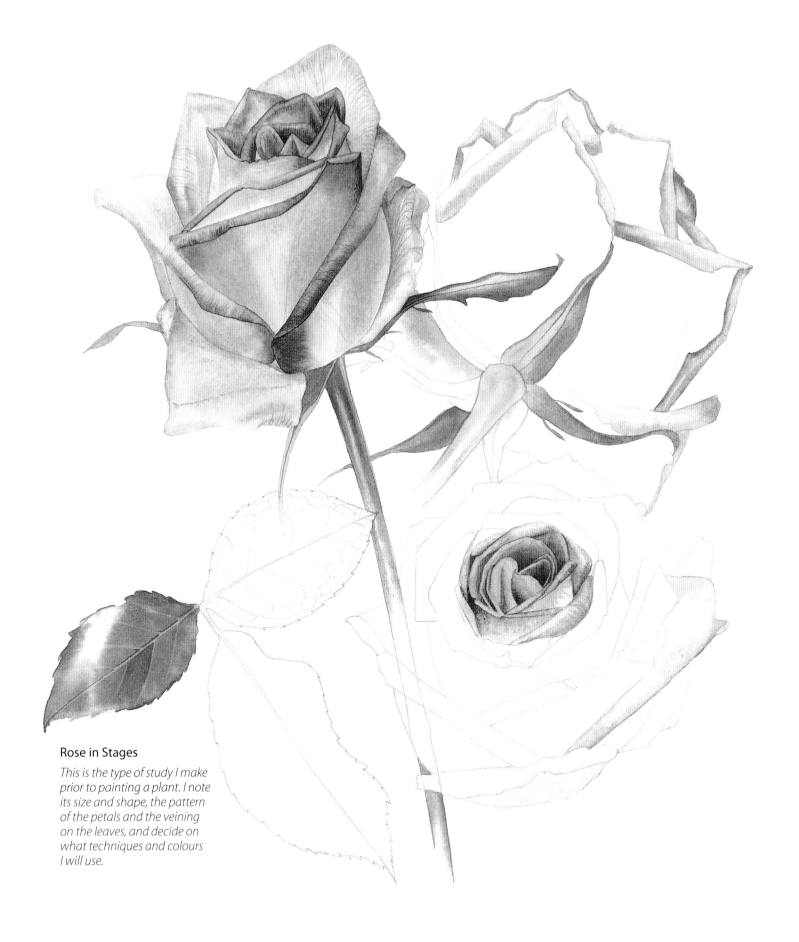

Rose in Stages

*This is the type of study I make
prior to painting a plant. I note
its size and shape, the pattern
of the petals and the veining
on the leaves, and decide on
what techniques and colours
I will use.*

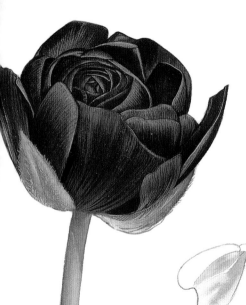

Dry brushing

I use dry brushing for building up colour, particularly when re-wetting the paper would not be desirable. I also use it for adding pattern, texture and for adding bloom or iridescence. It takes a little practice to get a soft and natural-looking finish, but the effect is wonderful when applied well, and is well worth practising.

Dry flat brushing

Dry brushing with a flattened brush is used to create a velvety, hairy or fuzzy surface such as a peach. If you want iridescence on a petal, then very lightly dry brush on some pure Cobalt Blue, Bright Violet or any other bright colours.

To train your brush to make the right marks will take a little practice. If your brush doesn't flatten out enough for the hairs to separate then you can gently flatten the brush between your finger and thumb.

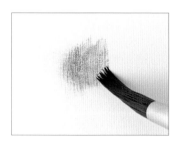

The brushmarks produced using dry flat brushing. They should be soft, subtle and resemble crayon marks.

Picking up paint and flattening the brush for dry flat brushing

Begin with a container of clean water, a clean, damp cloth and your colour mixed in a palette. I generally use a no. 4 or 6 brush for this technique.

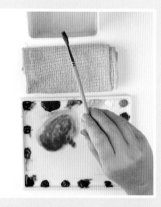

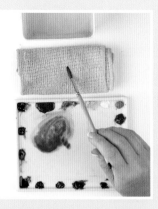

1 Wet the brush and wipe it on the side of the container to remove the excess water.

2 Dab the brush on the cloth to dry and flatten the brush.

3 Alternatively, flatten the brush using your fingers.

Dry brushing with a pointed brush (dry tip brushing)

Dry brushing with a pointed brush is a good way of creating fine patterns and texture in small areas. Here I used a no. 4 brush to build colour by adding random, textured marks.

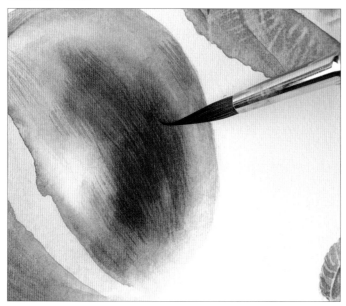

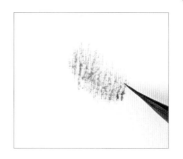

The brushmarks produced using dry tip brushing. The picture shows the marks magnified.

Take a nearly dry brush and twist the end into a point using your fingers. Apply the colour using small movements of the brush worked from side to side to gradually build up the texture on the apple. You can then use a clean, damp brush to soften over the dry brushing.

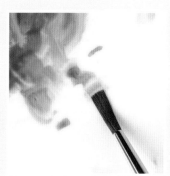

4 To pick up the colour, place the flattened side of the brush in the paint and wiggle it slightly from side to side.

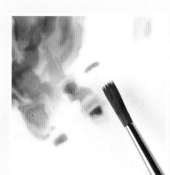

5 Hold up the brush and make sure the hairs are still separated.

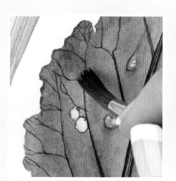

6 Apply the colour to your painting – it should be so soft you can barely see the brushmarks. Build the colour in short sessions, allowing three or four strokes to dry before adding more.

Tip

An older brush may be more suitable for dry brushing. A new brush with a fine tip may not perform this way until you have used it for a few months.

The eradicator

Most botanical watercolour painters will have a brush like this. It is a small, flat, synthetic chisel brush and it is marvellous at removing paint or pushing it about. Try not to use it too much because over-irritating the paper will damage it slightly.

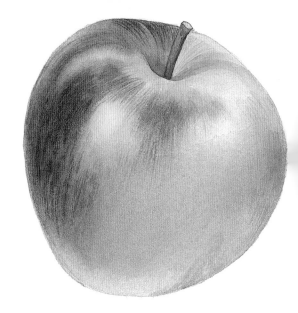

Removing hard edges

The eradicator is particularly good at removing a build-up of paint where two or three washes have been applied. It is most useful for fruit, to retain the light on the disappearing edge.

Removing the hard edge from a wash

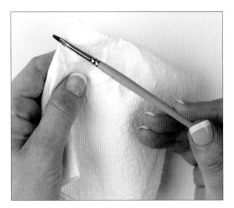
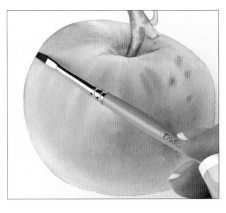
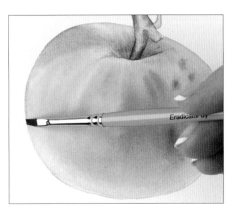

1 Dampen the eradicator and remove any water drops from the ferrule by wiping it on a sheet of paper towel.

2 Use the tip of the eradicator to agitate away the hard edge using short, sideways movements. Work from the inner side of the fruit.

3 Work your way gradually around the edge of the apple.

Softening patterning

An eradicator can be used to soften any surface marks, while they are either wet or dry. Use a damp eradicator, and 'wiggle' it around the area you wish to soften. Keep cleaning the brush to avoid adding extra paint to the area.

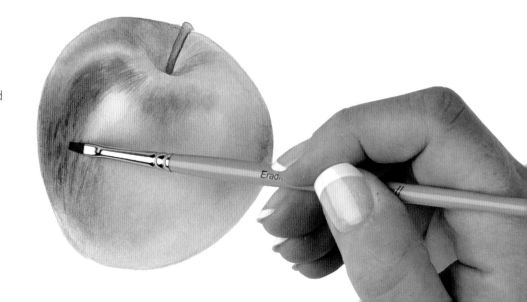

Lifting out fine lines and highlights

Use a damp eradicator to reveal highlights or veins by irritating away the width of the line. Then simply dab away the unwanted paint.

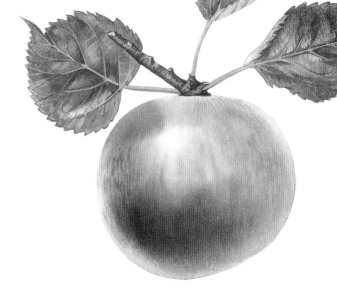

Creating fine veins

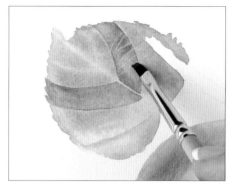

1 Working on a completely dry surface, lift out the paint using the edge of a damp eradicator. Clean the brush after lifting out each vein.

2 Dab the area with a clean piece of paper towel.

3 Once dry, the leaf is ready for the addition of further detail in order to define the vein edge and deepen the colour in between.

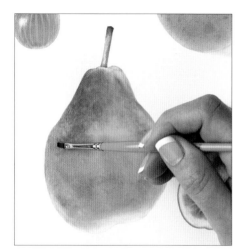

Creating texture

You can also use the eradicator to work into the texture you have achieved using other techniques. Always use a damp eradicator on the dry painting to avoid distressing the paper.

Dampen the eradicator and 'wiggle' it over the surface of the pear to create a mottled appearance.

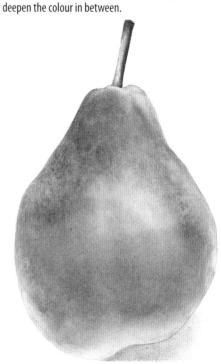

Slimming down and lifting out veins

If you have painted on the vein shadows too thickly, you can use an eradicator to slim down the line from one side. People are often afraid to remove any colour from such fine detail, yet at this stage of the painting the pigment is sitting on top of the paper and is relatively easy to remove.

Tip

Small adjustments can be made towards the end of a painting, but remember to let the paper dry and rest in between each process.

Slimming down the veins on a leaf

 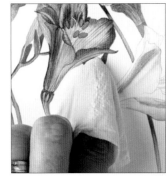

1 Use the eradicator to 'chisel out' the colour from one side of the vein.

2 Dab with a clean piece of paper towel.

Removing veins on a leaf where they go into the highlight

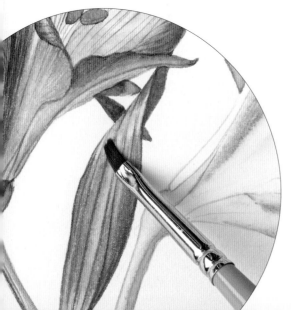

Use the same method to take out the veins in the highlight, then dab with paper towel, as before.

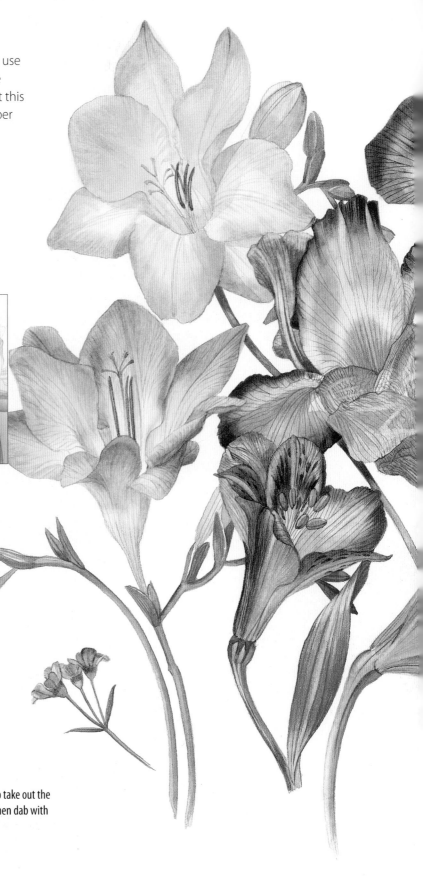

Lifting out lost veins

If you have accidentally painted over the small veins you can use the eradicator to gently lift them out.

1 Once the paint is dry, use the edge of a damp eradicator to irritate out the finer veins or brighten the larger veins.

2 Quickly dab off the loosened paint with paper towel. Repeat the process until you have revealed all the veins you can see.

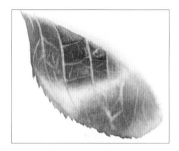

3 To complete the leaf, carefully paint either side of the veining to deepen the leaf. Make sure you maintain the highlight.

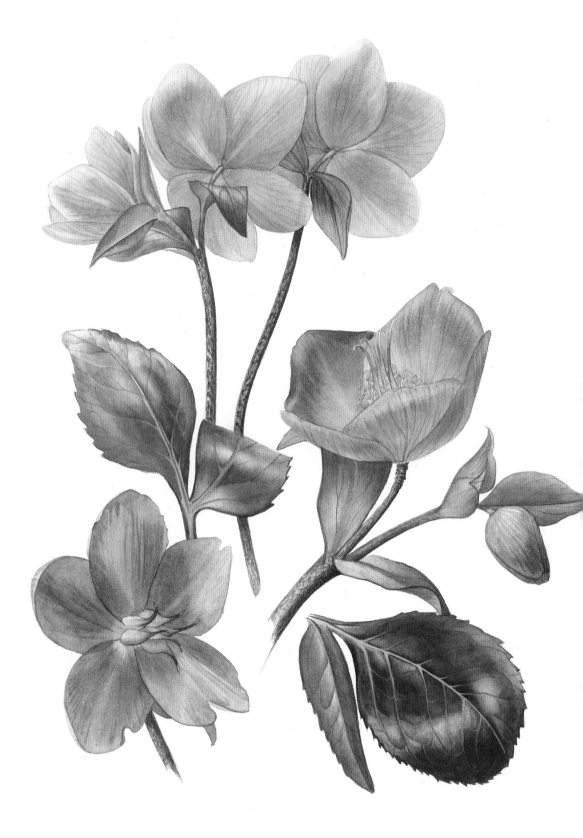

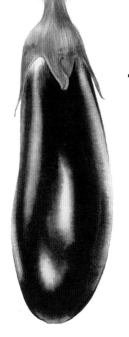

Troubleshooting

Even with practice, planning and patience, perfection is hard to achieve and mistakes do happen. But repairing a watercolour is simpler than you think. Do the repair gradually and allow the paper to rest and dry in between each technique.

Correcting over-working

Building up dark colour can be very difficult and it is easy to build it up too thickly. If this happens it is best to stop painting and retrace a couple of steps. The process below is very useful for removing the top layers of paint, so that you can reassess your painting and start building up the colour again from the remaining stain.

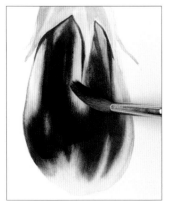

1 Use a large brush, for example a no. 8 brush, and glaze over the whole area. Always take the brush from light to dark so as not to spread the loosened dark paint.

2 Leave for a minute or two to loosen the colour, then irritate the paint using the tip of the brush to help lift it.

3 Lay a double layer of paper towel over the area and press it down firmly.

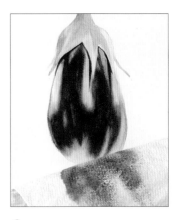

4 Lift the paper away, and the excess paint will be removed with it. Allow to dry completely, then the painting is ready to start work on again.

Using a polished stone

If you have over-worked an area and you want to add detail, smooth the paper without damaging it using a polished stone.

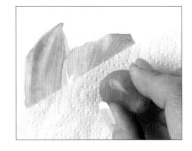

1 Lay a sheet of tissue paper or paper towel over the completely dry area and rub it firmly with the polished stone.

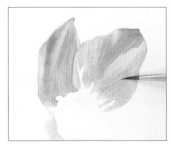

2 The area is now ready for the addition of detail.

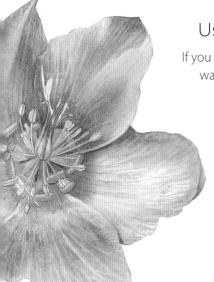

Removing a bloom that hasn't worked

On the rare occasion I use white paint to create a dusty bloom on a fruit, it is very easy to over-work it or put too much on. To remove this additional layer requires a gentle 'stirring' of the brush over the surface.

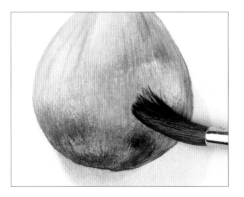

1 Soak the area by 'stirring' the water onto the surface using a large brush.

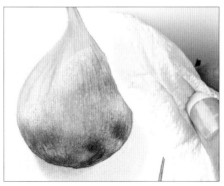

2 Dab off the colour with a clean piece of paper towel. Repeat this several times, using a clean sheet of paper each time. Allow the surface to dry and you are ready to re-work the glaze.

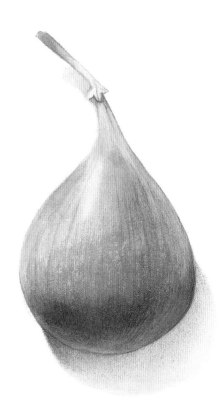

Retrieving highlights

If you lose the highlights on a subject do not lose heart; use the eradicator brush to lightly irritate the paint from the highlighted area and then darken around it to emphasise the contrast. Remember, though, you can only do this once as the paper will weaken and look rough if over-worked.

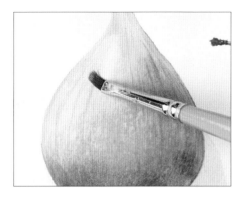

1 Use a wet eradicator to agitate the areas where you wish to reinstate the highlights. Dab off any loosened paint with paper towel as above.

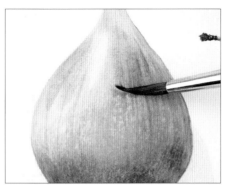

2 Wet the whole fruit again with a water glaze, then emphasise the new light areas by adding colour on either side of them.

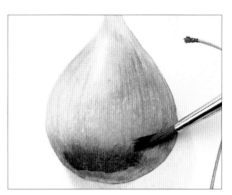

3 Continue deepening the rest of the fruit to make the highlight stand out.

Removing watermarks

On occasion your second glaze of colour may leave a watermark over the top of the original glaze. As a watermark is so light you only need to repair this using the tip of your paintbrush.

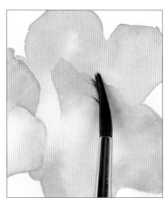
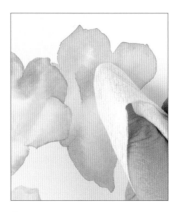
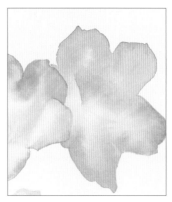

1 Identify the watermark you wish to remove.

2 Wet the area using a damp paintbrush to loosen the paint.

3 Dab it with a clean paper towel.

4 Repeat steps 1 to 3 until the mark has disappeared.

Removing accidental paint marks

If, like me, you are startled easily or maybe a little messy while you are painting, then you will from time to time drop paint on your paper when and where you least want it. There is a product available that is sold under various names, for example magic eraser block, which is a very slightly abrasive foam block that, when wetted and gently swept over the paint spill, will remove it from the paper.

Tip

Avoid using any foam eraser blocks that contain bleach or they will seriously damage the paper in the long term. Also, don't scrub too much as eraser blocks are very abrasive. Only attempt to remove unwanted marks once your painting is complete.

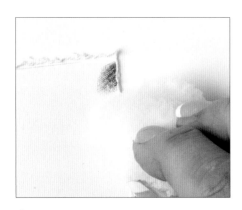

1 Rub the mark away firmly using a damp magic eraser.

2 Dab the area dry with a piece of paper towel.

3 The mark should have disappeared. You can also flatten the paper again using a polished stone, as on page 82.

Controlling too much paint

Sometimes you can pick up too much paint on your brush and it will bleed out onto the painting, making the colour flood to the edge. Below are the stages required for correcting this mistake.

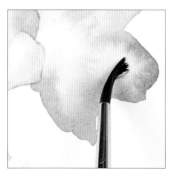

1 Working from the centre of the area outwards, mop up the colour using a flattened damp brush.

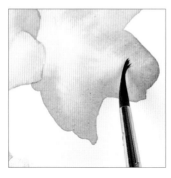

2 Feather the area with a dry brush and leave to dry thoroughly.

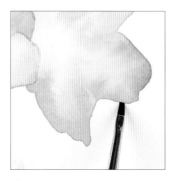

3 Once dry, soften any hard edges with an eradicator (see page 78).

4 Dab dry with a piece of paper towel.

Removing a water splash in a settling wash

If you accidentally drop water into a wash, it will push the paint aside and leave a mark. This demonstration shows how a water splash can be softened away. Follow the steps below and then leave the painting to dry before starting again.

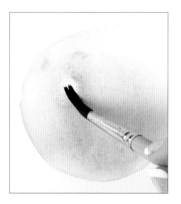

1 Use a flattened dry brush to mop up the water splash from the centre.

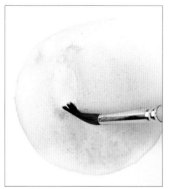

2 Use a clean, damp brush to lift away the extra paint that was pushed aside by the water drop.

3 With the tip of your brush, feather the area around the mark to blend it in.

4 Allow it to dry before continuing with the painting.

Correcting a hard or uneven edge

Sometimes, painting within the shape you have drawn is difficult. Perhaps the water glaze went over the edge or outside the shape, or perhaps it fell short of the edge. Either way, tidying up an uneven edge is essential for botanical painting. Follow these simple steps below and allow the paper to rest and dry before continuing.

1 While the paint is still wet, run a damp brush around the edge of the shape to even it up.

2 Leave the paint to dry, then remove any build up of paint with an eradicator, working from the inner side of the shape.

3 Dab the edge dry with a clean piece of paper towel.

4 Allow to dry, and repeat until you have a soft, even edge.

Removing a stubborn mark or stain with a blade

This technique should be perfected first on a test piece of paper as it requires gentle and careful execution. Always use the blade as flat to the paper as possible. It is also advisable to do this only when you know your painting is complete, as it damages the paper and any paint on or near it will soak into the bruise.

 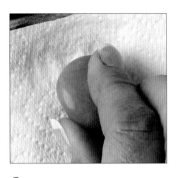

1 Firmly scratch away the mark using the flat side of the blade.

2 Brush away the scrapings, or use an eraser.

3 Cover the area with paper towel and polish the area with a polished stone (see page 82).

4 The area is now clean, and any damage to the paper has been rectified. Be careful not to get any dirt or paint onto the same area.

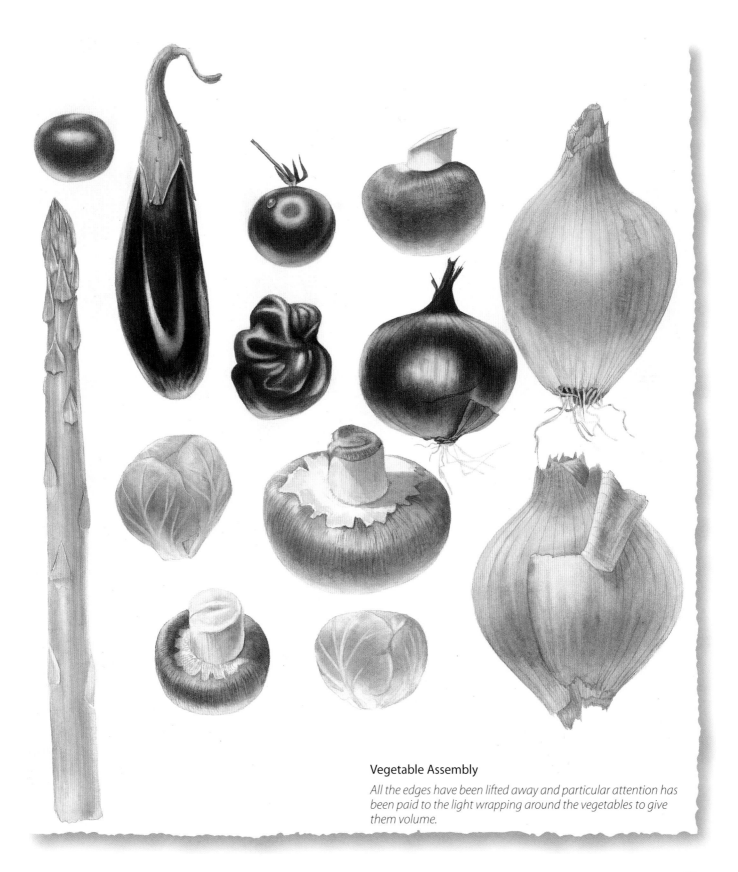

Vegetable Assembly

All the edges have been lifted away and particular attention has been paid to the light wrapping around the vegetables to give them volume.

Painting detail

The all-important detail boils down to observation. Familiarise yourself with the plant, and look closely at the patterning and the width and direction of the veining. Practise holding your brush at the right angle and perfect your fine lines beforehand on some spare paper. It is extremely difficult to get the exact width of the very fine veins and delicate patterns, but the closer they resemble those of the actual plant, the more convincing and stunning your depiction of the plant will be.

Veins

The dark lines we see when briefly observing a leaf can actually be the shadows or darkening of the leaf either side of the veins. Hold a leaf up to the light and generally the veins will be quite pale as the light shines through them, so it is actually the dip next to the vein that is darker. You will see more dips or more transparent veining depending on the angle they are viewed at. At other times, what look like veins can actually be fine bands of colour.

Adding long, parallel lines of colour

Begin by turning the paper so you are drawing horizontally. Use the tip of the brush, and support your hand on the worksurface.

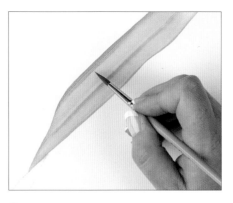

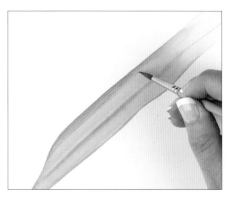

1 With a steady hand, paint in each of the fine lines. Go as far along the leaf as you can in a single brushstroke. I find it helpful to rest the side of my hand on the paper and sweep from the wrist.

2 Paint several veins in this way. Try to keep the brush at a steady, upright angle and the point just touching the paper. Stagger the length of the lines so they don't all break at the same point.

3 Continue the fine lines, picking up each one in turn where they finished and carrying on down the leaf, always working in single brushstrokes. Rest intermittently, and always keep the brush well loaded with paint. Keep the brush upright and use just the tip.

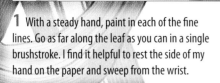

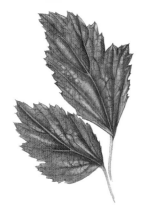

Adding fine shadows either side of the veins

Having lifted out the veins (see page 79), you may need to add a shadow or dip to one side of each vein. The shadow will fall on the opposite side to the light source, so remember to observe carefully. If the light is coming from the left, the dip or darker side will be on the right. I always work small sections at a time to avoid smudging the small pockets of detail.

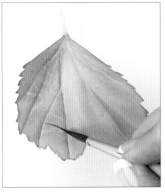

1 Using the tip of a no. 4 brush, paint in the shadows on one side of each of the main veins. Soften to one side with a clean, damp brush.

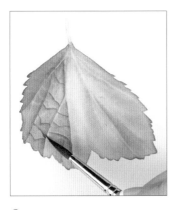

2 Once the main shadows are dry, use the same process to add the shadows to the finer veins.

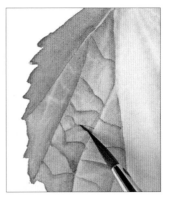

3 Continue to paint in and soften the shadows on the veins, taking them progressively down in size. Change to a smaller brush if necessary.

4 When dry, put a watery green glaze on the shadow side of each vein.

5 Add a very watery Cobalt Blue glaze on the highlighted side of the veins.

6 Use an eradicator to sharpen up any edges where the colour has over-run, and dab with a paper towel.

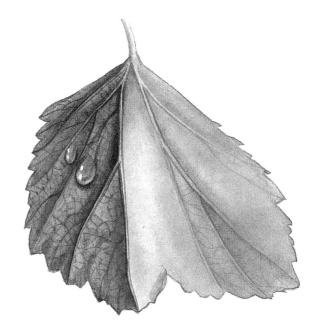

Soft veining

Very soft or blurred veining can be
difficult to achieve. Very fine, painted
lines can be softened by following the
steps below, but the timing is crucial.
Use quite a strong yet fluid mix of paint
for the vein, then after around ten
seconds run a clean, damp brush over
the top. Most of the definition should
remain but the vein should be softer
and slightly blurred on either side.

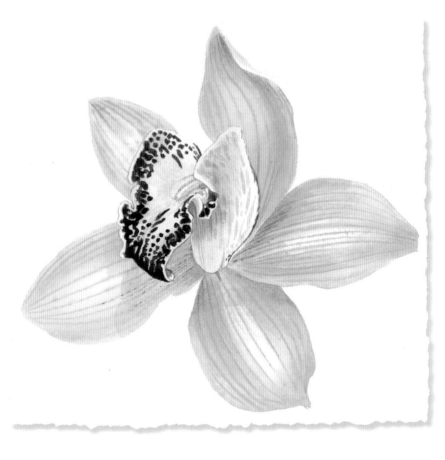

*Find flowers to paint that stay alive and
remain still and unchanging for several
days. That way you will get plenty of time
to study the plant and practise painting the
various details.*

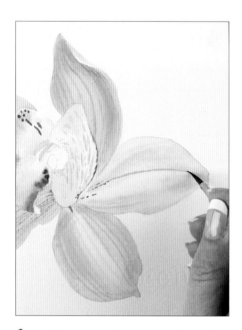

1 Begin by painting on the veins using the tip of
your brush.

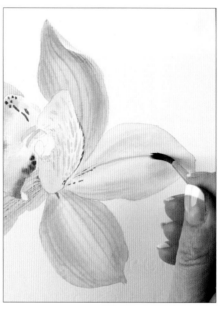

2 Wait until the paint is almost dry, then run a
clean, damp brush over the top of each vein to
soften it.

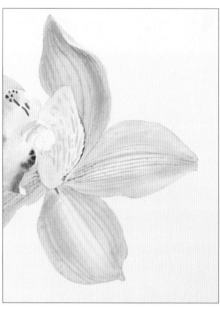

3 Continue until all of the veins have been added.

Water droplets

My students love painting water droplets in my classes. They are easier than they look and fun to do. Here I have used a no. 2 brush, though you can use a larger brush with a very fine point.

Tip

Observe closely the light, colour and shade on a real water droplet before you start to paint one.

Painting a water droplet on a leaf

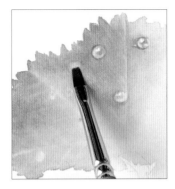

1 Use an eradicator brush to irritate away a small patch of any colour that is the same size as a water droplet.

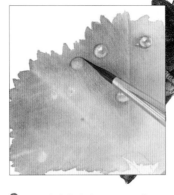

2 Mix a slightly darker green and place it round the shadow side of the droplet using the tip of a fine brush. Allow this to dry.

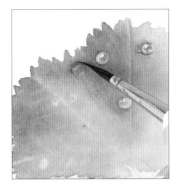

3 Mix a brighter green and use it to paint the inside of the droplet. While the paint is drying, place a little cast shadow to one side of the droplet.

4 When totally dry, pick out the highlights on the droplet using the tip of a scalpel.

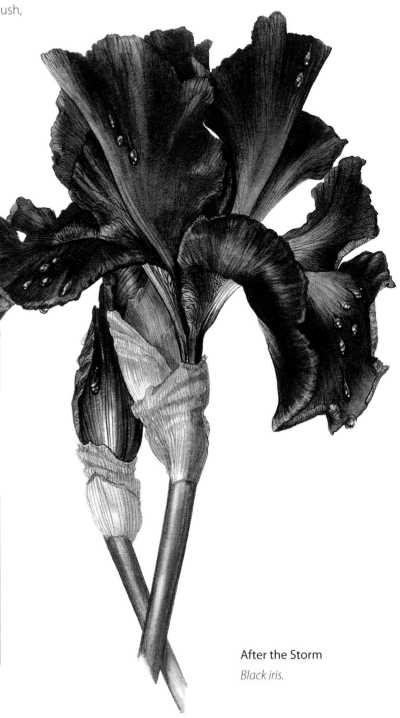

After the Storm
Black iris.

Stems

Stems can make or break your painting; a perfect flower study can be ruined with a wobbly, irregular stem. It is not just about having a steady hand – you can develop strategies to help you achieve perfectly smooth stems. Here are some suggestions.

Fine stems

Don't make the mistake of drawing both sides of very slender stems. When you start to paint them in you might be tempted to fill the space in between instead of carefully gauging the correct width as your brush travels the length of the stem. Instead, draw one line to represent one side of the stem, then gently push on the brush until the tip is the exact width of the stem and take it carefully along the stem to the required length. It is easier and surprisingly more accurate.

Facing page:
Japanese Anemone Study

These anemones grow in my garden. They are a wonderful source of fresh flowers that I enjoy painting at the end of the summer.

Painting the stem of an anemone

1 Mix up your colour, and then use a no. 4 or no. 6 brush to run a little water alongside the pencil line, starting at the top of the stem.

2 Paint two parallel lines along the first part of the stem – one on the line and the other just to the left of it. Use a single brushstroke for each line. Alternatively, push down on the tip of the brush until it is the same width as the stem and paint the stem in a single stroke.

3 Run a clean, damp brush between the two painted lines, taking the water further down the stem. Alternatively, run the tip of a clean brush through the line down the centre of the stem to create a highlight.

4 Repeat step 2, and continue in this way down to the base of the stem.

5 Introduce different colours to your mix as the stem colour changes along its length. You can also widen the stem if necessary.

6 Once the stem is dry, smooth out any irregular edges using a damp eradicator (see page 78).

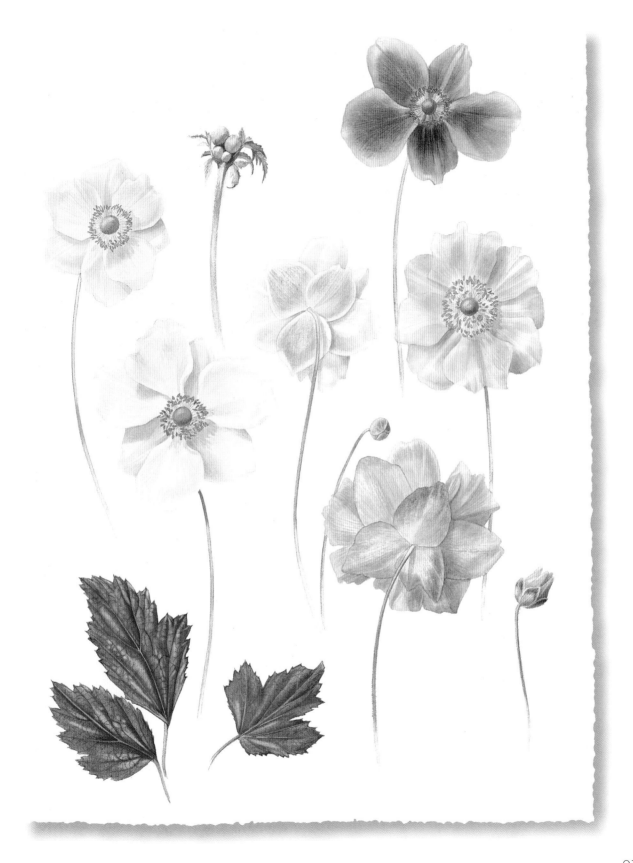

Thick stems

Thick stems are easier to execute than fine ones, but always draw them slightly narrower than they actually are to allow for any mistakes or wobbles. Observe the stem carefully to see where the light falls and whether there is reflected light on either side of the stem. Once you have located the positions of any highlights, turn your painting to a position that offers maximum comfort and sweep of your dominant hand.

Below I am working along the stem horizontally and from left to right, but do experiment to see what painting position suits you. Use a brush large enough to deposit a good amount of water and paint onto the stem. The stem below has a highlight on one side and reflected light on the other.

Facing page:
Elements of Amaryllis

I love to play around with composition. The cropped amaryllis is unusual and makes an interesting composition. It focuses the eye on the flowers and detracts from the wide, unappealing stems.

Painting the stem of an amaryllis

1 Mix up your colour, and then use a large brush to lay a generous glaze along part of the stem. Here I have used a no. 8 brush. Dry the brush and mop up the excess water.

2 Pick up a generous amount of colour and run it down the middle of the stem, leaving a highlight on either side.

3 Feed in more colour until you reach the required depth, then allow the paint to settle for a few moments.

4 Run a clean, damp brush along the edges of the colour to soften it on both sides of the stem. Repeat this several times.

5 If the paint is still wet, feed some stronger colour into the centre of the stem. Allow this to dry.

6 To create parallel veining, run fine, parallel lines along the stem using the tip of the brush.

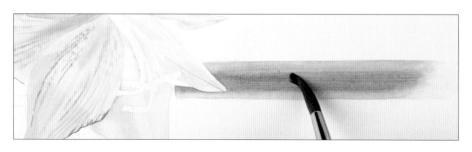

7 When the paint is completely dry, remove the pencil lines, then glaze the stem with water and add another layer of colour. This will both strengthen the colour of the stem and soften the detail.

94

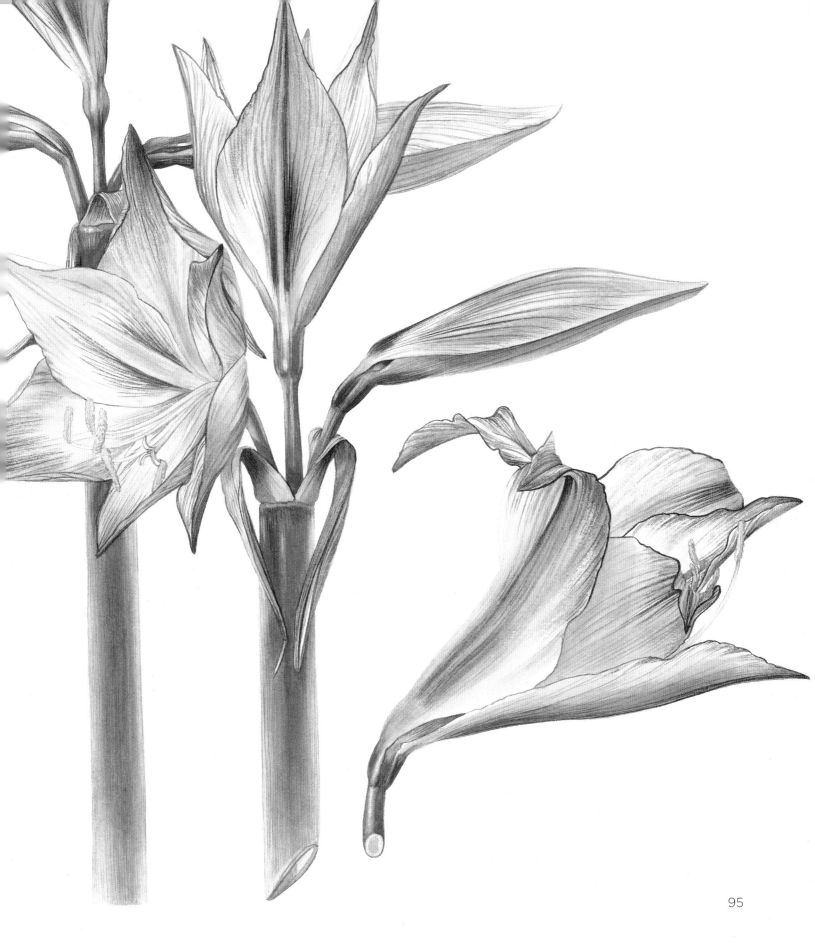

Medium stems

With medium-sized stems, note (as with large stems) the position of the highlight and be aware that it is on the side where it catches the light. If the highlight is not clearly visible, try lighting the plant with a stronger lamp. The effect of light falling heavily from one direction will give the stem more of a three-dimensional cylindrical shape.

Painting the stem of a hyacinth

1 Mix up your colour, glaze the stem with water and apply the colour. Bring the colour down the stem from top to bottom, then move quickly on to step 2.

2 While the paint is still wet, lift out the central highlight using a clean, damp brush. If the light is not revealed on the first lift, try a further two or three times.

3 Use a damp eradicator to tidy up the edges, and to blend any joins between dry and damp colour along the length of the stem.

4 When dry, add the detailing. Here, fine vertical veins are being added using the tip of a no. 6 brush. The ends of the veins are being softened away with a damp brush where they fade.

Thorns and stems with sections

Stems with natural breaks in them can be painted in sections, allowing you to obtain a more even and neater result. Study the plant carefully and make sure you don't widen the stem in the wrong places. Paint the stem as you would a medium stem, stopping at each junction and lifting out the highlight as you travel down the stem.

Painting the thorns on the stem of a rose

Pick up some colour on the tip of a no. 2 brush, and place the tip on the point of the thorn (1). Pull the colour back towards the stem (2, 3). Clean the brush, and wipe out a small highlight (4). Repeat for each thorn along the stem. You can then work up the thorns with fine dry brushing.

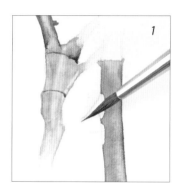

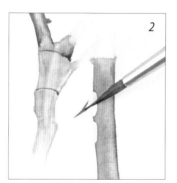

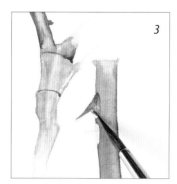

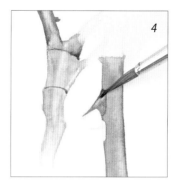

Tip
Turn your painting as you work, so that you are always pulling the paint towards the stem.

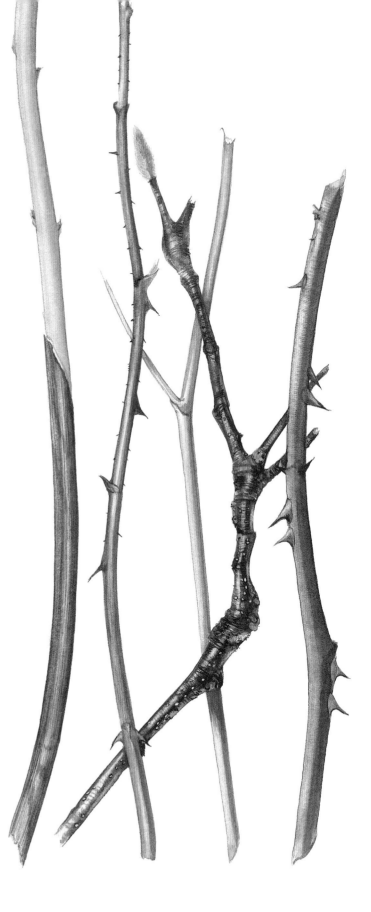

Pleats, folds and fluted edges

Many beautiful summer buds unfold to reveal flowers that are delicately folded or fluted. With so much detail to capture, it is important to have some knowledge of the techniques required to paint them. Always work on a small section at a time, and allow each section to dry before moving on to the next.

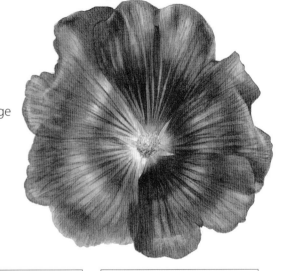

Adding detail to the petals of a pink hollyhock

Apply the first glazes using the wet-in-wet process (see page 54), then allow to dry.

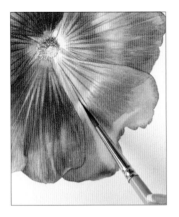

1 Taking one section at a time and using a slightly darker shade of the petal colour, paint on two fine lines for the fold shadows using the tip of a no. 2 brush.

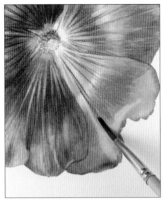

2 Clean and dampen the brush, and run it between the lines to soften out a space in between. Repeat where needed.

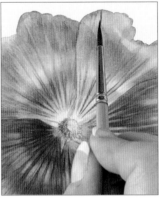

3 Next paint in the tiny folds at the edges of the petals using the same process.

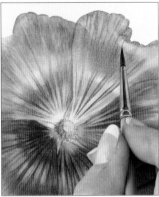

4 Using a fine line from the tip of your brush, paint in the veins. Curve over the top of the creases in the flower to emphasise the raised areas of the folds.

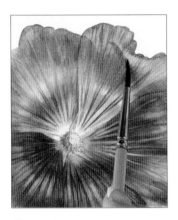

5 Put some shading in between or behind the larger folds.

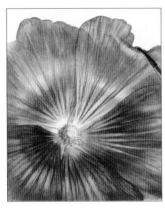

6 Soften the edge of the shading using a clean, damp brush.

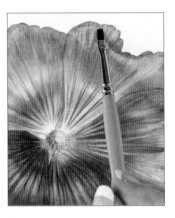

7 Reveal a little more highlight if necessary using a damp eradicator. Dab afterwards with a piece of clean paper towel. Allow to dry completely.

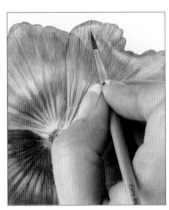

8 Put the veins back in over the highlight, where these have been lost. Continue with each section. Darker areas can be created using dry brushing (see pages 76–77).

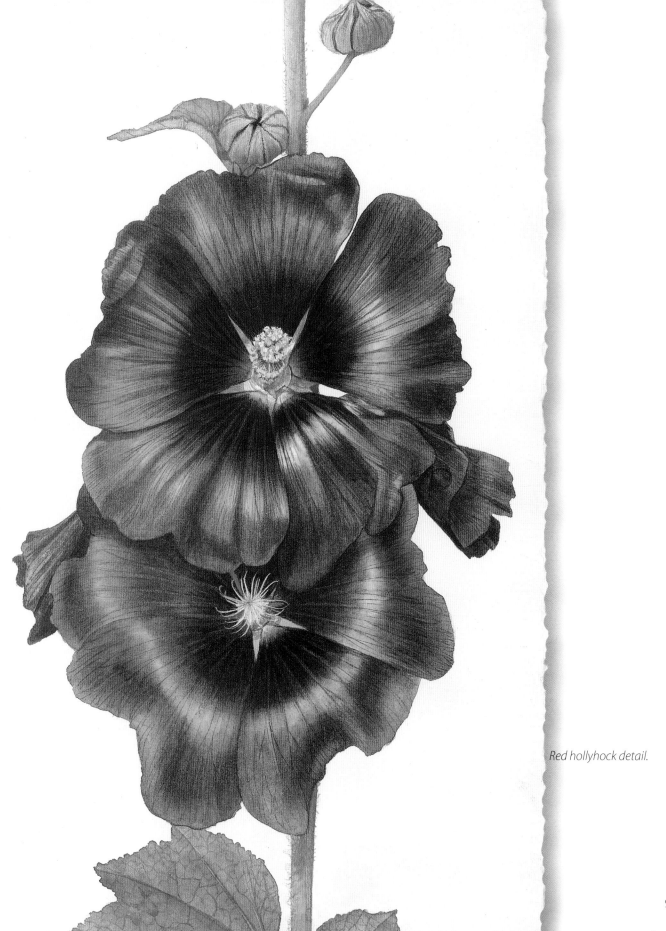

Red hollyhock detail.

Fused petals

I am always amazed by the variety of form and design displayed by flower petals, and almost every plant requires its own, unique approach to painting them. Fused petals offer the dilemma of having to paint all the petals at once while retaining their individuality. Below is the process I use, but remember to practise it first as it may prove difficult to get right.

Tip
Always have all your colours mixed and ready before you begin.

Painting the fused petals of a petunia

1 Glaze the whole flower with water, then drop colour into half of it. Leave a highlight in the centre of the petals.

2 Flatten the brush, and soften through the highlight. Allow the paint to spread and soften into the wet, unpainted half of the flower.

3 Soften the inner edges where the colour finishes to stop the spread of paint, and allow to dry.

4 When completely dry, glaze the entire flower with water again.

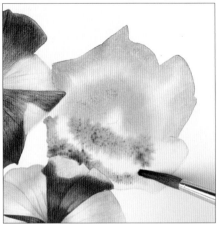

5 Drop colour into the lower half of the flower. The two halves should soften together seamlessly.

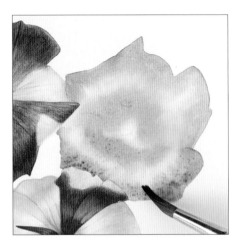

6 Gently blend the two areas together with a clean, damp brush. Allow to dry. You will then be ready to gradually add the details.

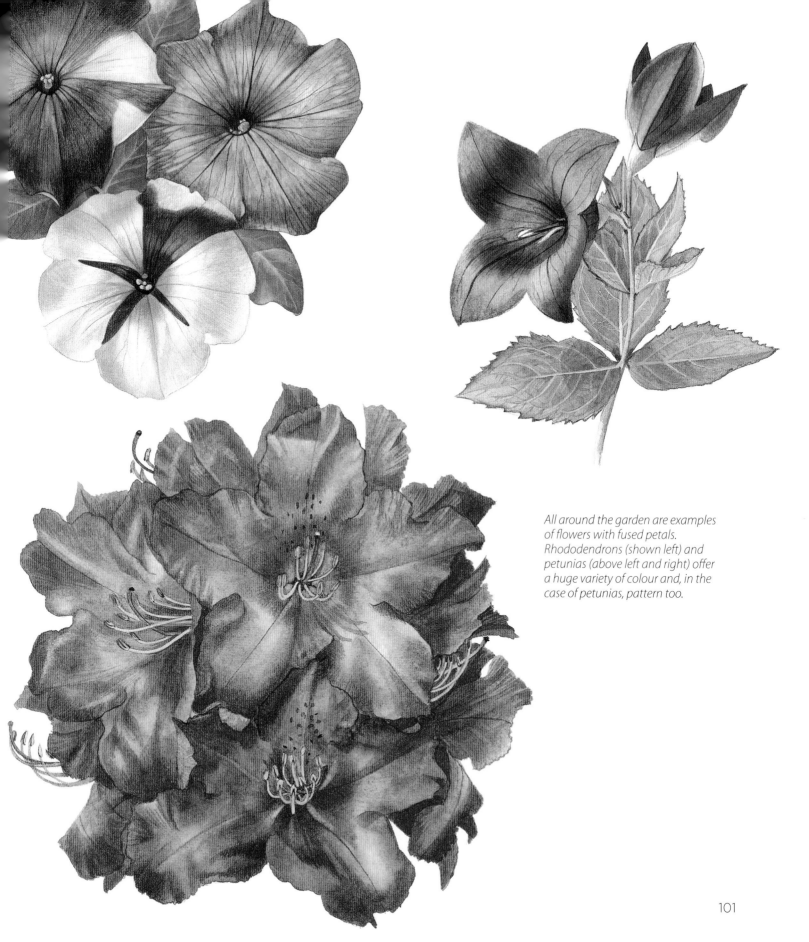

All around the garden are examples of flowers with fused petals. Rhododendrons (shown left) and petunias (above left and right) offer a huge variety of colour and, in the case of petunias, pattern too.

Serrated edges

'How do I paint serrated edges?' must be the most common question that my students ask me. The trick is to include them in the initial wash, but without making them too long or too wide. Once the first wash is dry, follow the steps below. Remember to always pull the brush towards the leaf and not the other way round or you may make the serrations too long.

Painting the serrated edges of a holly leaf

1 After the first wash of colour is dry, pick up colour on the tip of the brush, apply it to the end of the first prickle and pull the colour back into the body of the leaf. Soften it into the main leaf with a clean, damp brush.

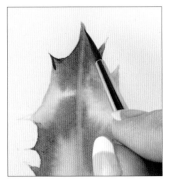

2 Continue round the edge of the leaf. For wide points, work on one side of the point at a time.

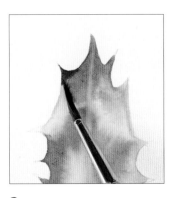

3 Return to deepen the colour once the first application is dry.

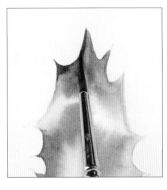

4 Perfect the edges as you go, and soften in with a damp brush.

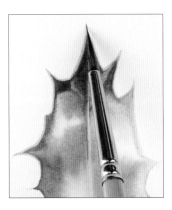

5 Mix a light green. Pick up the colour on the end of the brush and place it just beyond the end of the first prickle. Run the colour around the edge of the leaf to the next prickle.

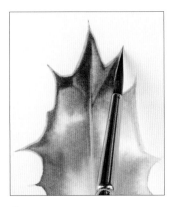

6 To finish, touch in the tip of each prickle using a single hair on the end of the brush. These tend to be a golden brown colour.

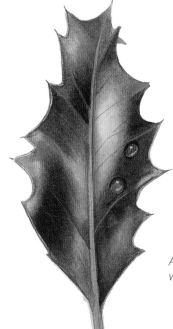

A completed holly leaf, with water droplets.

Prickly surface

To paint prickly fruits takes patience and requires precision. Always try to keep your brush upright on its tip. I find it is easier to paint the prickles from the tip towards the base. The foreshortened prickles are achieved by picking out the highlight on the tip and defining the base.

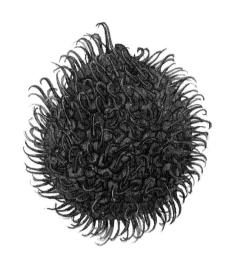

Painting a rambutan

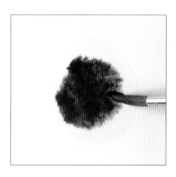

1 Wet the surface of the fruit and lay in a strong mix of colour.

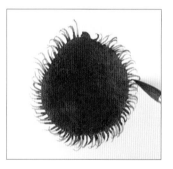

2 While the paint is still wet, tease out the prickles using the tip of a no. 4 or no. 6 brush, whichever has the finer point.

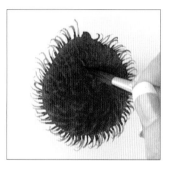

3 Clean and dampen the brush, and use the tip to lift out a little of the colour, revealing the prickles on the surface of the fruit.

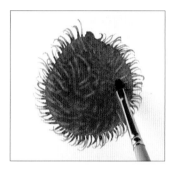

4 As the paint dries, use a damp eradicator to lift out more light. Clean the tip of the eradicator on a piece of paper towel at regular intervals.

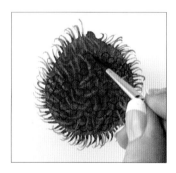

5 Leave to dry, then make a deeper mix of the same colour and strengthen the colour at the base of the prickles.

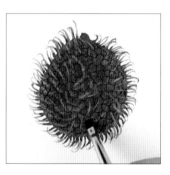

6 When dry, bring in more light using the eradicator. Irritate out a little of the colour, then blot with paper towel and repeat over the surface of the fruit.

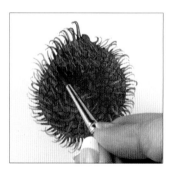

7 With a strong, dark mix, add shadow to the prickles and add more colour at the base using the tip of the brush. Avoid the highlights.

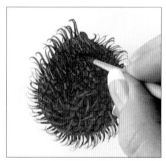

8 Mix a darker colour, and further define the base and tips of the prickles. Irritate out the fine tips as you go.

Irregular and complex detail

Painting small clusters of fine detail can seem daunting, so I choose to lay some groundwork first to speed up the process. In the example of a broccoli head below, the traditional technique would be to painstakingly paint each tiny floret. The joy of my technique is that you can enjoy the watercolour process first and then take it forward to the level of detail you wish to achieve.

Painting a broccoli head

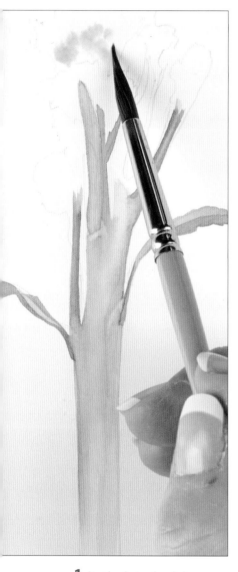

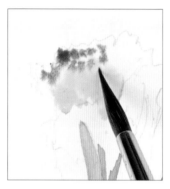

2 While the paint is still wet, dot in a darker shade over the top.

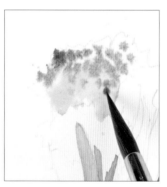

3 Continue dropping in colour all the time that the base green is wet.

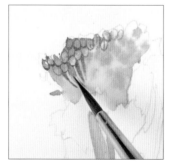

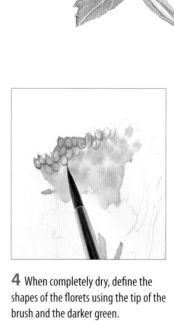

4 When completely dry, define the shapes of the florets using the tip of the brush and the darker green.

1 Start by glazing the whole area with water, then dot in concentrated patches of colour. I have used a fresh, pale green.

5 Put in the small, very dark negative spaces in between the tiny stems. Continue to build up the detail.

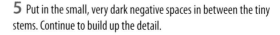

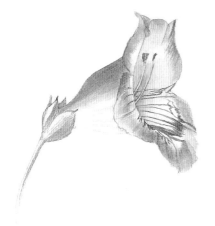

Flower centres

The fine reproductive parts of a flower are often the trickiest parts to paint. If they are paler than the petals, mask them using masking fluid before painting (see page 73). If they are darker, apply them with a fine brush once you've completed the painting and all the washes have dried. Alternatively, you can pick them out and paint around them, as shown below.

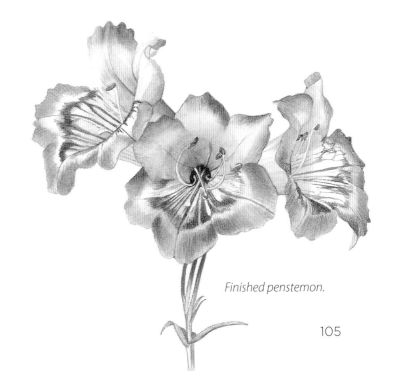

Painting the centre of a penstemon

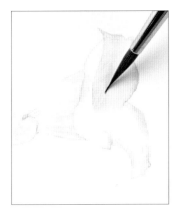

1 Lay a colour wash on the flower and, while the paint is still wet, lift out the filaments that you can see clearly. Allow to dry.

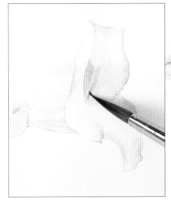

2 Once dry, define the stamen using the background colour and shadows. Allow to dry.

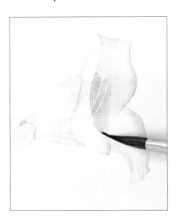

3 Continue to paint in the shadow within the trumpet. Allow to dry.

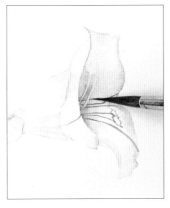

4 Once dry, paint on the pattern and add definition around the filaments if necessary.

Finished penstemon.

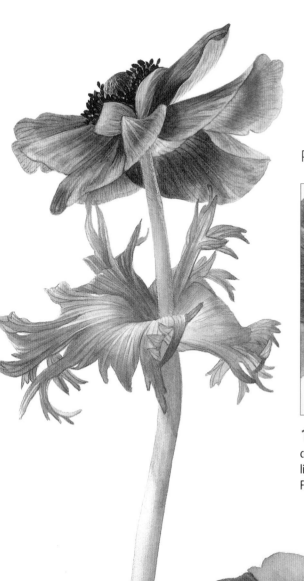

Painting the centre of an anemone

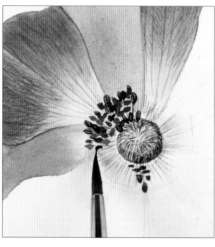

1 Lay a light glaze of pale green over the flower centre and, once dry, paint in the tiny hairs. Add a little purple to the mix and put on the fine filaments. Finally, add the shapes of the anthers.

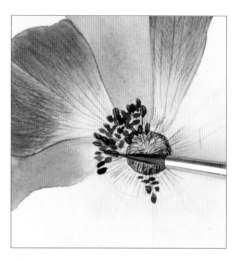

2 When dry, define the anthers, making sure some are darker and others foreshortened.

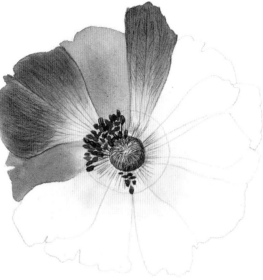

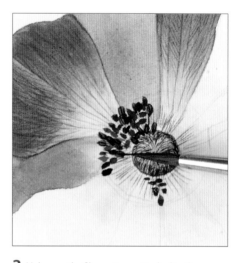

3 Make sure the filaments are attached to the anthers by running the filaments to the anthers on top.

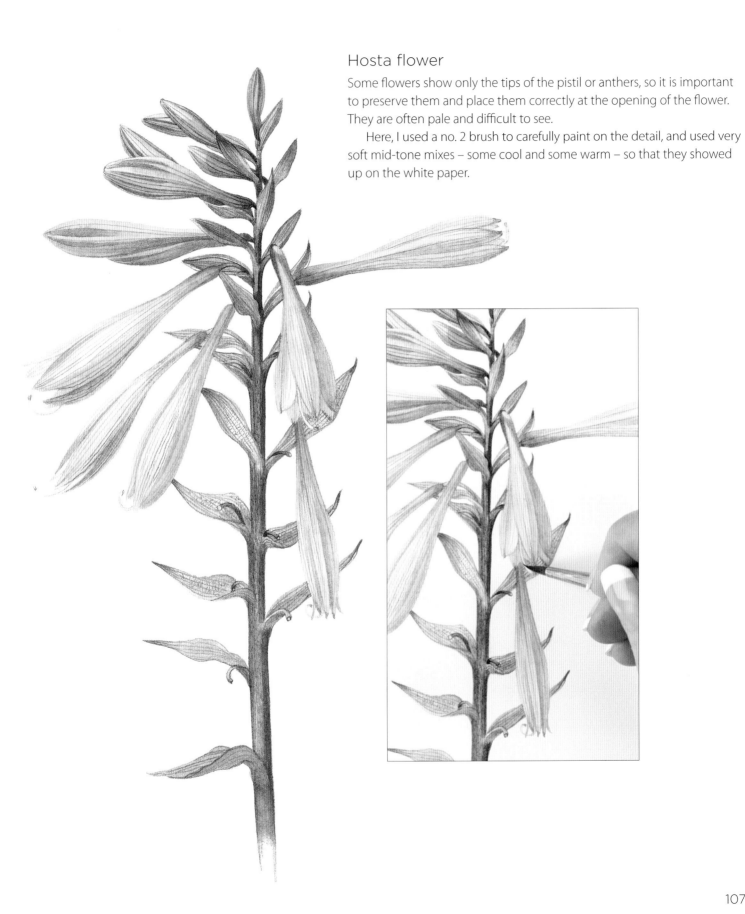

Hosta flower

Some flowers show only the tips of the pistil or anthers, so it is important to preserve them and place them correctly at the opening of the flower. They are often pale and difficult to see.

Here, I used a no. 2 brush to carefully paint on the detail, and used very soft mid-tone mixes – some cool and some warm – so that they showed up on the white paper.

Pips and stones

Adding studies of the internal
structures of a plant can enhance the
beauty of a botanical painting as well
as its usefulness. It requires a keen eye
and a delicate touch. The secret to fine
detail is not to over-work the paper.

Painting a cherry stone

A cherry cut in half shows the beautiful colour
and fine, juicy streaks of the flesh, which is a great
addition to a fruit study. The pip will still be moist,
so make sure you leave the shine on the stone and
build up the colour with tiny strokes of the brush.
The colours I used for this stone were Rose Madder
Lake with French Ultramarine, and a touch of
Sennelier Yellow Deep, but most combinations of
the three main primaries will achieve a nice brown.
An extremely fine line around the finished pip will
define it and push it forward.

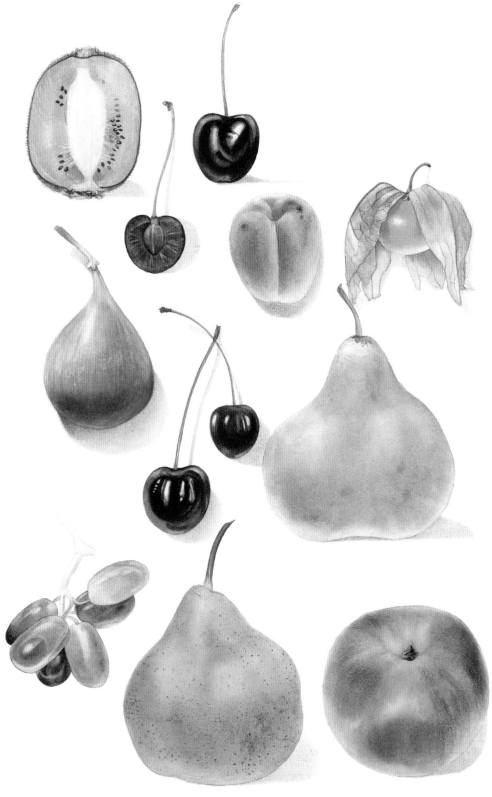

Painting the pips in a kiwi fruit

1 On a dry background, paint little, dark lozenge shapes around the centre of the fruit.

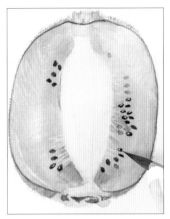

2 Leave a tiny highlight on some of the shapes. Add definition around the highlight.

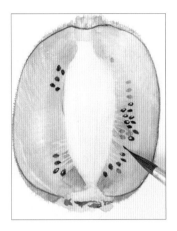

3 Make others thinner and paler where they lie just under the surface of the cut fruit.

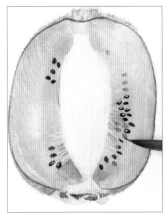

4 Define the edges of some of the pips and leave others soft.

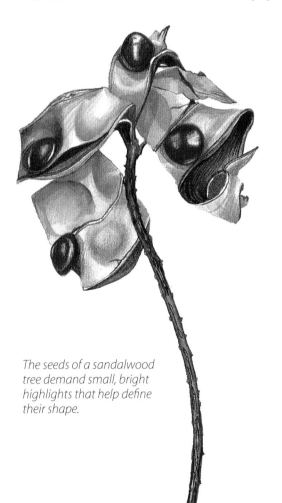

The seeds of a sandalwood tree demand small, bright highlights that help define their shape.

Painting an almond

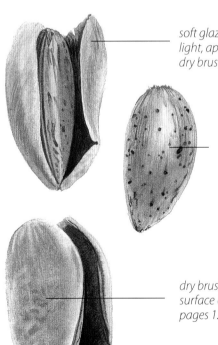

soft glazes to keep the colour light, applied using moistened dry brushing

highlight retained and fine detail applied with the point of the brush for holes and ridges

dry brushing for a furry surface (see the peach on pages 128–129).

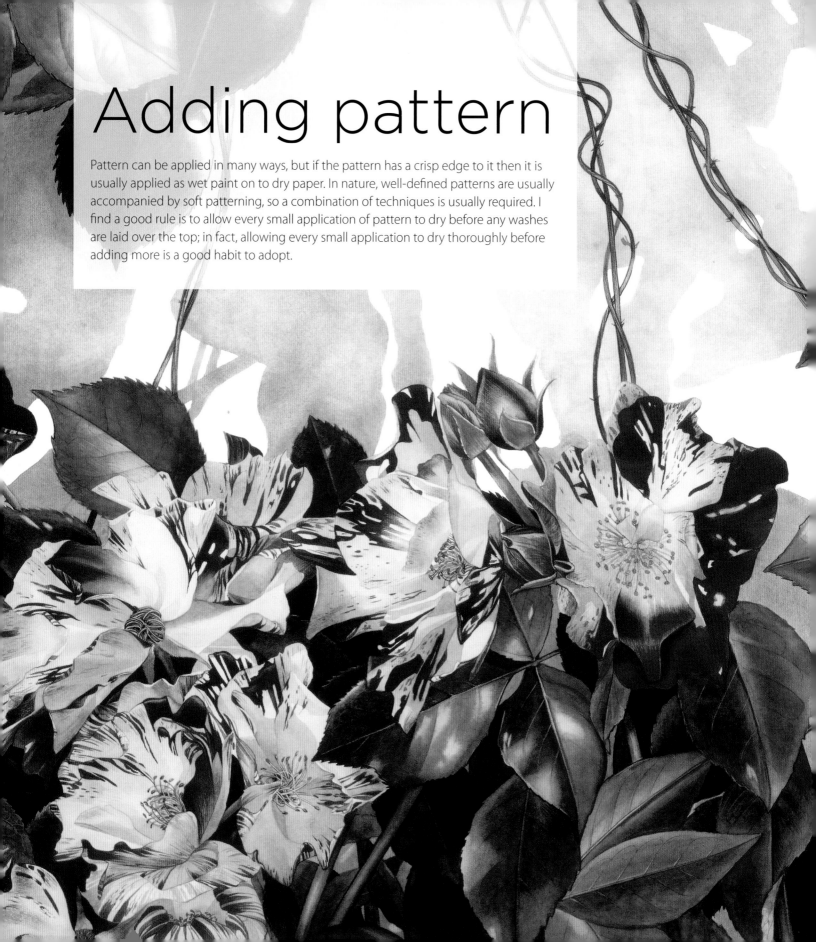

Adding pattern

Pattern can be applied in many ways, but if the pattern has a crisp edge to it then it is usually applied as wet paint on to dry paper. In nature, well-defined patterns are usually accompanied by soft patterning, so a combination of techniques is usually required. I find a good rule is to allow every small application of pattern to dry before any washes are laid over the top; in fact, allowing every small application to dry thoroughly before adding more is a good habit to adopt.

Delicate patterns

Below are the stages I used to add fine detail to the rose called 'Crazy for You', shown bottom right. Each petal was created this way. Observation is key to achieving a convincing end result.

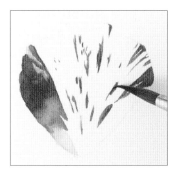

1 Map in the main areas of pattern, beginning with the large area of colour on the left of the petal. Use a no. 4 brush to apply and lift out any highlight within the pattern. Continue to carefully add more of the smaller marks.

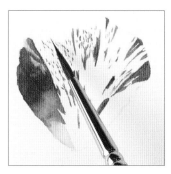

2 Change to a no. 2 brush and apply the finer patterning. Use the tip of the brush and apply a lighter colour for a softer appearance. Use the very tip of the brush and barely touch the paper to achieve a light, subtle finish.

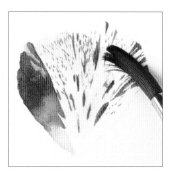

3 Wait for the paint to dry thoroughly, then lay a clear water glaze over the top using the no. 4 brush. This will loosen some of the colour to give a soft colour glaze to this area.

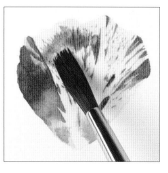

4 While still wet, drop in some gentler pinks and use a flattened, damp brush to soften them in. Gently sweep at the margin to bend away the edges.

Tip

This method also works if you need to add in other colours.

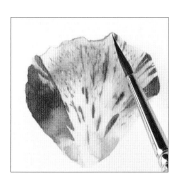

5 While the paint is drying, you can put in the brown edges using the very tip of the brush. Soften with water just behind the line so that a little of the colour bleeds into the petal.

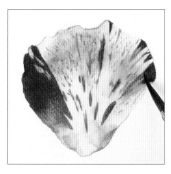

6 Strengthen the darkest areas of the petal using the tip of a brush and apply the extra paint in small, soft strokes.

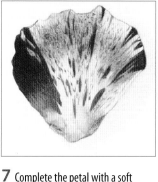

7 Complete the petal with a soft shadow round one side.

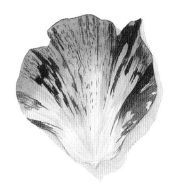

Left: a section from a painting 'South Facing Wall', one of my larger paintings inspired by a flower bed in my garden.

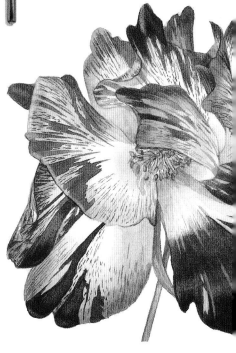

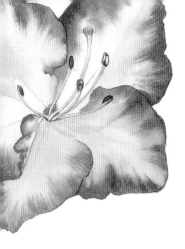

Bold patterns

There are a myriad of patterns on plants and some are more difficult to paint than others. With a little guidance, though, even the boldest and most complicated patterns are achievable.

The patterning on a flower petal is an intrinsic part of the plant, so I often sandwich it in between glazes so that it becomes integral to the plant as a whole, rather than a later addition.

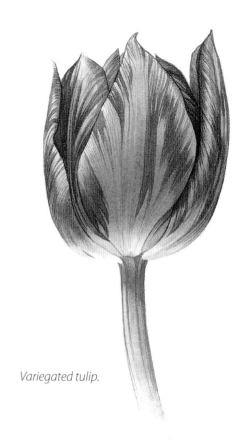

Variegated tulip.

Painting the pattern on a petunia

Painting a large flower with a bold pattern that falls into areas of light and shade is quite challenging. Below is the process I use for the patterns on petunias. The base colour is a mix of Sennelier Lemon Yellow with a touch of Phthalocyanine Blue, and the pattern colour is a mix of Rose Madder Lake, Dioxazine Purple and a hint of Cobalt Blue.

Preparing the background

1 Glaze one half with water, then sweep on a pale wash of the yellow mix. Lift out any highlights.

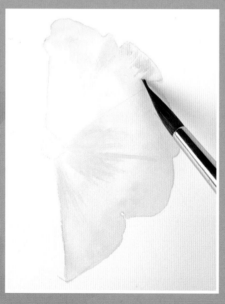

2 When dry, vary the colour slightly and add a little more yellow here and there using dry brushing.

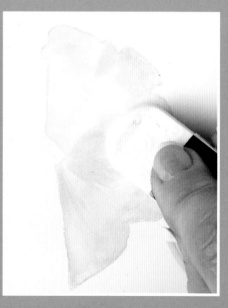

3 Allow to dry, then remove the pencil lines.

Painting the pattern

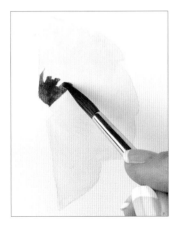

4 Place on the red colour using the wet-on-dry technique. Start in the centre of the flower and work outwards.

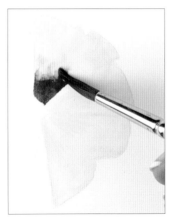

5 Quickly use a wet brush to keep the edge of the paint soft. Create a highlight, then while it is still glistening ...

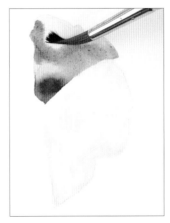

6 ... pick up more colour and add it at the edge of the glaze. Continue working towards the edge of the flower, then, with clean water, wipe next to the colour to get a soft edge to the pattern.

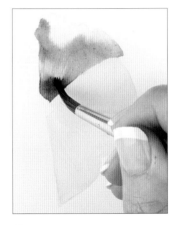

7 Once the first red wash is dry, use the dry brush method to deepen the colour towards the centre.

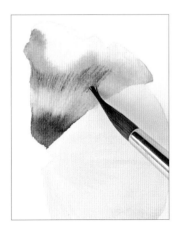

8 Continue dry brushing on the other side of the highlight.

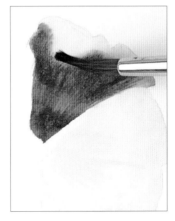

9 Continue adding colour by dry brushing and soften it with a damp brush, especially on the edges where it meets the yellow.

10 Allow this to dry completely before starting the next section.

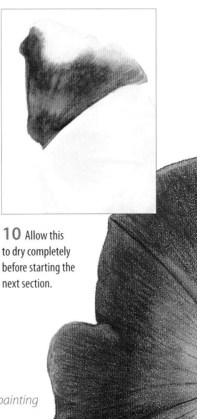

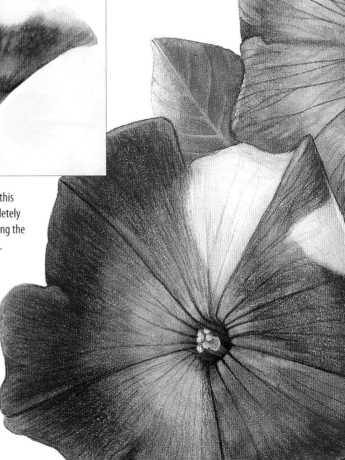

The next stage of the painting is to add the veining.

Painting a boldly patterned phalaenopsis orchid

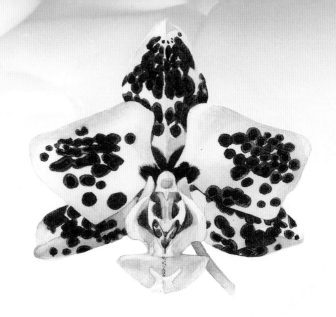

Orchids open very slowly and stay in bloom for weeks. They are therefore a great subject for perfecting challenging patterns, as you can return to them again and again over a period of several weeks.

The orchid shown opposite belongs to a collector. To paint the striking, soft, purple spots I used Helios Purple with French Ultramarine, Dioxazine Purple and Bright Violet.

1 Start by establishing the white flower by glazing one petal with water and dropping in a light mid-tone mix to depict the shadows on the white petal.

2 Map in the second petal in the same way and allow to dry. Where you see a little colour in the background, add this to the mix too.

3 When completely dry, remove the pencil lines and sharpen the edges using a damp eradicator.

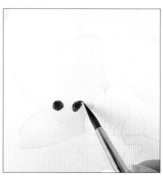

4 Make a Bright Violet and Helios Purple mix, and a second slightly darker violet mix by adding a little French Ultramarine. Start to apply the pattern using the lighter of the two mixes. Keep the circles of violet neat.

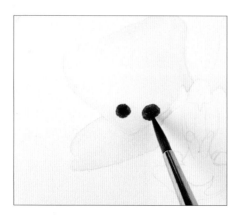

5 While the first colour is still drying, drop in the darker colour. The two colours should remain separate but blur where they meet.

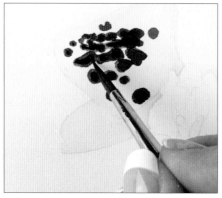

6 Continue to build up the pattern in this way until you have completed the patterning on one petal. Work on one area at a time. Leave to dry.

Tip
Try to match the pattern to the original plant as closely as possible.

114

7 When completely dry, soften the edges of the marks with a clean, damp brush. Keep the brush very clean and wash it after each stroke.

8 While the paper is still damp, dab with a piece of paper towel to give the marks a natural edge.

9 When the pattern is complete on one petal, build up the shadows if necessary, carefully working around the purple marks.

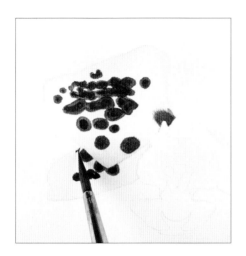

10 Continue adding pattern to the remaining petals. Use the patterning on the lower petals to accentuate the pale edges of the upper petals.

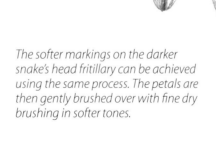

The softer markings on the darker snake's head fritillary can be achieved using the same process. The petals are then gently brushed over with fine dry brushing in softer tones.

Lifting out spots

The soft markings on the inside of a foxglove flower are absolutely fascinating. With the following technique you should be able to achieve soft spots without having to use masking fluid or lifting preparation. Work quickly and, while lifting out the colour, make sure you use a clean, damp brush. If the brush is too wet it will deposit water and push all the pink to the edges.

Painting the spots on a foxglove

 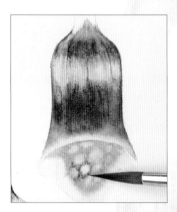 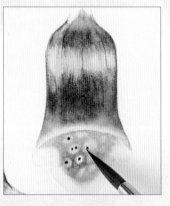

1 Glaze the area with water and drop in the background colour.

2 While the paint is still wet, lift out the spots with the tip of a clean, damp brush. Work quickly and use tiny, circular movements of the brush. Allow to dry.

3 When completely dry, use dry brushing to define the colour in between the spots. Use small, nearly dry brushmarks.

4 Using a very dark mix and the tip of a no. 4 brush, place a tiny dot in the centre of each spot. Here, I have used a mix of French Ultramarine, Sennelier Red and a touch of yellow.

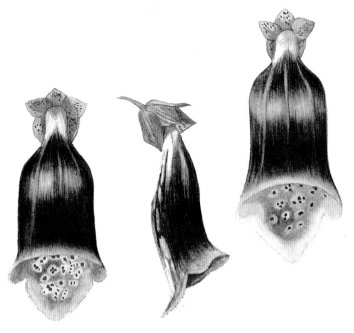

Use this method to complete the spots on the foxglove. Notice the random nature of the patterning, and the less obvious spots on the sepals at the base of the flower.

Patterned rose petal.

Applying a subtle pattern

The method shown below is a good way of utilising the colour mixed up for the top colour without having to water it down. It also has the advantage of making the soft, subtle marks more permanent. I also use this technique for the softer patterns on roses, fritillarias and sweet peas, with the addition of soft dry brushing.

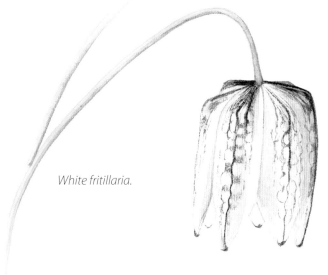

White fritillaria.

Patterned sweet pea.

Adding softer shades of pattern

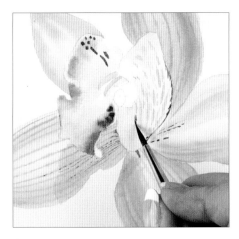

1 Use a no. 4 pointed brush and apply the pattern a dash at a time.

2 While the pattern is still damp, dab with a clean paper towel. This should lighten the pattern to a ghostly blemish.

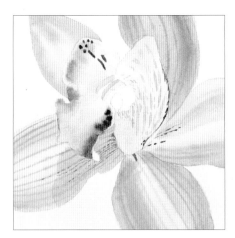

3 A subtle version of the pattern will remain on the flower.

Creating texture

Natural textures range from fluffy and hairy to smooth and shiny, and although their depiction in watercolour is challenging, all are achievable by following the correct technique. I tend to use whatever is to hand and have no shame in using white paint to create texture. I am aware that some artists think white paint should never be used, but the word 'never' always brings out the rebel in me, and I think you should feel free to experiment with it.

Madame Edouard André

This clematis has soft down on the underside of the petals and buds. The top of the petals has a deep colour and a fine texture that gives it a velvety appearance.

Furry texture

The downy surface of the quince is one of the most challenging textures I have ever painted. The best advice I can give you is to be patient and not give up; it takes many layers and careful application of paint to achieve a good result.

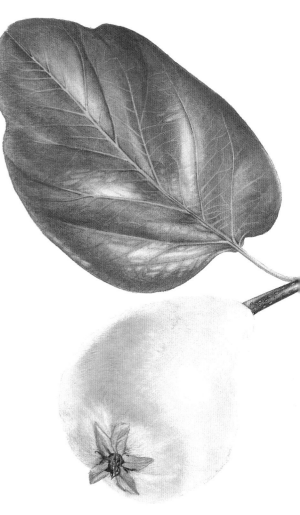

Creating a furry surface on a quince

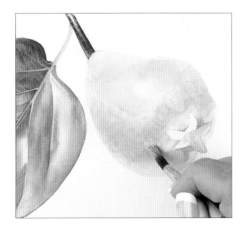 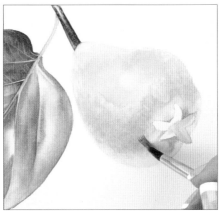

1 Study the fruit to see the direction of the tiny hairs. Then, using a flattened no. 6 brush, dry brush the hairs on using Titanium White mixed with a tiny amount of Lemon Yellow. Use short brushstrokes and repeat several times to build up the texture.

2 Use the same technique to place a layer of yellow over the top. Use Lemon Yellow with just a touch of Titanium White (the reverse of the previous mix). Continue to build up the layers (up to four in total) to achieve the right depth of colour.

Velvety texture

The technique for creating a velvety texture on the surface of a plant is similar to dry brushing. A softer finish is achieved by using the brush on its side rather than flat.

Creating a velvety surface on a clematis flower

Add the colour by dry brushing carefully then quickly sweep over with water (1). This softens and blurs the dry brushing. Gradually build up the colour, allowing the area to dry in between layers, until the desired effect is achieved. Finish by feathering the paint on either side of the highlights (2).

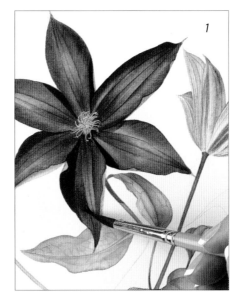 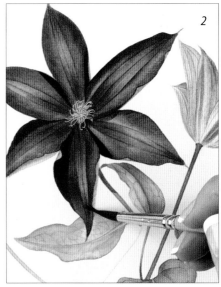

Hairy texture

Many plants are covered in tiny hairs, some of which are not easy to see without a magnifying glass. The addition of the hairs results in a painting that is botanically accurate and has a more realistic finish.

 Although many people might recommend a fine brush with just one or two hairs, a slightly larger brush with a super-fine point will do the job without the need to constantly refill the brush.

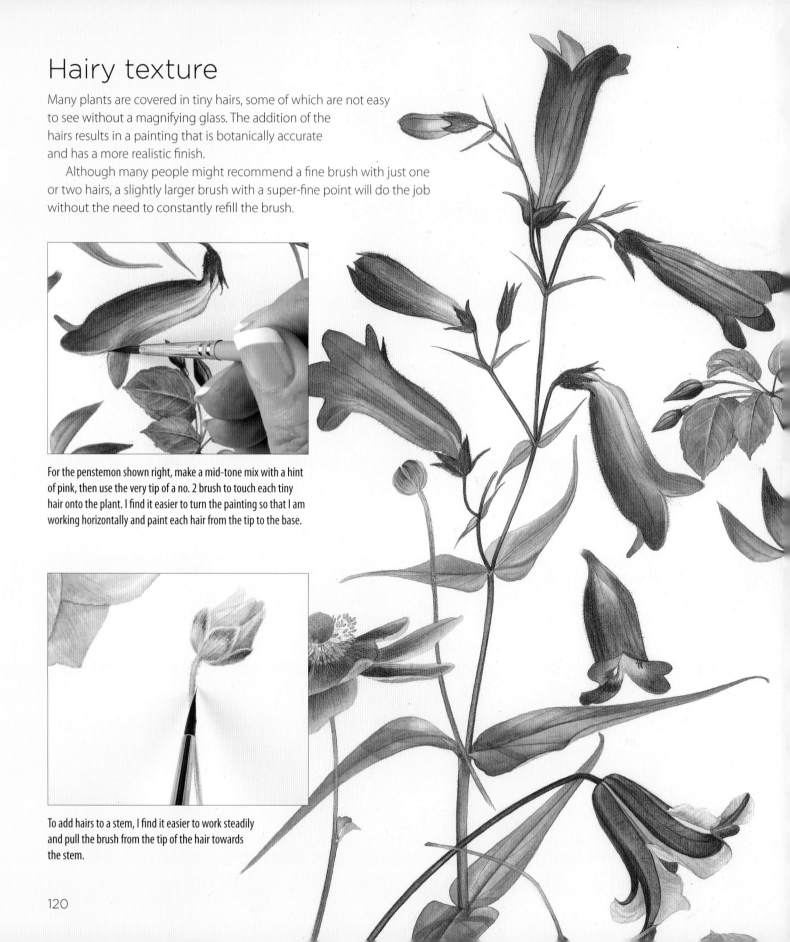

For the penstemon shown right, make a mid-tone mix with a hint of pink, then use the very tip of a no. 2 brush to touch each tiny hair onto the plant. I find it easier to turn the painting so that I am working horizontally and paint each hair from the tip to the base.

To add hairs to a stem, I find it easier to work steadily and pull the brush from the tip of the hair towards the stem.

Fluffy texture

The fluffy little buds of the willow tree are a joy to paint. Though capturing their texture in watercolour can appear challenging, the following technique will allow you do so in relatively easy steps.

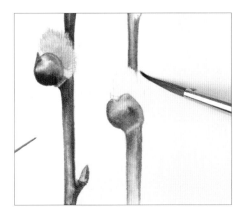

1 Glaze the fluffy area with clean water, taking the glaze slightly beyond the edge of the area.

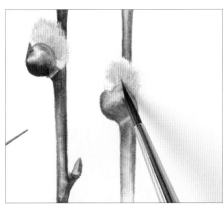

2 Pick up a grey mix of paint on the tip of the brush and dab it gently into the middle of the water glaze. Allow it to spread naturally. When it has settled and dried slightly, pull the tip of a clean, damp brush through the grey 'cloud' to create fine, pale lines.

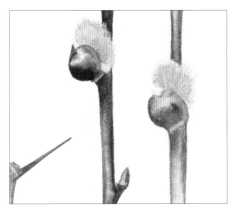

3 To finish, flick in further little hairs beyond the grey area using the tip of a no. 2 brush.

Willow and Quince Stems

Make a study page of stems and you will be surprised at how dark you have to mix the browns. They make a strong contrast with the fluffy, white catkins.

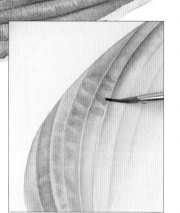

Crinkly surface

Depicting the small pleats, dips and rises on the surface of some leaves, for example hosta or poinsettia leaves, can seem daunting. I choose a small section of the leaf, complete that, and then move on. By following this method I can perfect the structure as I go and not get lost in the detail. Below are the steps for painting one section; I allow this to dry thoroughly before moving on to the next.

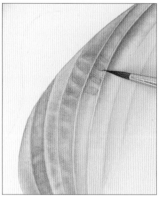

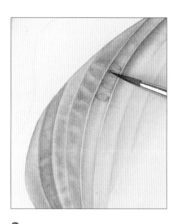

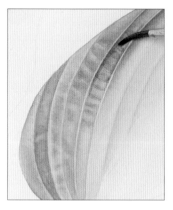

1 Paint in the dips in the crinkles using the wet-on-dry technique. Do this just a few times.

2 Soften the edges quickly using the tip of a clean, damp brush and allow to dry.

3 Strengthen the shadows inside the dips to give more depth to the leaf surface. Allow to dry.

4 Shade either side of the dips inside the main veins using the wet-on-dry technique, then run a damp brush between them to soften. This softens the tiny dips and ridges too.

Surface bloom

You need to decide to include the surface bloom on a fruit early on, and add the colour to the initial wash or soon after, as the light of the paper shining through enhances the colour. Lay the colour on gently and try not to disturb it as it dries.

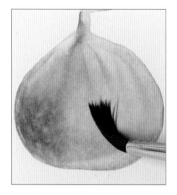

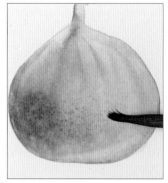

1 Paint on your basic colours, maintaining the highlight and base-reflected light. When it is dry, dampen the whole fruit with water.

2 While it is still wet, lay on a weak glaze of Cobalt Blue. The blue will settle down to give a subtle impression of surface bloom.

Soft grey and blue tones have been added to these grapes to create surface bloom.

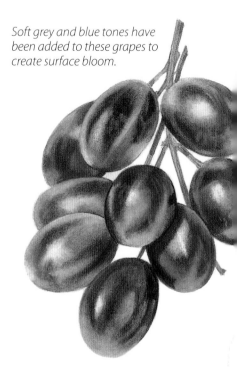

Shiny leaves

The secret to creating shine is to retain the white paper highlights and allow the surrounding colour to soften around them without compromising it in any way. Try to light your subject so that you can observe the light and paint it exactly where it falls.

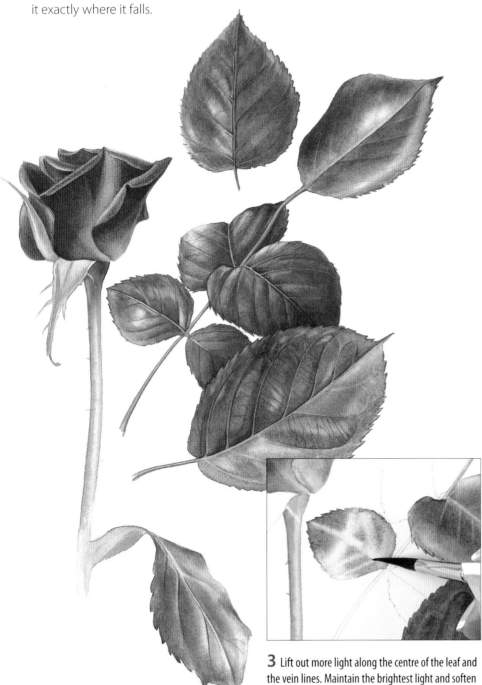

1 Begin by glazing the area with water. Allow it to soak in, then apply more water so it glistens.

2 Drop in colour either side of the highlight. Wait a few seconds, then wipe a clean brush through the highlight to soften the edges of the colour and maintain the light.

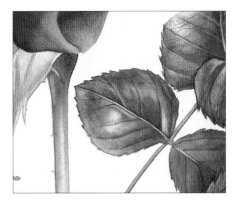

3 Lift out more light along the centre of the leaf and the vein lines. Maintain the brightest light and soften the mid highlights.

4 Allow to dry and continue to build up the colour using the wet-on-dry and dry brushing techniques.

Shiny surface

I love painting a shiny surface as it is so rewarding when you get it right. The secret to getting good results is to let the water and the paint do all the work; try not interfere with the glazes, but let them move and settle on their own. The main thing to watch is that you don't lose the highlights, so the initial water glaze is important. The paper should be glistening evenly before you drop on the colours, and leave plenty of clean water glaze where the highlights are.

Creating a shiny surface on an apple

Start by mixing the red and the green on your palette.

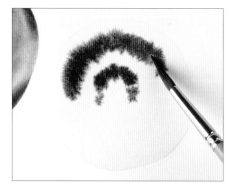

1 Lay an even water glaze over the whole fruit drawing. Make sure it is even and glistening. When fully settled, drop in the red and allow the colour to feed into the wet glaze, avoiding the highlight. You will find the more you allow the water glaze to soak in, the longer you will have to paint.

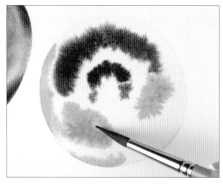

2 Work fast, as the initial water glaze should still be wet when you drop in the green. Drop in as much colour as you can while it is still wet, avoiding the highlights, then swiftly move on to step 3.

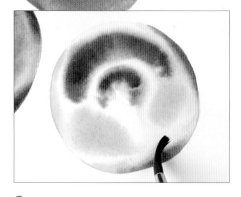

3 Allow the paint to spread, then drag a clean, damp brush through the highlights to soften the edges of the colour. Clean the brush after every stroke, and aim to achieve a smooth, even finish. When the colour has stopped spreading, allow it to dry thoroughly.

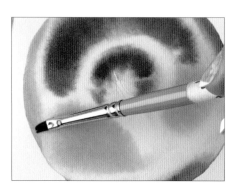

4 When dry, use a damp eradicator to remove any build-up of paint on the edges of the apple. Don't scrub; the paint should just lightly lift away.

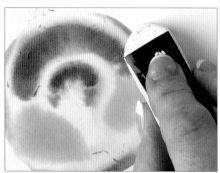

5 Allow to dry, then remove the pencil lines using an eraser.

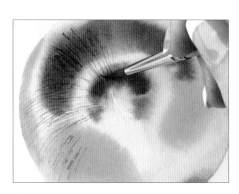

6 Load either a no. 2 or no. 4 fine-tipped brush with red paint and start to put on the light, red markings radiating out from the centre of the apple. Drag a little of the colour through the highlights. Allow the paint to dry.

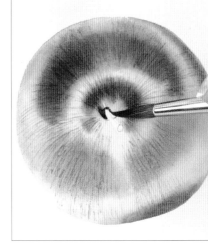

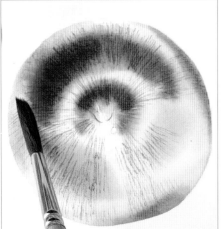

7 Using wet on dry, start to build up the colour on the apple. Soften the edge of the colour with clean water. The markings will then be sandwiched between the glazes of colour.

8 Continue round the apple until you have achieved the desired depth of colour. Allow each patch of colour to dry before moving on to the next.

9 Make a dark mix of French Ultramarine and Sennelier Red and paint in the dark interior surrounding the stalk.

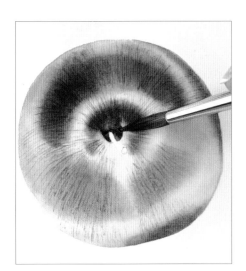

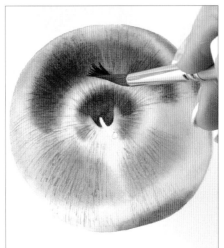

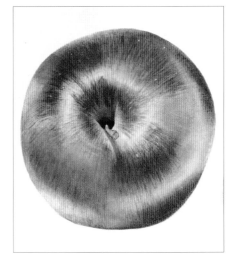

10 Use a clean, damp brush to soften the edge of the deep shadow colour into the fruit.

11 Dry brush over the apple to build up the red textured colour to the required depth.

12 To finish, add slightly deeper greens and reds to create a shadow through the belly of the apple. Every colour should be added onto dry paper and carefully softened in with a clean, damp brush.

Pitted surface

Painting a fruit with a pitted surface takes time, precision and patience. Here I have demonstrated painting an orange. There are a lot of stages, and I would plan to paint this subject over two to three days as it is quite intense. It is important to set up the fruit so that it doesn't move and to keep the lighting consistent.

Tip

Remember that masking fluid will become sticky and permanent over many weeks, so if you are taking a long break in between stages always remove the masking fluid before the painting is stored and then, if necessary, reapply it before continuing with the project.

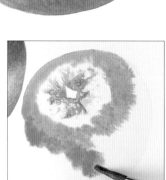

Painting the pitted surface of an orange

1 Apply dots of masking fluid to the top of the fruit to protect the highlights.

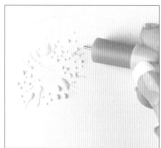

2 Use the point of the applicator lid to tease out the dots and create finer ones.

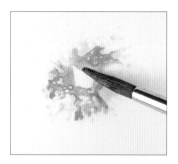

3 When thoroughly dry, glaze the whole fruit with water, mop up any puddles and drop in the colour at the top of the fruit. I used Red Orange and Quinacridone Red.

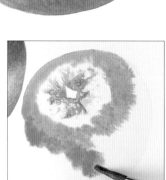

4 Skip over the highlights and reflected light, and take the colour further down the fruit. Drop in a darker orange as you work your way down.

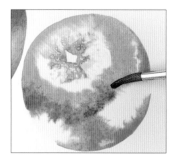

5 For the shadow areas, drop a little French Ultramarine blue into the mix. Note that all the highlights should be as wet as the painted parts. All the colour is dropped in while the first water glaze is wet.

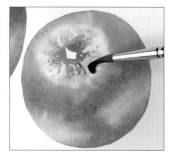

6 Blend the colours, but retain a little texture. With a flattened brush, pull some colour in towards the highlight.

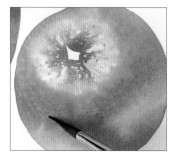

7 Before it dries completely, use the tip of a clean, damp brush to lift out little dots of highlight from the settling paint.

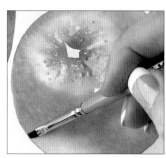

8 When thoroughly dry, use a damp eradicator to remove any build-up of paint on the edges of the fruit. Allow it to dry.

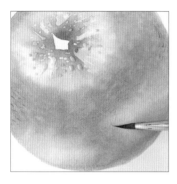

9 Put in the shadows next to some of the dimples in the shaded area using the shadow mix (see step 5). Use the tip of the brush.

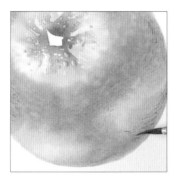

10 Repeat using a bright orange mix, in the brighter area at the base of the fruit.

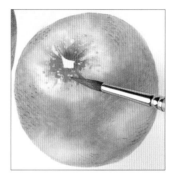

11 Use the same mix to add more depth to the top of the fruit. Place a tiny dot of the same colour inside each dimple.

Tip
In some areas, the pattern will be less distinctive – only add pattern where you can see it.

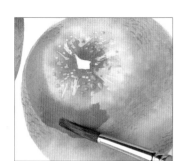

12 When dry, gently build up the colour on the fruit using the wet-on-dry technique. Focus on one area at a time.

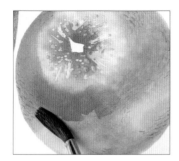

13 Soften the edges of each glaze with water and allow it to dry before moving on to the next. Apply several layers to achieve the right depth of colour.

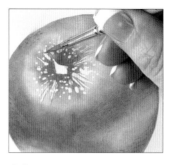

14 Allow to dry, then rub off the masking fluid. Use a no. 2 brush to perfect and define the edges of the little highlights.

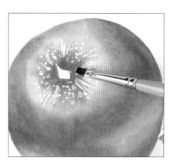

15 Wiggle away some of the unwanted marks using a damp eradicator. Also use it to tone down some of the masked-out highlights.

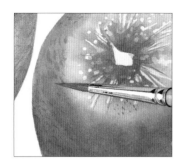

16 Use the tip of a no. 2 brush to strengthen the shadows on the dimples.

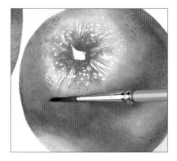

17 When dry, lay a light orange glaze over the fruit and soften with water.

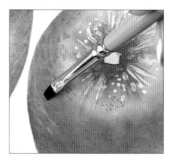

18 Use the eradicator to irritate out some tiny highlights and dab the paint away with paper towel.

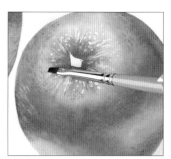

19 Use the eradicator to soften away any hard edges. Carefully paint in the detail on the top of the orange in green.

Downy surface

Painting fruit with a downy texture brings together many techniques. The initial water glaze needs to be extremely wet, then mopped up to remove the puddles. If at any point you put paint onto a glaze that has dried out, simply lift away any hard marks, allow it to dry and then reapply a fresh water glaze. When you start to dry brush at the end, make sure that the painting is totally dry and perfect your mark making on some scrap paper before you start to paint.

Painting the downy surface of a peach

For this peach, I used Rose Madder Lake, Quinacridone Red, French Ultramarine, Lemon Yellow, Red Orange and Cobalt Blue. From these, I mixed a selection of peach tones.

1 Lay a water glaze over the whole fruit, then drop in a watery mix of Cobalt Blue where the peach picks up the light.

2 Allow to dry, then use a damp eradicator to soften the edges and ensure the outline remains soft. Prepare all your colour mixes while this dries.

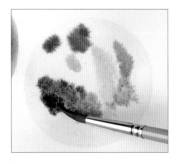

3 Prepare your mixes, then glaze the whole area with water and drop in the colours. Allow the colours to spread gently and blend into each other.

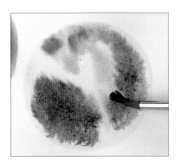

4 Flatten the brush and use it to tease the colours into position. Keep cleaning and drying the brush in between softening.

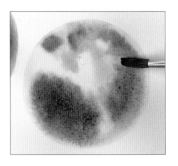

5 Use the brush to keep the colour away from the edges of the fruit. Follow the shape of the peach with your brush movements.

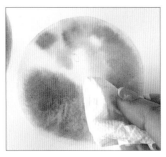

6 Before the fruit dries completely, dab it with a piece of paper towel to obtain more texture. Prepare the darker colour mixes.

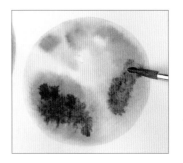

7 When completely dry, reglaze the peach with water, ensuring you follow the original edge exactly. Use slightly stronger mixes and drop in the colours as before. Allow the colours to fade at the edges.

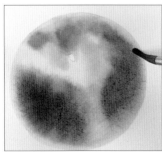

8 Soften the edges of the colour with a clean, damp brush and leave to dry.

9 If you want to, at this stage take a fairly thick mix of Titanium White and dry brush it on sparingly over the areas where you initially placed the blue.

10 Use dry brushing to intensify some of the other colours too.

11 Create the fine marks on the top of the fruit using the same technique.

12 Soften any marks you feel are too heavy with a damp brush.

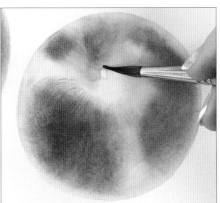

13 Place a little green in the dip on the top of the peach, mixed from the blues and yellow.

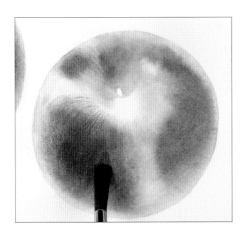

14 Dry brush over the surface of the peach to strengthen the colour and add texture. Add a pale yellow glaze where required, and then paint the fine centre detail to finish.

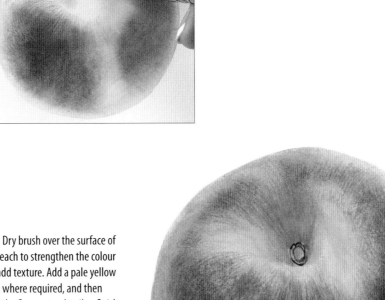

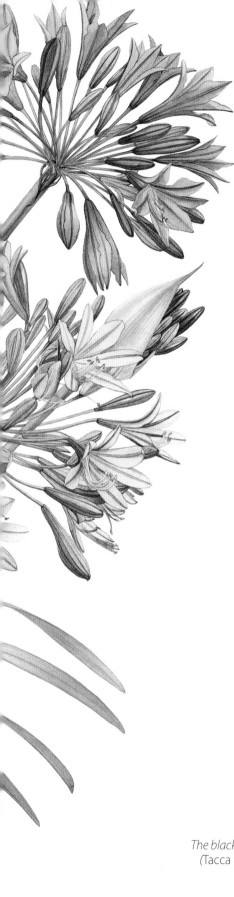

Painting multi-headed flowers

Planning is the secret to success in painting multi-headed flowers. I map in the heads lightly in pencil starting with the front flowers, then work backwards to the flowers behind. This is optional, however, and depends on the composition. Once they are all mapped in I paint them a flower at a time. For flowers that are closely arranged or overlapping, I start with the flower at the back and then move forwards to the flowers in front. This allows me to paint over any edges that have spilt over into the adjacent flower. Think about light and shade – some flowers will have the light shining through the petals; some will be totally in shadow.

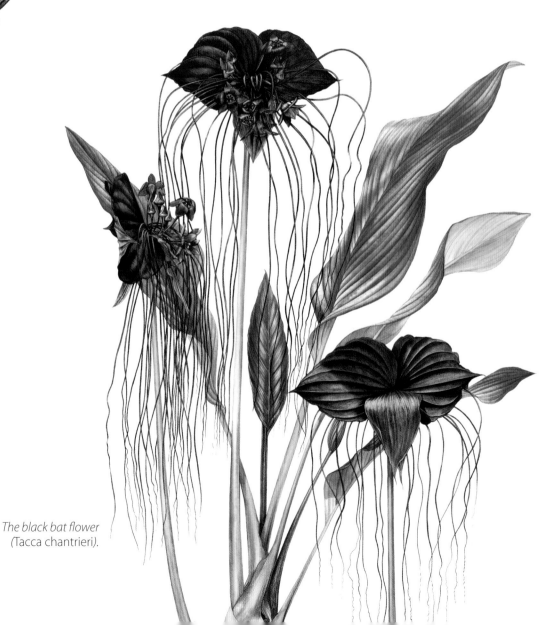

*The black bat flower
(Tacca chantrieri).*

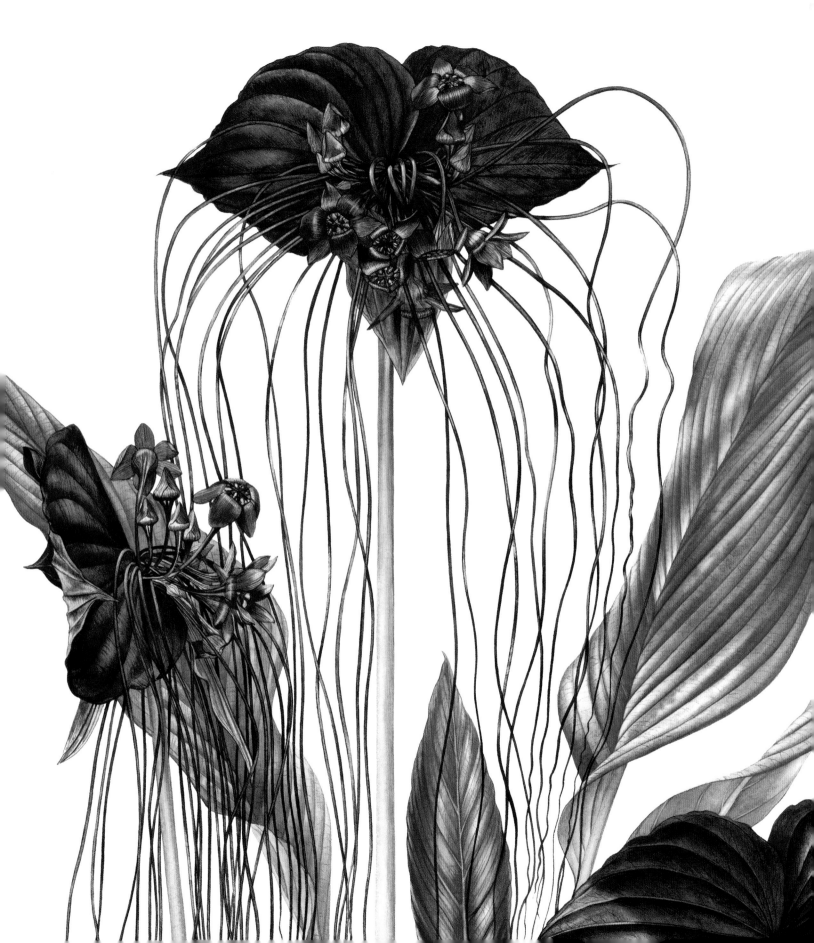

Painting the flowers on a hyacinth

Begin by mixing up two puddles of colour: one of Cobalt Blue and a little Phthalocyanine Blue, and the other of Dioxazine Purple. I decided to paint one flower cluster at a time, so as not to get lost in the myriad of petals.

1 Draw the flowers as accurately as possible, then roll over the drawing with a piece of malleable adhesive to lift off the excess graphite.

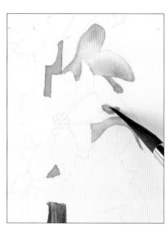

2 Map in the background flowers. Working on one flower at a time, glaze first, then drop in the colours.

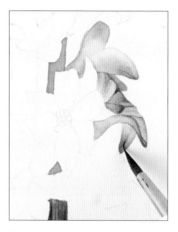

3 When dry, make a darker purple mix and use the tip of a no. 2 brush to add the detail. Use the dry brushing technique.

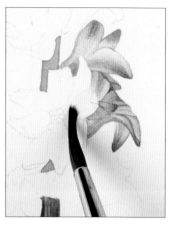

4 Leave to dry, then start work on the foreground flowers. Begin by glazing the flowers with water.

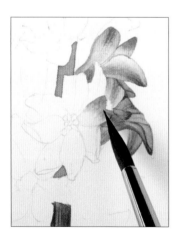

5 Use the tip of a no. 6 brush to drop in the colours.

6 Paint alternate petals, allow these to dry, then paint the ones in between. Lift out the highlights as you work.

7 Leave to dry, then use a damp eradicator to create a highlight round the centre of the flower.

8 Use the tip of a no. 2 brush to put in the veins.

9 Put in the remaining detail using this technique as well as dry brushing. Start to paint in the stamen.

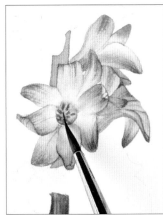

10 Paint in the base of the trumpet with a green mix and soften with a little water where the petals emerge. When dry, add some colour behind the stamen for the filaments.

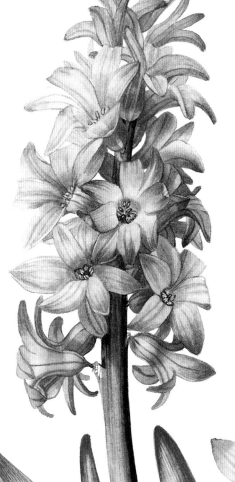

The finished painting. A light glaze of purple was added to the stem once the green paint was dry.

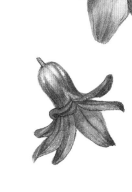

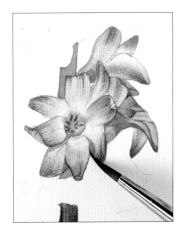

11 When dry, make a shadow mix of purple, blue and yellow and put in the cast shadows and the shadows on the petals.

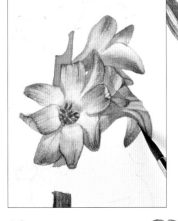

12 Use the shadow mix to push back the background flowers and accentuate the light on the foreground flowers. Always soften the edges of the shadows to prevent hard edges.

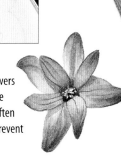

Painting the stems of an agapanthus

I find the fine stems of an agapanthus are best painted horizontally. My hand is steadier in this position and I am more likely to get the stems even.

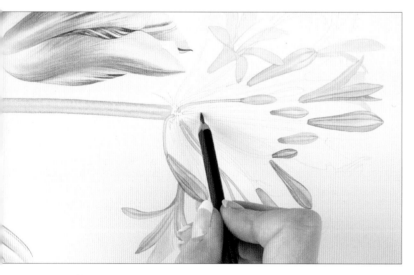

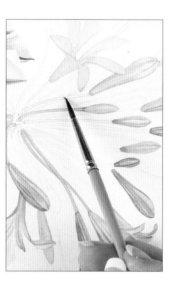

1 Draw in the stems ensuring that each flower has a stem. Refer constantly to the plant to check their shape and position.

2 Using a fine-tipped brush, run water carefully along one stem.

3 Bring the green paint along the stem, keeping a clean, sharp edge as you go.

4 Adjust the colour as you paint in each stem, as they will vary from dark to light along their lengths.

5 Carefully observe the various stems. If some fall behind other flowers, then paint them in two halves.

6 Very slightly widen each stem where it meets the flower.

Tip

In complicated arrangements like this, it is often helpful to plan the order in which you will paint the subject in advance, and perhaps paint the foreground flowers first.

Facing page: this is a mixed flower bouquet containing flowers from different seasons. It was painted over the course of a year. Remember to always keep the highlight on the same side of each new bloom you add to the composition.

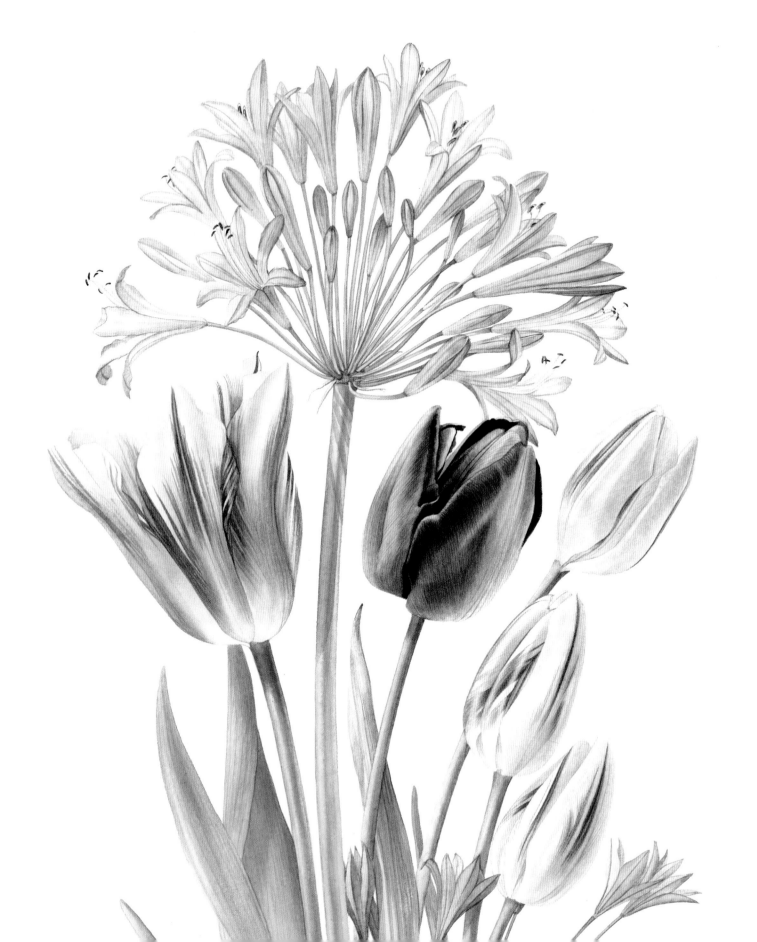

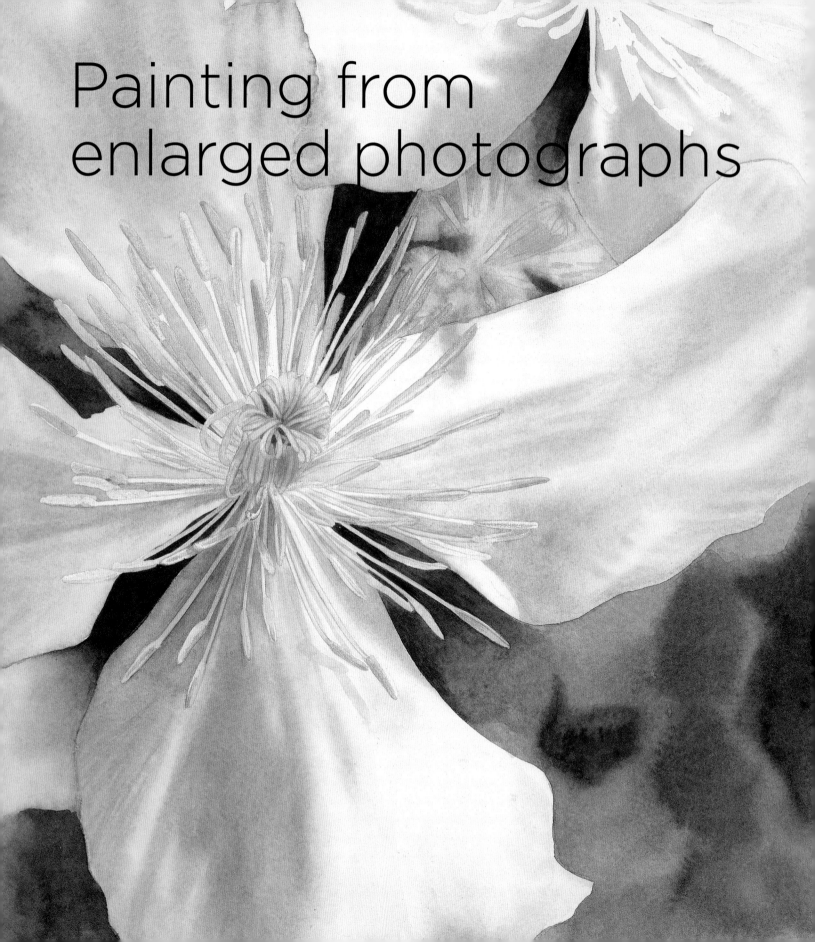

Painting from
enlarged photographs

Painting an enlarged clematis

A large image can have a huge amount of impact, so I have included this section to show you how to paint an enlarged version of a plant from a photograph. It also allows you to really enjoy the wet-in-wet process of painting. I use blending medium on the very large washes to give me a slower drying time. This project also gives you some tips on mixing colour for painting white flowers. The method used to transfer the image to the paper is known as the trace back method (see page 36).

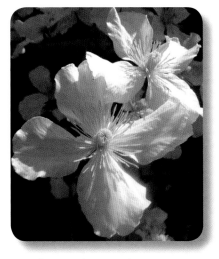

My reference photograph.

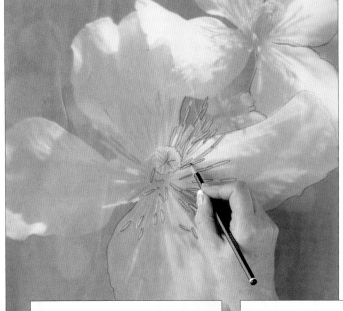

1 Lay tracing paper over the top of the image and trace over the parts you wish to use using an HB pencil.

2 Turn the tracing over onto an old sheet of paper and shade over the back of the drawing with a 2B pencil. Don't press so hard that you can no longer see the outline underneath.

3 Turn the tracing back over and position it accurately on a sheet of watercolour paper. Now use a 4H pencil to draw carefully over the outline and transfer the soft pencil shading to the paper. Rest your hand on a piece of paper towel to avoid smudging.

4 Roll back the tracing paper every now and then to make sure the outline has been transferred successfully. Take care to reposition the tracing accurately each time. When you are satisfied that every part of the drawing has been transferred, remove the tracing and check it against the photograph.

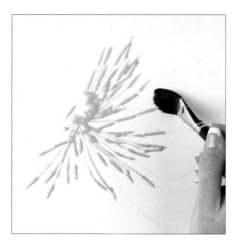

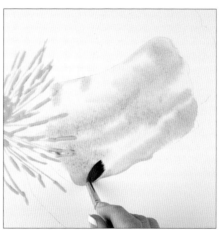

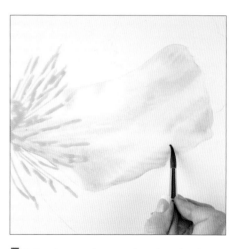

5 Painting one half of the flower at a time, apply masking fluid to the stamen in the flower centre. When completely dry, use a large wash brush to glaze one petal with water. Take your time and ensure the whole petal is wetted evenly.

6 Put in the main grey shadows using the mid-tone colour (see page 68) with a dash of blending medium mixed in. Apply the paint with a no. 8 brush. Bring in some subtle blue and yellow shadows here and there. As the paint is settling, reinstate the highlights by sweeping through them with a clean, damp brush. Soften the edges of the grey area.

7 Before the greys dry, use a clean, damp brush to lift out any light and create the fluted petal edges. Brighten the main highlights where required by wetting then dabbing out the colour using paper towel. Allow the paint to dry.

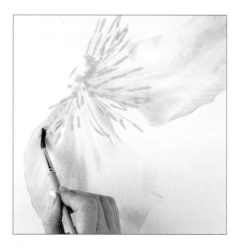

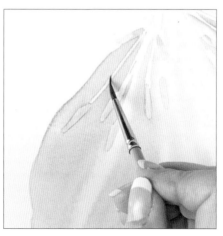

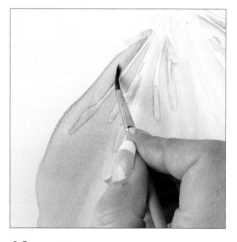

8 Work the remaining petals in the same way. If they are overlapping, work alternate petals followed by the ones in between. Allow to dry.

9 Once the petal is dry, remove the masking fluid and start to put in the anthers and other details in the flower centre using a no. 6 brush. Change to a no. 2 brush and colour in the filaments that are in shadow using a light grey. Tidy them up if necessary.

10 Use a darker grey to put in the shadows on either side of the filaments. Soften these in, then strengthen and soften again where necessary.

Tip

Don't put in the very small shadows while the paint is still wet as they'll just disappear - add only the main shadows and highlights at this stage.

Tip

Complete all the stamen before moving onto the next stage.

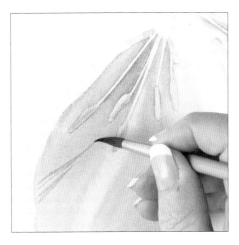

11 Begin to add more detail to the petals, using a darker grey mid tone.

12 Just before the marks dry, soften over the detailing with a damp brush to create a subtle effect, and repeat for each petal. Allow to dry.

13 Glaze the cluster of anthers in the middle of the flower with water and drop in a watery yellow mix. Make it darker for the filaments in the shadow using Sennelier Yellow Deep with Quinacridone Gold.

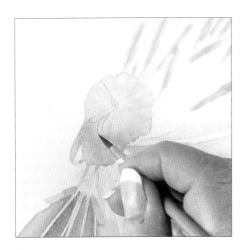

14 Use a slightly darker yellow for the shaded areas, and lift out the highlights on the top of the anthers using a clean, damp brush. When completely dry, use the tip of the brush and a darker mix to define the shadows in between the filaments and the anthers.

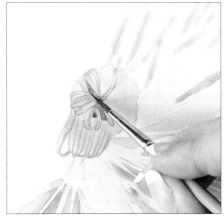

15 Start to strengthen and define all of the parts using a stronger yellow mix. Paint the shaded areas in between using a grey-brown mix. For this I used the previous two yellows plus a little Cobalt Blue and Sennelier Red. Allow to dry.

16 Continue to strengthen and define the component parts of the flower centre. Repeat the process for the remaining petals, starting with further masking fluid followed by washes then detail.

When you have painted all the petals, put in the background in a softer style using the wet-in-wet technique.

Colour and colour mixing

Practising colour mixing is sometimes more beneficial than picking up a paintbrush and painting. I would recommend setting yourself a challenge each day of matching the colour of three random objects. It won't be too long before you see an improvement in your colour-mixing skills.

When mixing colour, throw away the rules and mix from instinct; you will soon find what colours work well together. Of course, you can take advice from established artists but gradually you will discover the colour mixes that work for you.

Paler tones are achieved by simply adding water. Beginners often make the mistake of adding white paint to make a lighter version of a colour, which is a method used for some other painting mediums but never for watercolour. In fact, I use white paint very rarely, perhaps for fine hairs, very fine veining, tiny white blemishes, bloom and occasionally to create a dull, opaque colour, if it is required.

Right: these are all the colours that are currently in my palette. All of them are Sennelier colours, apart from Opera Rose, which is made by Winsor & Newton, and Bright Violet, made by ShinHan.

Yellow Deep

Lemon Yellow

Dioxazine Purple

Blue Violet

Quinacridone Gold

Red Orange

Sennelier Red

Rose Madder Lake

Alizarin Crimson

Quinacridone Red

Helios Purple

French Ultramarine

Phthalocyanine Blue

Cobalt Blue

Indigo

Winsor & Newton Opera Rose

ShinHan Bright Violet

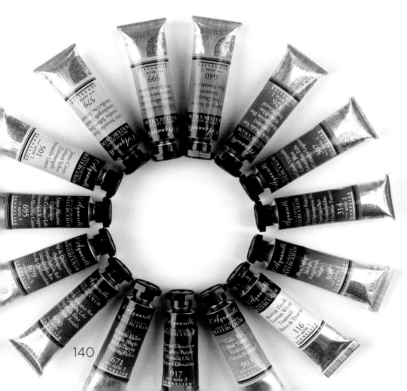

Left: these are the main Sennelier colours that I use. I also add one or two other manufacturers' colours to my palette that I find work for me and that I love too much to give up.

140

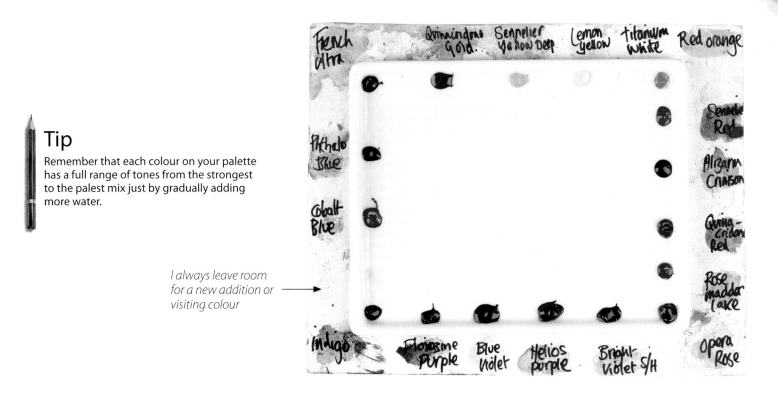

Tip

Remember that each colour on your palette has a full range of tones from the strongest to the palest mix just by gradually adding more water.

I always leave room for a new addition or visiting colour

I always try to set out my colours in groups on the palette: the reds on one side, the blues on another, the yellows on the other side, and predominantly purples on the remaining side. I position the colours right at the edge of my palette to allow plenty of room in the centre for mixing, and place my palette on a piece of cardboard with the names of the colours written round the outside. This helps me, and my students, identify each of the colours on the palette.

Remember that this is how I set up my own palette, and you are free to lay out your colours however you choose. It is important to always lay out your paints in the same way so that you become familiar with the position of each colour, and don't be afraid to include colours of your own that you particularly like.

Painting is all about experimentation and trying things out for yourself, and the same applies to colour mixing. We all see the world slightly differently and interpret colour in subtly different ways. I forget how many times I have seen an artwork only to ask myself, 'how did he or she interpret those colours so well?' So as you lay out your palette, say to yourself, 'let the discovery begin'.

Tip

Don't be afraid to use paints from different manufacturers, but always use professional quality paints. They work in a superior way and make painting a joy.

Colour key

On pages 144–177, the following abbreviations have been used for each of the colours used in the mixes.

	
Yellow Deep	YD
Lemon Yellow	LY
Dioxazine Purple	DP
Blue Violet	BV
Quinacridone Gold	QG
Red Orange	RO
Sennelier Red	SR
Rose Madder Lake	RML
Alizarin Crimson	AC
Quinacridone Red	QR
Helios Purple	HP
French Ultramarine	FU
Phthalocyanine Blue	PB
Cobalt Blue	CB
Indigo	I
Opera Rose	OR
Bright Violet	BRV

Basic colour mixing

If you are fearful of mixing colours, there is no need to be; it's all very simple. Learn the basics first and then add to your knowledge through practice. Watercolour is simply water and colour, and it's important to get the relative amounts just right. New students often add too much water or not enough, so the first thing is to practise mixing up one colour on its own.

Start by wetting the mixing brush. Wipe it a few times on the top of the pan of paint or, if you are using tubes, push the tip of the mixing brush gently into the paint but do not scoop. Mix this onto a clean palette and make a puddle of colour that is smooth, slightly transparent but colourful enough that the colour is true. Sweep this onto dry paper and allow it to dry.

Now do the same with the same colour but sweep it onto wet paper. Note the difference in the finished dry tone. The watery mix will be much weaker in tone than that on the dry paper.

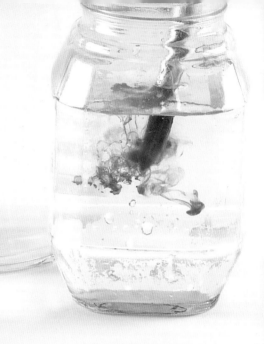

Mixing browns

In my palette I have no browns, greys or blacks, so I mix them using the primary colours. These three hearts show how using three different primary colours you can achieve three different browns. Vary the quantities and the number of browns you can mix will far exceed the number you actually need.

Tip

Keep your water clean and your colours should stay fresh.

Always clean your brush in between colours so as not to contaminate the paints.

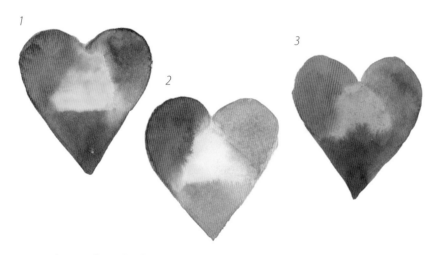

Mixing browns from the three primary colours red, blue and yellow.
1 – Sennelier Red, Yellow Deep and French Ultramarine
2 – Rose Madder Lake, Cobalt Blue and Lemon Yellow
3 – Phthalocyanine Blue, Quinacridone Gold and Alizarin Crimson

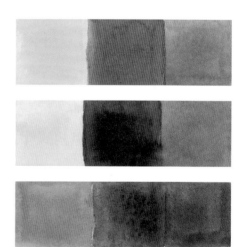

Mixing browns from opposite colours (a primary and the opposite secondary). From top to bottom – green and red; yellow and purple; orange and blue.

Mixing greys

I mix greys from the three primary colours in the same way as I mix browns, simply by adding more blue to the mix than each of the other two primaries. I call this colour mid tone. As with browns, you can mix different greys using different primary colours. Just remember to add lots of blue.

To lighten the mid-tone grey just add more water, and to adapt it to the plant you are painting, add touches of other colours. On the right I have added small amounts of yellow, green or pink to both a dark mid tone and a pale mid tone.

Here I have mixed a large quantity of French Ultramarine with small amounts of Sennelier Red and Yellow Deep to create the mid tone.

Mixing dark tones

To make the darkest tones I use exactly the same process; three dark primaries mixed together make a dark deep grey, which I use for black. Remember to add more blue than the other two colours as for the mid tone, but this time mix lots of pigment with a little less water.

Here I have mixed French Ultramarine, Sennelier Red and Yellow Deep to make a dark deep grey.

I often need a very dark mix, so for this I add Dioxazine Purple to my darkest mid tone.

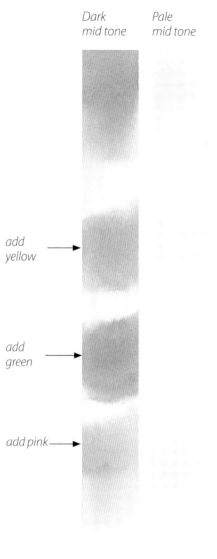

Dark mid tone *Pale mid tone*

add yellow →

add green →

add pink →

Adding yellow, green and pink to dark and pale mid-tone mixes.

Tip

Don't add Indigo to your darks on the first wash as it stains the paper bright blue. If you are retaining highlights, it may contaminate the lighter adjacent areas.

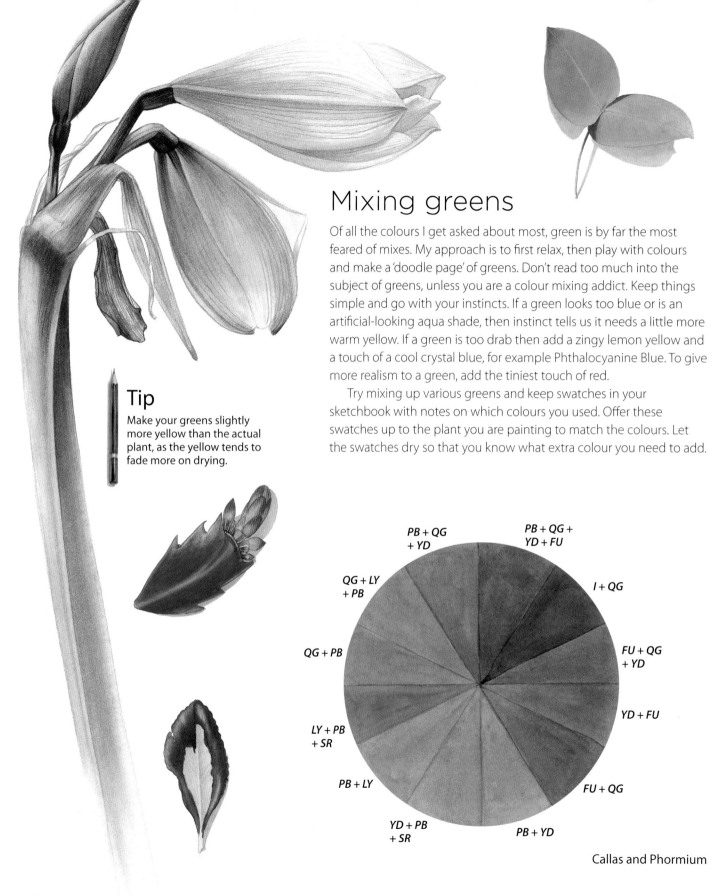

Mixing greens

Of all the colours I get asked about most, green is by far the most feared of mixes. My approach is to first relax, then play with colours and make a 'doodle page' of greens. Don't read too much into the subject of greens, unless you are a colour mixing addict. Keep things simple and go with your instincts. If a green looks too blue or is an artificial-looking aqua shade, then instinct tells us it needs a little more warm yellow. If a green is too drab then add a zingy lemon yellow and a touch of a cool crystal blue, for example Phthalocyanine Blue. To give more realism to a green, add the tiniest touch of red.

Try mixing up various greens and keep swatches in your sketchbook with notes on which colours you used. Offer these swatches up to the plant you are painting to match the colours. Let the swatches dry so that you know what extra colour you need to add.

Tip
Make your greens slightly more yellow than the actual plant, as the yellow tends to fade more on drying.

PB + QG
+ YD

PB + QG +
YD + FU

QG + LY
+ PB

I + QG

QG + PB

FU + QG
+ YD

YD + FU

LY + PB
+ SR

FU + QG

PB + LY

YD + PB
+ SR

PB + YD

Callas and Phormium

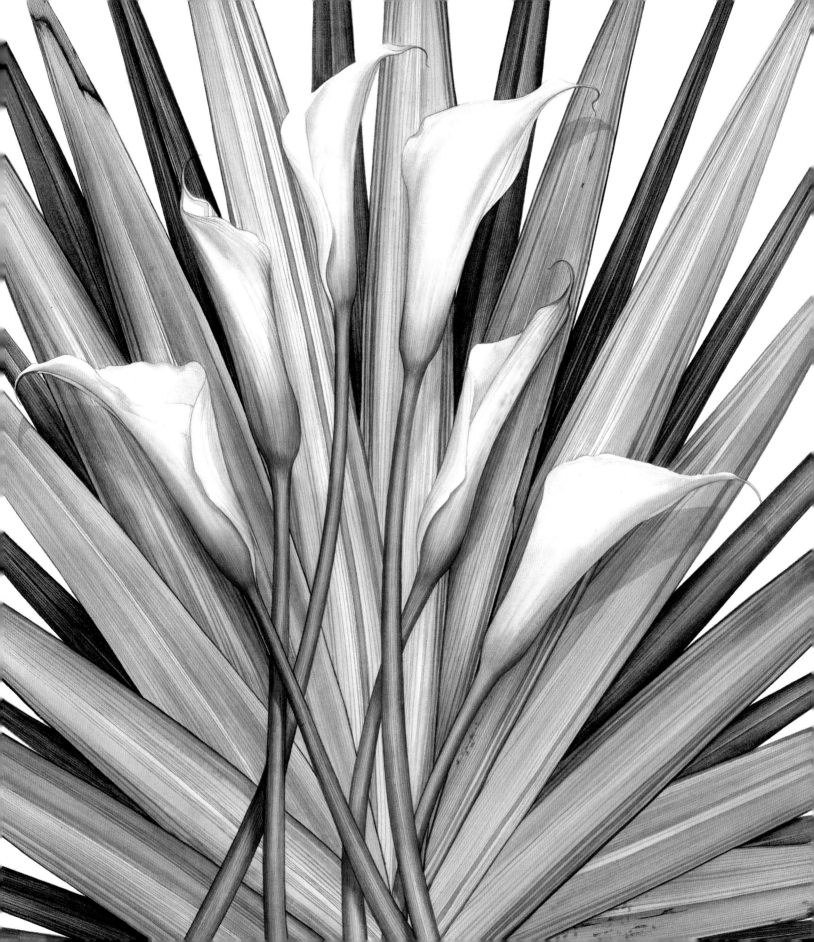

Here are some examples of different greens, showing the colours I have used to create them. You will notice that I tend to use the same blues and yellows in each mix but in differing quantities. A simple palette is the key to successful paintings that have a sense of harmony.

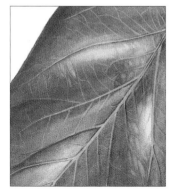

A rich blend of Yellow Deep, Phthalocyanine Blue, French Ultramarine and Lemon Yellow.

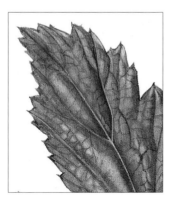

A rich blend of Yellow Deep, Phthalocyanine Blue, French Ultramarine, Lemon Yellow and Sennelier Red.

The centre is a light mix of Lemon Yellow and Phthalocyanine Blue. The outer edges are Phthalocyanine Blue, French Ultramarine and Lemon Yellow.

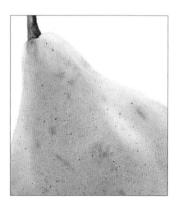

A blend of Lemon Yellow, Quinacridone Gold, Phthalocyanine Blue and a touch of Sennelier Red.

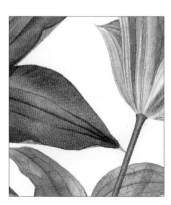

Phthalocyanine Blue, Lemon Yellow and French Ultramarine.

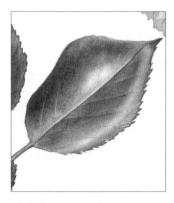

Phthalocyanine Blue, Lemon Yellow, French Ultramarine and Quinacridone Gold.

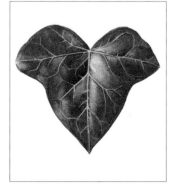

This very deep green was created using French Ultramarine, Phthalocyanine Blue, Yellow Deep and Lemon Yellow.

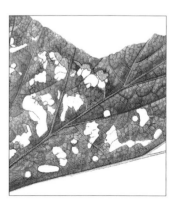

A medium mix of French Ultramarine, Phthalocyanine Blue, Yellow Deep, Lemon Yellow and Quinacridone Gold.

As you can see from the swatches on the opposite page, there are many variations on the same combinations of colours, and very subtle changes to a mix can result in a very different green once the colour is applied to your painting. If this happens, don't panic: a green that has dried too blue can be corrected by a light wash of yellow, and a leaf that is too yellow can be altered by a light wash of a neutral blue like Cobalt Blue.

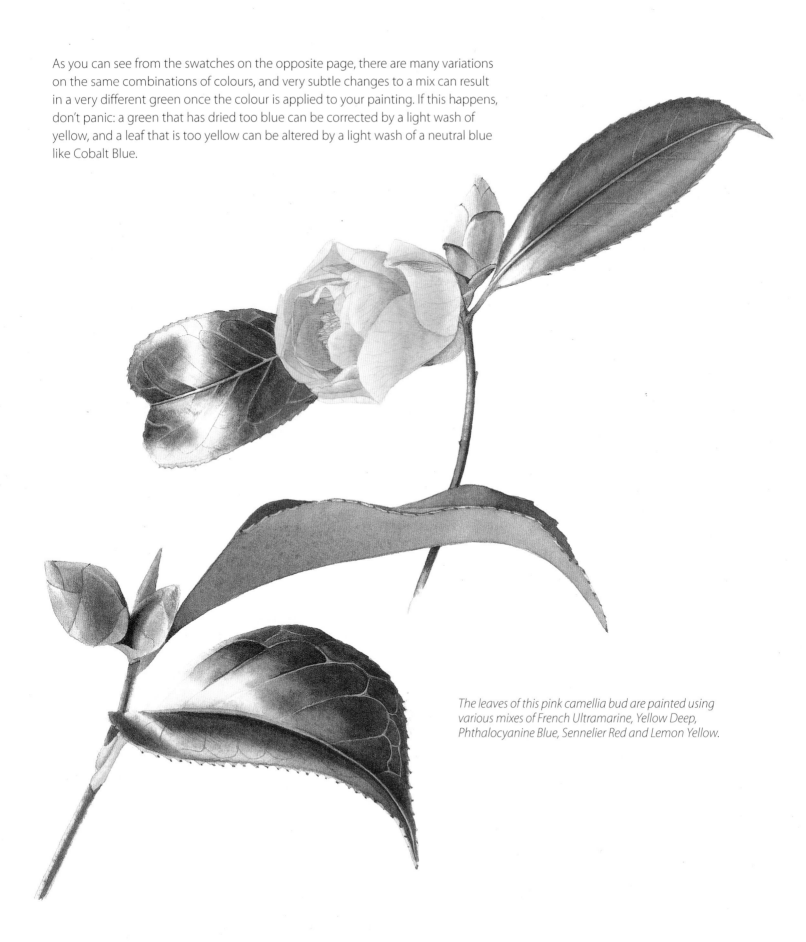

The leaves of this pink camellia bud are painted using various mixes of French Ultramarine, Yellow Deep, Phthalocyanine Blue, Sennelier Red and Lemon Yellow.

Mixing oranges and yellows

Yellows and oranges are exciting colours to work with. However, they will make pencil permanent if you paint yellow over the top, so keep your pencil drawing very light indeed.

I always paint the shadows of yellow plants first. I use mid-tone greys (as for white flowers), pale lilacs and greens. When all the shadows are dry I lay on the yellow as a wash. The yellows can then be intensified with extra layers of yellow without becoming muddied by the shadow colour.

You can use the same process for orange plants, but you will need to paint on deeper shadows to allow them to shine through the orange glazes.

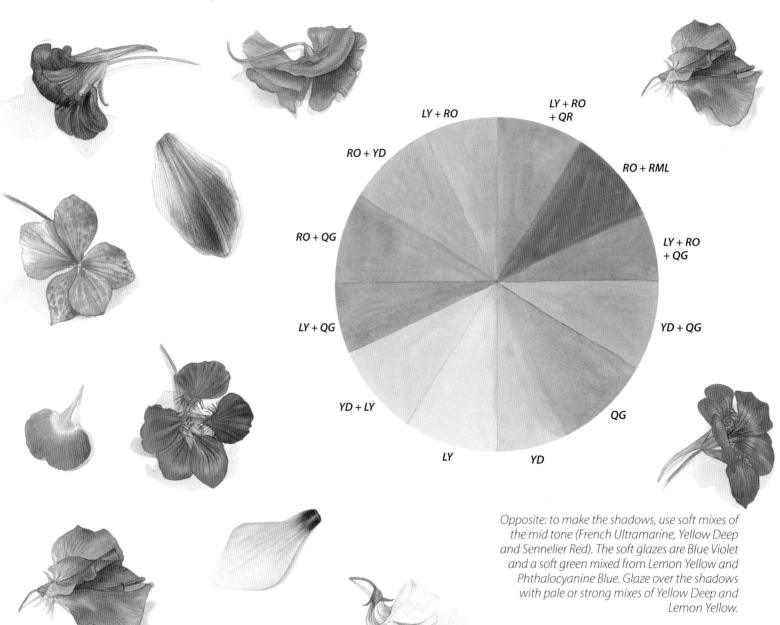

Opposite: to make the shadows, use soft mixes of the mid tone (French Ultramarine, Yellow Deep and Sennelier Red). The soft glazes are Blue Violet and a soft green mixed from Lemon Yellow and Phthalocyanine Blue. Glaze over the shadows with pale or strong mixes of Yellow Deep and Lemon Yellow.

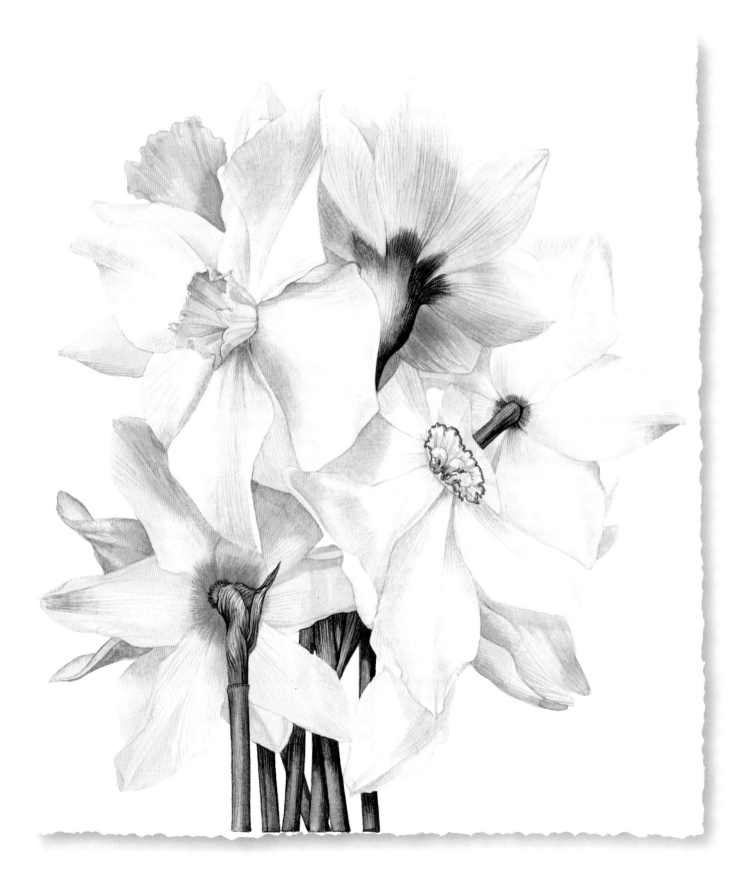

Quinacridone Gold is one of the most recent colours that I have added to my palette. Just a small touch of this colour will intensify and transform a yellow or an orange. I used Quinacridone Gold on the papery sepals at the base of the daffodil flowers shown opposite.

The trick with very pale, transparent petals is to paint a pale version of what sits behind the petals and, once that has dried, lay over a very watery wash of yellow. This should give the impression that you can see through the petal.

Many yellow flowers have a green tinge. To paint these, mix a very fresh green and gently feed it into the yellow while it is still wet.

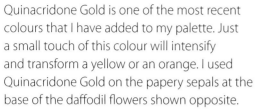

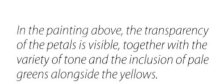

In the painting above, the transparency of the petals is visible, together with the variety of tone and the inclusion of pale greens alongside the yellows.

The small, yellow flowers of erythronium 'Pagoda' need to be kept as fresh as possible. Include as many shadows as you can without losing too much light and use a very clean, fresh mix of yellow to paint over the petals.

150

The quince (top left) has a dull bloom over it and appears slightly green-grey in the shade, whereas the cape gooseberry below it has a glossy, smooth surface behind its papery wings. Keep oranges and yellows mixed on clean palettes so that they are not compromised by other mixes.

Mixing pinks

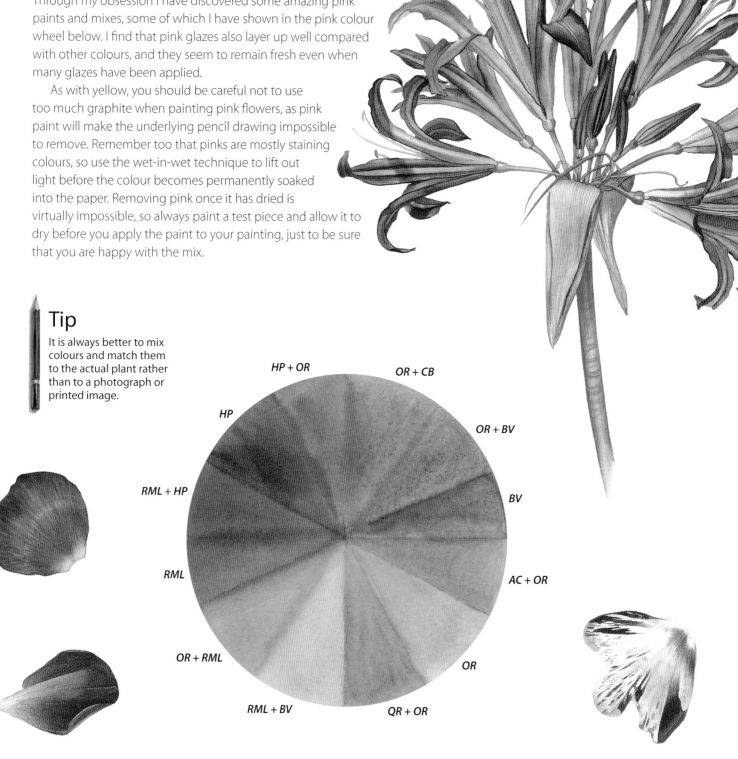

I have to confess to an addiction to pink flowers, so it is no surprise that there are a great deal of pink paintings in my portfolio. Through my obsession I have discovered some amazing pink paints and mixes, some of which I have shown in the pink colour wheel below. I find that pink glazes also layer up well compared with other colours, and they seem to remain fresh even when many glazes have been applied.

As with yellow, you should be careful not to use too much graphite when painting pink flowers, as pink paint will make the underlying pencil drawing impossible to remove. Remember too that pinks are mostly staining colours, so use the wet-in-wet technique to lift out light before the colour becomes permanently soaked into the paper. Removing pink once it has dried is virtually impossible, so always paint a test piece and allow it to dry before you apply the paint to your painting, just to be sure that you are happy with the mix.

Tip

It is always better to mix colours and match them to the actual plant rather than to a photograph or printed image.

HP + OR

OR + CB

HP

OR + BV

RML + HP

BV

RML

AC + OR

OR + RML

OR

RML + BV

QR + OR

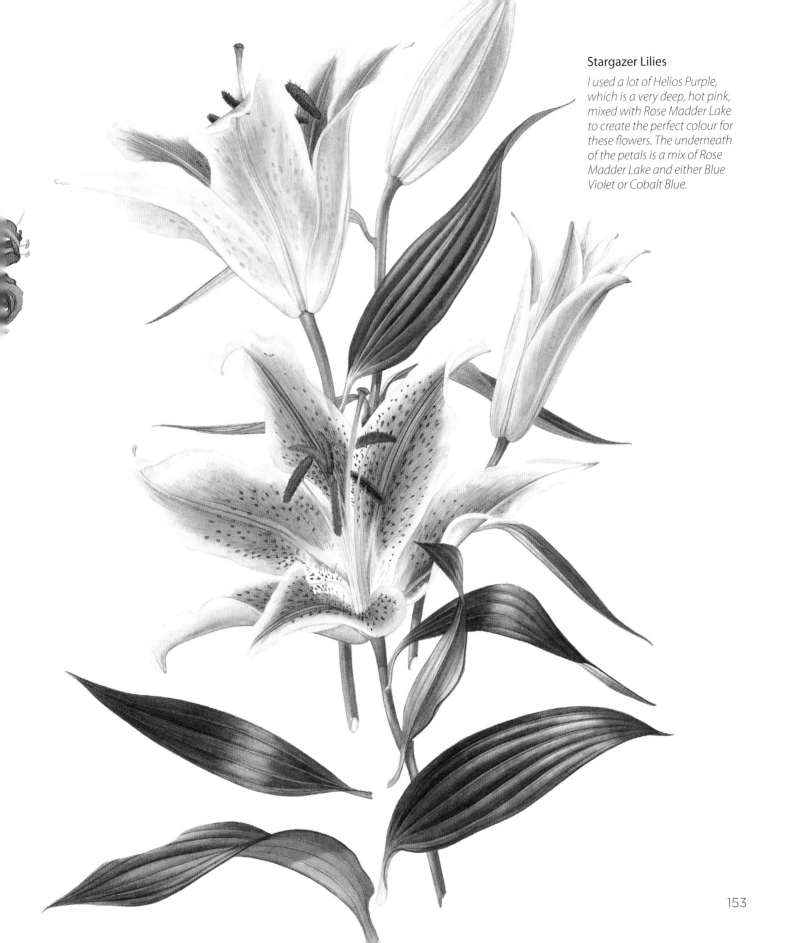

Stargazer Lilies

I used a lot of Helios Purple, which is a very deep, hot pink, mixed with Rose Madder Lake to create the perfect colour for these flowers. The underneath of the petals is a mix of Rose Madder Lake and either Blue Violet or Cobalt Blue.

The hot pinks are often bordering on a red or magenta, so bear this in mind when you are mixing dark shades for shady areas. For red pinks mix a deep orange with the pink, and for deep magenta pinks add a little Cobalt Blue for the shadows.

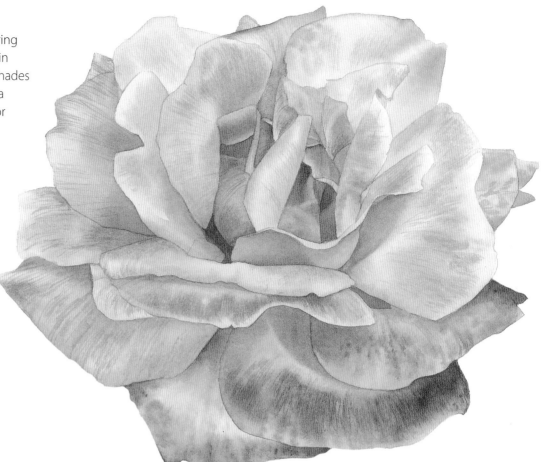

This rose has a very warm centre that is reflected in the pinks around it. For this I used Lemon Yellow and Rose Madder Lake.

Hellebore.

For pale or contrasting colour details, use masking fluid to protect them from staining. For example, on the rhododendron flower opposite (top right), mask out the stamen with masking fluid until all the petals have been completed. For the cast shadows, use a little Cobalt Blue mixed with the pink. Paint all of the highlights on the petals using wet in wet, and drop the pink around the palest areas. This prevents the pink from staining the light areas. Keep the light for as long as you can and then glaze over the highlights if they are too bright.

Back of orchid flower.

For the gladioli opposite, I used various blends of Rose Madder Lake, Quinacridone Red, Dioxazine Purple and Alizarin Crimson.

154

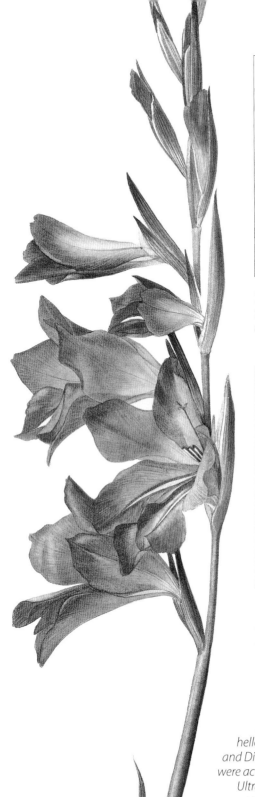

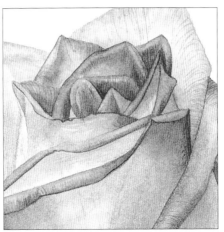

The deep pink is Rose Madder Lake. For the lighter shades, add water and for the creamy shades add a little yellow.

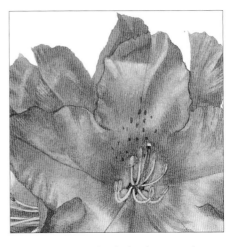

For this stunning rhododendron I used a mix of Bright Violet, Dioxazine Purple, Rose Madder Lake and Opera Rose, with touches of Cobalt Blue.

Helios Purple is similar to Quinacridone Magenta, so either could be used here. Add some Rose Madder Lake and a touch of Cobalt Blue for the shadow tones.

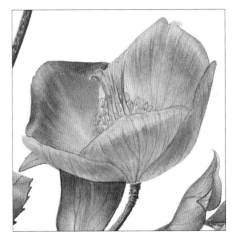

This hellebore was created using a mix of Helios Purple and Rose Madder Lake, with the addition of Lemon Yellow for warmth and Cobalt Blue for shadow.

Right: for the main colours on this dark hellebore I used mixes of Rose Madder Lake and Dioxazine Purple. The deep maroon pinks were achieved by adding Cobalt Blue or French Ultramarine and a touch of Yellow Deep to warm the colour up. You can experiment with the addition of Alizarin Crimson and always mix up a good reserve with a couple of alternative paler or brighter mixes for where the light shines through.

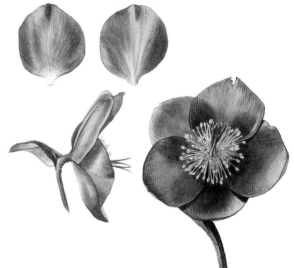

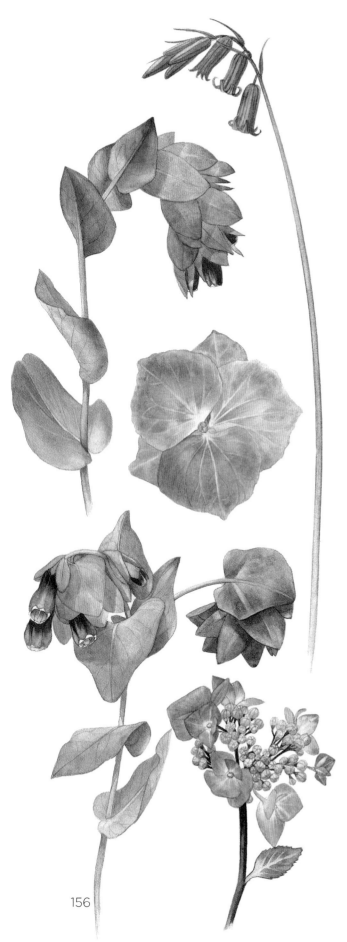

Mixing blues

There are few true blue plants in nature, though you will find many subtle and beautiful variations combined with pinks, purples and even black. Some of the loveliest blues can be found in hydrangeas and delphiniums. The appearance of blue flowers is very much dependent on the light, giving the colour an elusive, almost transient quality.

When mixing blues, first decide whether the blue is warm or cold and then make the colour either deeper with more pigment or paler with more water. I like to use French Ultramarine in my blue mixes, even though some people have issues with granulation. However, most flowers are rarely completely smooth and granulation can often aid in the depiction of texture and detail. It would be very hard for me to give up using French Ultramarine!

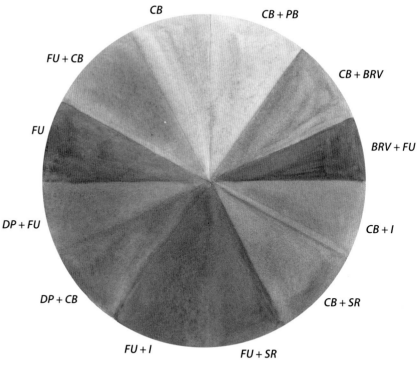

A small blue study showing the predominance of purples and lilacs amongst flowers that are generally thought of as being blue.

There is huge variation in the shades of blues found in agapanthus flowers. I usually mix up the bud shade first and then water this down and add any additional tinges of colour as and when required. Adding a touch of Dioxazine Purple to the dark blue mix will help achieve a black-blue shade; if it goes too purple add a touch of Sennelier Red or Rose Madder Lake.

Tip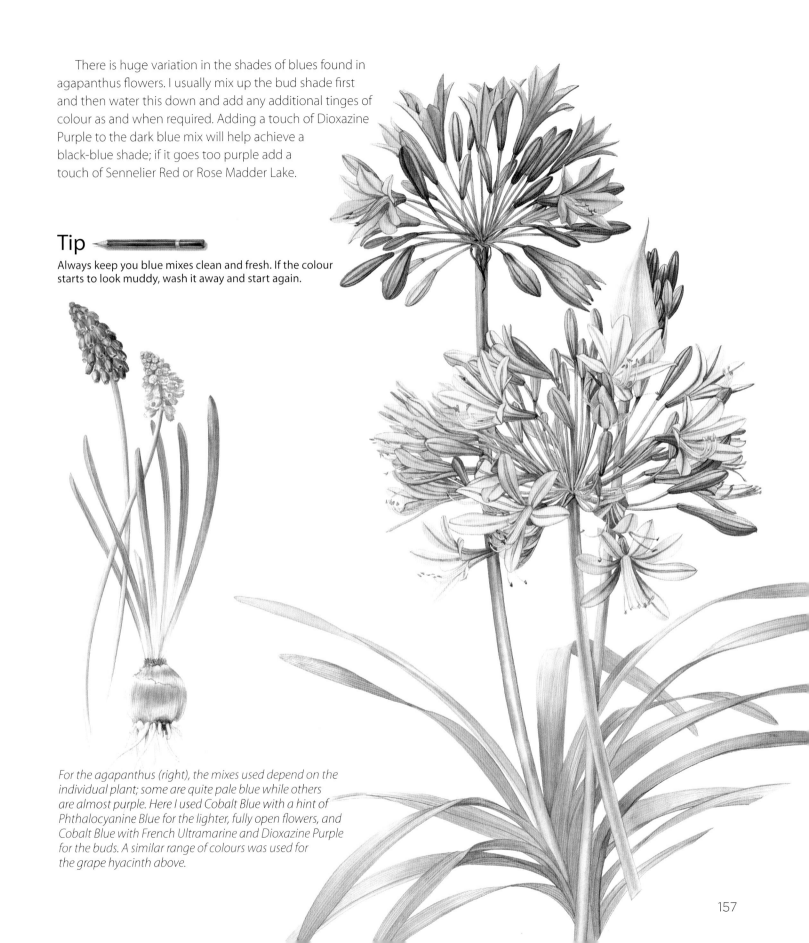

Always keep you blue mixes clean and fresh. If the colour starts to look muddy, wash it away and start again.

For the agapanthus (right), the mixes used depend on the individual plant; some are quite pale blue while others are almost purple. Here I used Cobalt Blue with a hint of Phthalocyanine Blue for the lighter, fully open flowers, and Cobalt Blue with French Ultramarine and Dioxazine Purple for the buds. A similar range of colours was used for the grape hyacinth above.

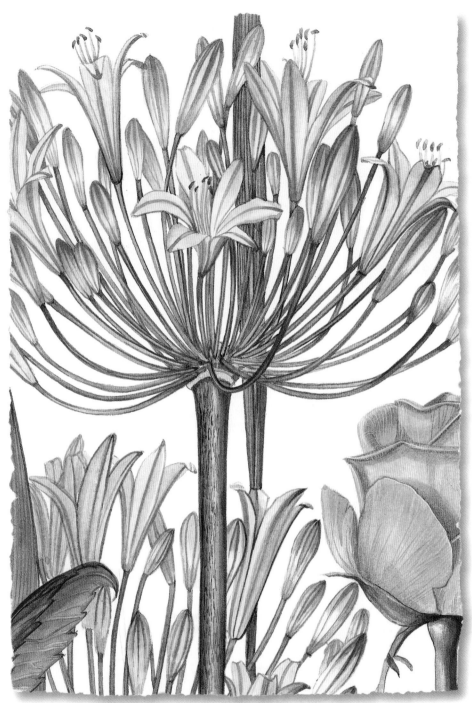

Small garden flowers can make lovely little compositions. There are hints of Cobalt Blue on the aquilegia and I mixed Cobalt Blue and Dioxazine Purple for the grape hyacinth.

Blues and pinks look beautiful together. Here, the agapanthus blues were a pale mix of Cobalt Blue and Rose Madder Lake, which sits well with the pink rose.

This image is from a larger painting that was eventually trimmed into smaller studies as my composition had become too complicated. I rather like this 'rescue remedy', and some of the rescued studies can be made into cards.

Opposite: hints of blues, purples and pinks work so well together. This composition is a combination of florist flowers and flowers from my garden. The gentian flower (bottom right) was painted with pure Cobalt Blue, softening into a pale Bright Violet centre. I also used Cobalt Blue in many of the shadow mixes.

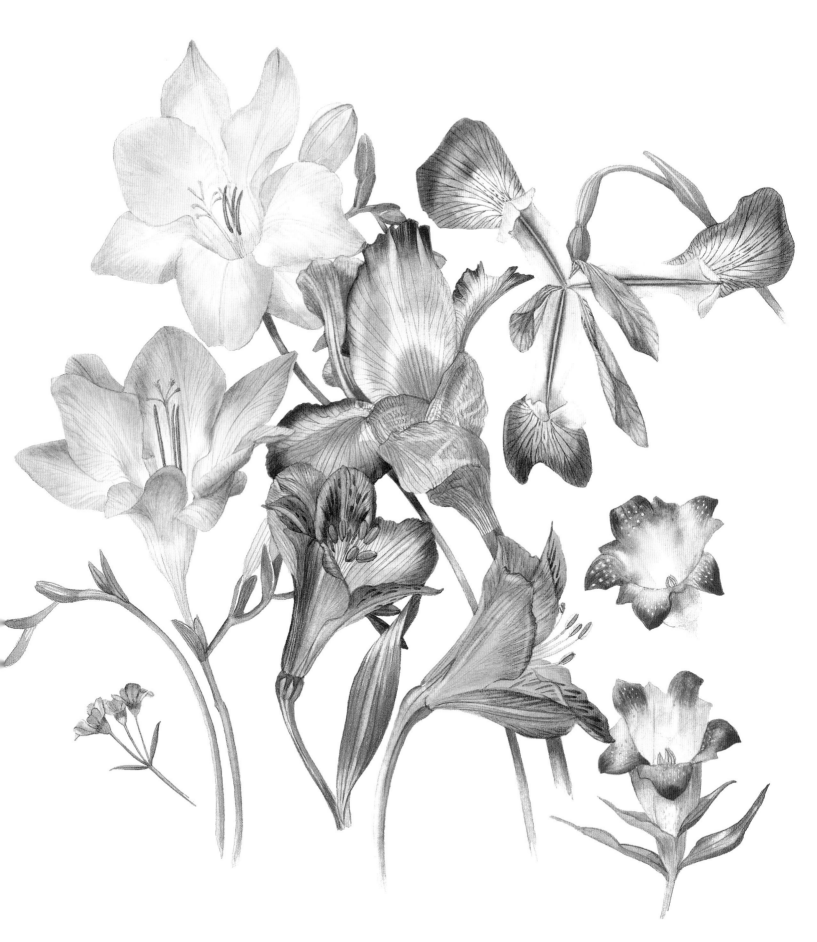

Mixing purples

I have just three or four ready-mixed purples in my palette, the majority of which are transparent. My favourite is ShinHan's Bright Violet, which is similar to Cobalt Violet. By adding a small amount of a clean blue, pink or red to any of my purples, I can make a vast array of purples, violets and mauves.

To mix a cool violet you need only add a touch of Cobalt Blue. For the dark chocolate-mauves, add a touch of French Ultramarine and a whisper of red and/or yellow and you will achieve a rich, dark mix. The variety is seemingly inexhaustible but, as with the blues, if you feel the mix has grown muddy or dull then clean it away and start afresh.

Little plump figs have wonderful shades of purple and lilac. For these, I used Rose Madder Lake with French Ultramarine and touches of Cobalt Blue and Yellow Deep.

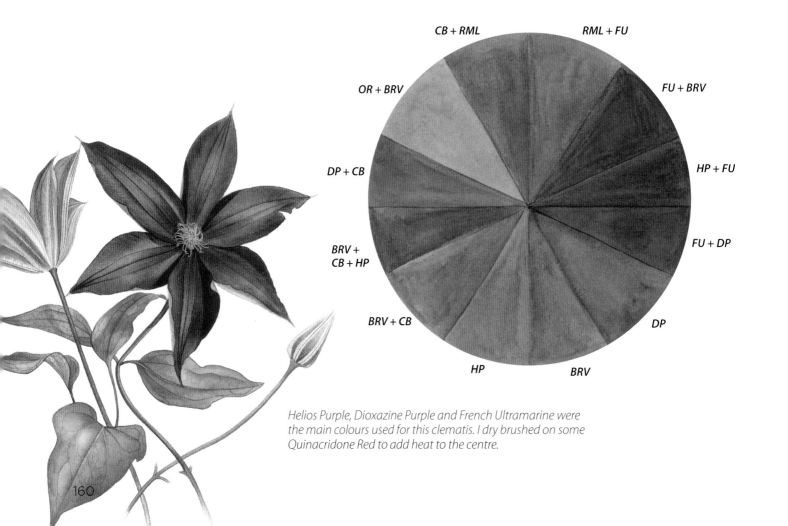

Helios Purple, Dioxazine Purple and French Ultramarine were the main colours used for this clematis. I dry brushed on some Quinacridone Red to add heat to the centre.

This composition was created from plants from both the hot house and the garden.
The African violet (top left) required a lot of dry brushing to achieve the dark tone, created
using a mix of Dioxazine Purple and French Ultramarine. The rose (bottom right) was
painted using a combination of Bright Violet and Dioxazine Purple. The paler purples in this
composition were made from a blend of Cobalt Blue and Bright Violet.

Often I will need to bring a painting together by using a touch of one particular colour in each colour mix on the paper; if each flower has a small amount of one shared colour it will unite the flowers and create a stronger design. It only needs to be a small amount to have a convincing result. This also underlines the importance of keeping your palette simple and not having too many colours to maintain.

Tip
To brighten a violet or purple flower try dry brushing on a little Opera Rose and/or Cobalt Blue to create a shimmer effect.

In this painting, the velvety finish on the top-right clematis flower was achieved by laying on the main Dioxazine Purple and then carefully dry brushing on Cobalt Blue and then Opera Rose.

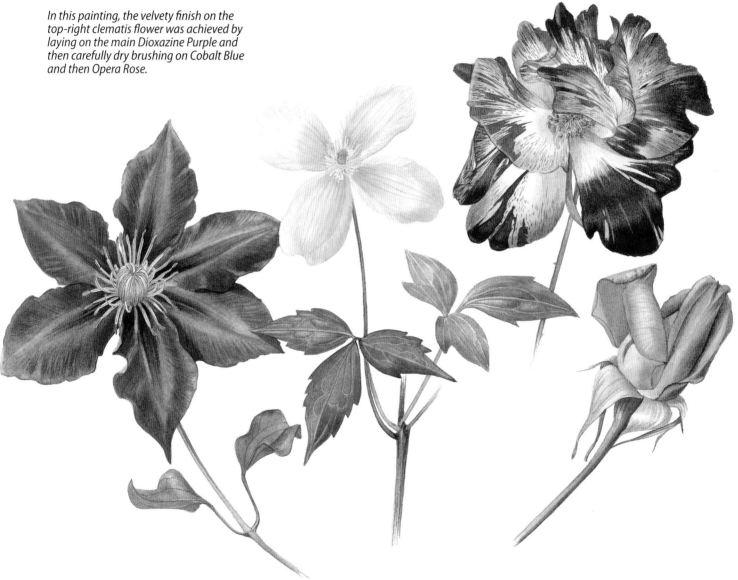

Four Cuttings

For the purple clematis (shown far left in the painting above) I used Dioxazine Purple, Cobalt Blue and Helios Purple, with Alizarin Crimson for the flash along the centre of each petal.

Opposite:
Purple in Progress

For the pinker tones, try adding Rose Madder Lake or Bright Violet; for the blue tones use Cobalt Blue.

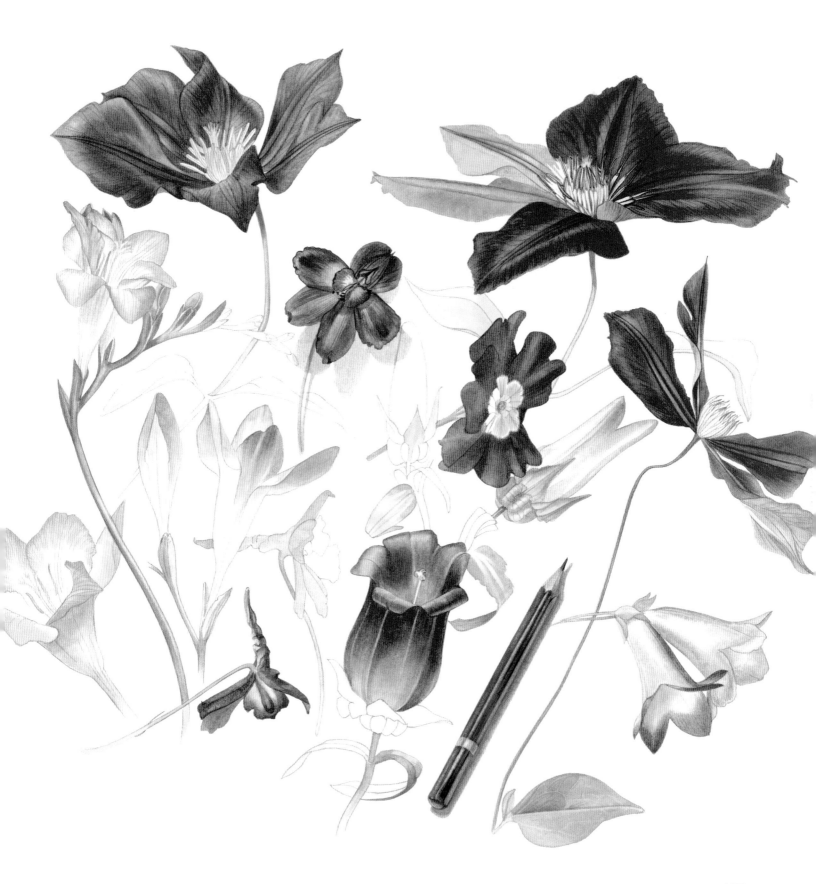

Mixing reds

When mixing reds, you will find that Quinacridone Red and Rose Madder Lake become your most important ingredients. The vibrancy of these two paints creates a level of luminosity required for most hot reds.

A small addition of French Ultramarine and occasionally Indigo will help create the colour of the dark shadow between deep red petals. To add warmth to any of the ready-made reds, add a delicate amount of yellow or Red Orange.

To obtain the strong colours of these orchids, mix the deepest reds from the chart on page 140 and drop in Yellow Deep at the same time. Dry brush on more dark red to get the deepest tone and some pink for the lighter tones once the first glaze is dry.

RML + SR + DP + QR

AC + DP

RML + SR + QR

AC + SR + FU

RML + QR

AC + SR

RML + SR

AC + QR

RML

AC

QR

SR

Start this two-tone tulip by mapping in all the mid reds, remembering to preserve the highlights. Then overlay a wash of Yellow Deep to obtain the golden edges. To warm the tone I used Quinacridone Gold once the reds were dry.

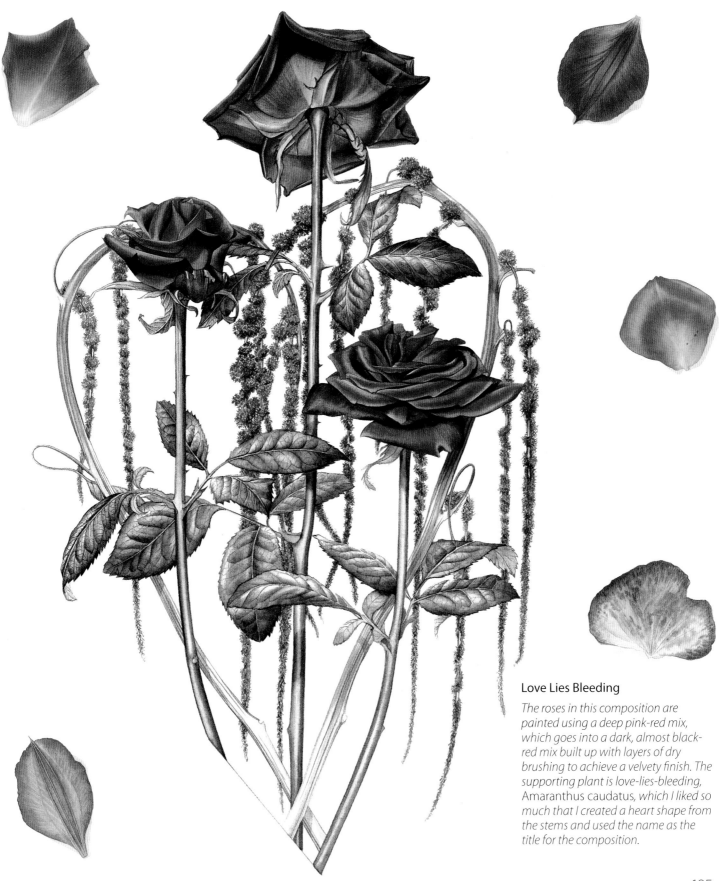

Love Lies Bleeding

The roses in this composition are painted using a deep pink-red mix, which goes into a dark, almost black-red mix built up with layers of dry brushing to achieve a velvety finish. The supporting plant is love-lies-bleeding, Amaranthus caudatus, *which I liked so much that I created a heart shape from the stems and used the name as the title for the composition.*

165

For this parrot tulip, I have mixed all my pink-reds: combinations of Quinacridone Red with Rose Madder Lake and Sennelier Red.

For these poppies I used Sennelier Red, Quinacridone Red, Bright Violet and Dioxazine Purple. For the deeper reds I added Alizarin Crimson to the mix.

To create the colours of this onion, mix Sennelier Red and then add a touch of yellow and Cobalt Blue. Keep the colour from the highlights and the far edges to maintain volume.

This strong red tulip is a mix of Sennelier Red and Rose Madder Lake with a touch of Lemon Yellow. Add a little French Ultramarine for the shadows.

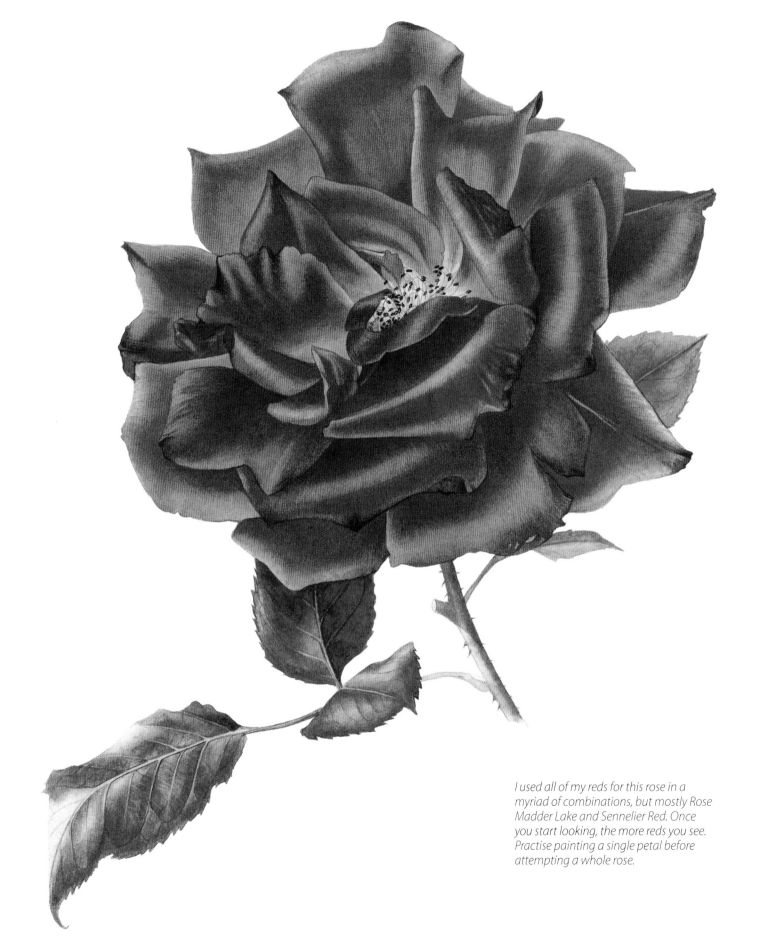

I used all of my reds for this rose in a myriad of combinations, but mostly Rose Madder Lake and Sennelier Red. Once you start looking, the more reds you see. Practise painting a single petal before attempting a whole rose.

Mixing blacks

Mixing blacks need not be as daunting as you think. Hold a black flower to the light and you will see that it is actually a deep purple or a chocolate-red. The secret to mixing black is to be bold. Use tubes of colour and don't be afraid to create a strong mix.

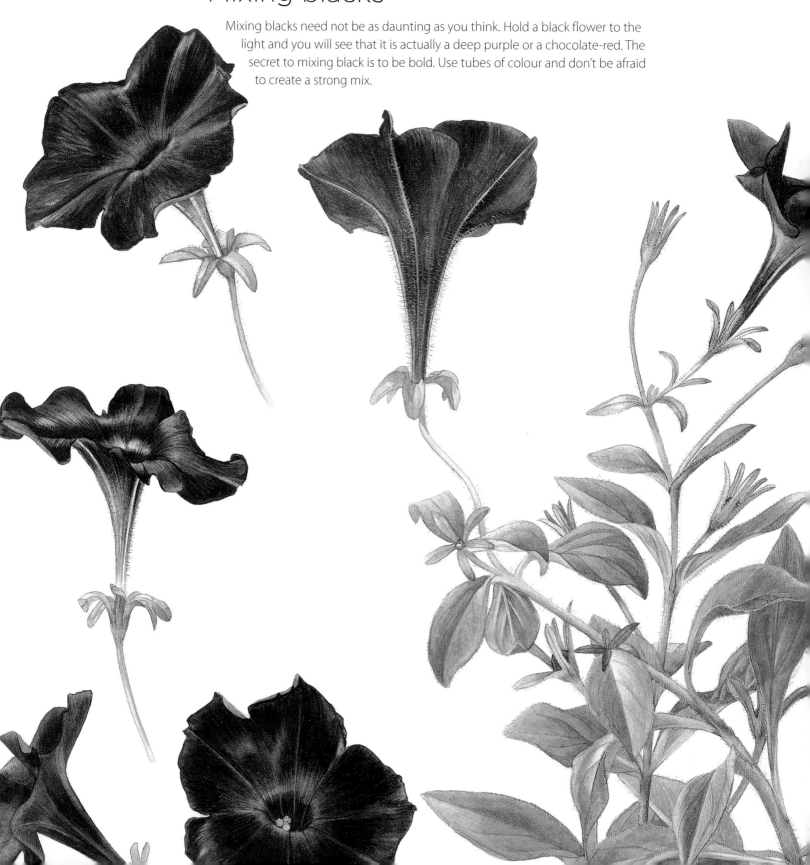

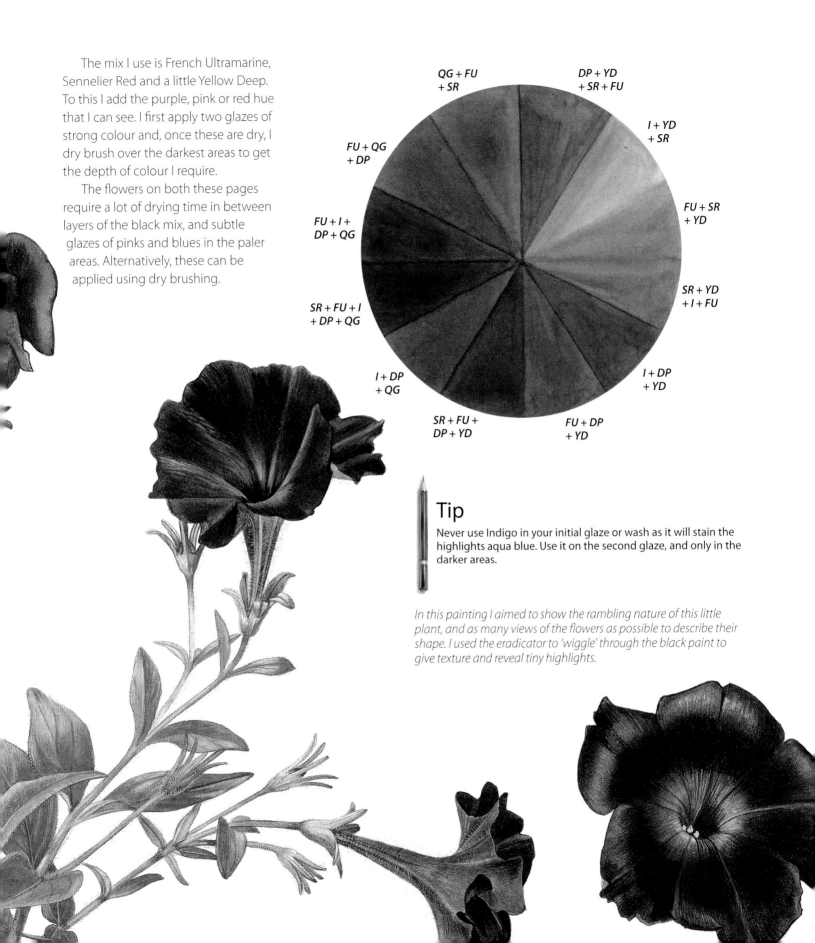

The mix I use is French Ultramarine, Sennelier Red and a little Yellow Deep. To this I add the purple, pink or red hue that I can see. I first apply two glazes of strong colour and, once these are dry, I dry brush over the darkest areas to get the depth of colour I require.

The flowers on both these pages require a lot of drying time in between layers of the black mix, and subtle glazes of pinks and blues in the paler areas. Alternatively, these can be applied using dry brushing.

QG + FU + SR

DP + YD + SR + FU

I + YD + SR

FU + QG + DP

FU + SR + YD

FU + I + DP + QG

SR + FU + I + DP + QG

SR + YD + I + FU

I + DP + QG

I + DP + YD

SR + FU + DP + YD

FU + DP + YD

Tip
Never use Indigo in your initial glaze or wash as it will stain the highlights aqua blue. Use it on the second glaze, and only in the darker areas.

In this painting I aimed to show the rambling nature of this little plant, and as many views of the flowers as possible to describe their shape. I used the eradicator to 'wiggle' through the black paint to give texture and reveal tiny highlights.

There are other ways of mixing black. One that I use often is Dioxazine Purple and Quinacridone Gold. This makes a deep black-brown mix that is perfect for red-black flowers. Once the first wash is dry, mix in a little Indigo and use this as your second glaze.

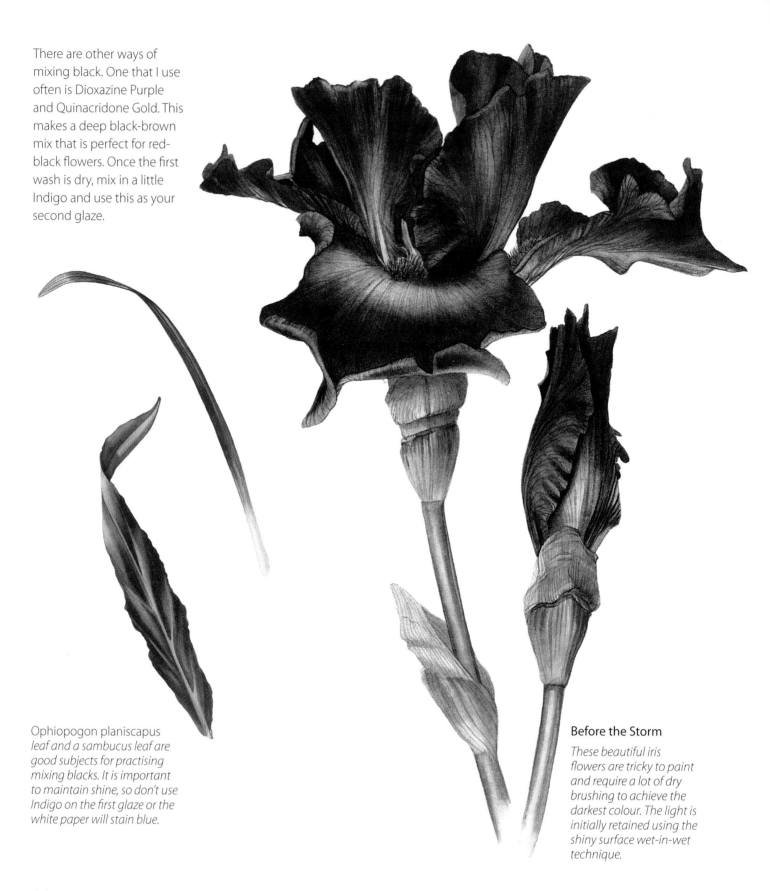

Ophiopogon planiscapus leaf and a sambucus leaf are good subjects for practising mixing blacks. It is important to maintain shine, so don't use Indigo on the first glaze or the white paper will stain blue.

Before the Storm

These beautiful iris flowers are tricky to paint and require a lot of dry brushing to achieve the darkest colour. The light is initially retained using the shiny surface wet-in-wet technique.

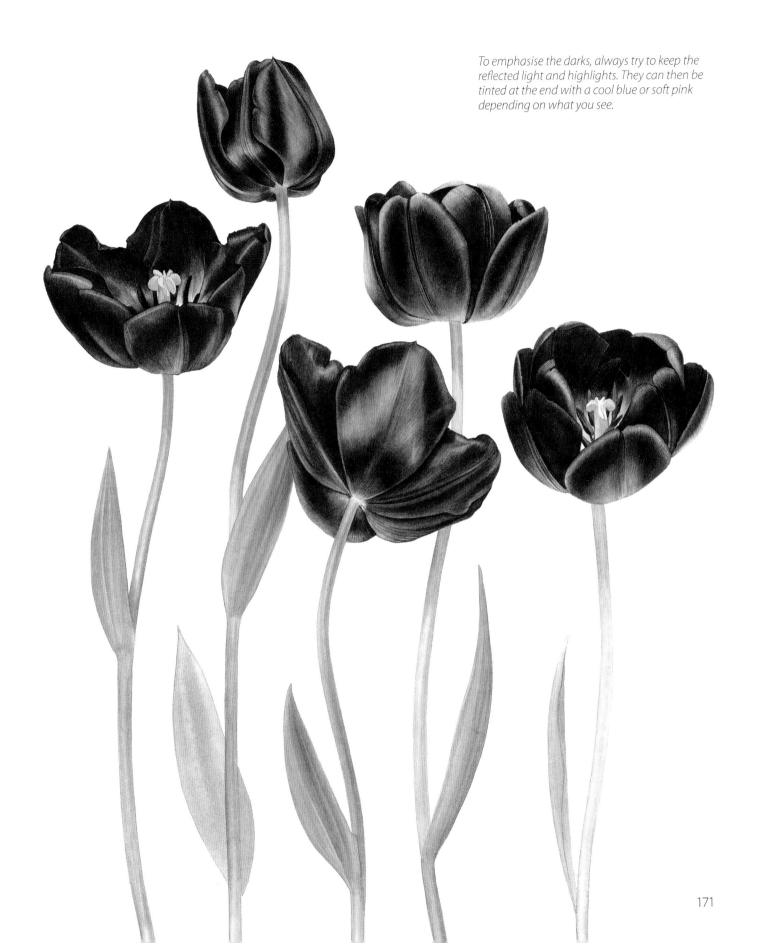

To emphasise the darks, always try to keep the reflected light and highlights. They can then be tinted at the end with a cool blue or soft pink depending on what you see.

Mixing whites

The most important thing to remember when painting white in watercolour is that the paper is your white paint. Painting white plants is made easier by the wet-in-wet technique as the water helps the paint to move and to give a soft edge, resulting in a soft, realistic finish to your paintings. It also helps to protect the paper, preventing it from absorbing the colour straight away and allowing you enough time to lift out colour and reveal the white paper underneath. It also helps avoid watermarks.

The secret to painting white plants is that you are actually painting the shadows that surround the whites. I use the same colours to mix the shadows as I do for mixing black; the only difference is that you add a lot of water to create a soft grey or mid-tone colour.

Use the wet-in-wet technique to ensure that a whole petal is glazed with water and then apply a small amount of the mid-tone colour. A pale grey mid tone can be mixed using blue, yellow and red. Use plenty of blue and just a touch of the other two colours. This mid tone can then be changed by adding a little more yellow, pink or blue depending on the shade of grey you wish to create.

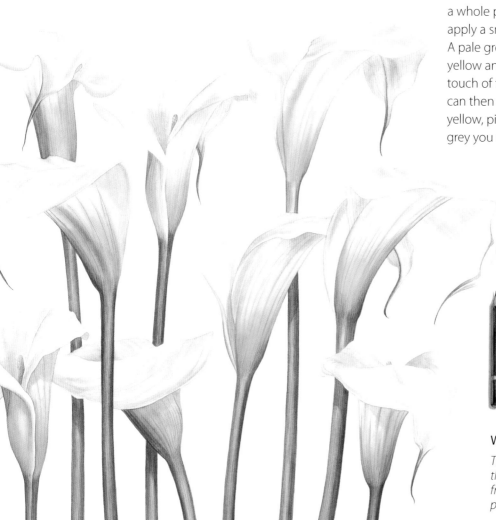

Tip

If the shadow colour is too wet it will spread and cover the entire area that you have glazed; if it is a little drier it will be simple to control. Practise on individual petals to find the right balance between how much paint and how much water you need, and how far it will spread.

White Zantedeschia in a Row

These white lilies have subtle greys to define the tops of the flowers. I placed them in front of and behind each other to further promote the purity of the white.

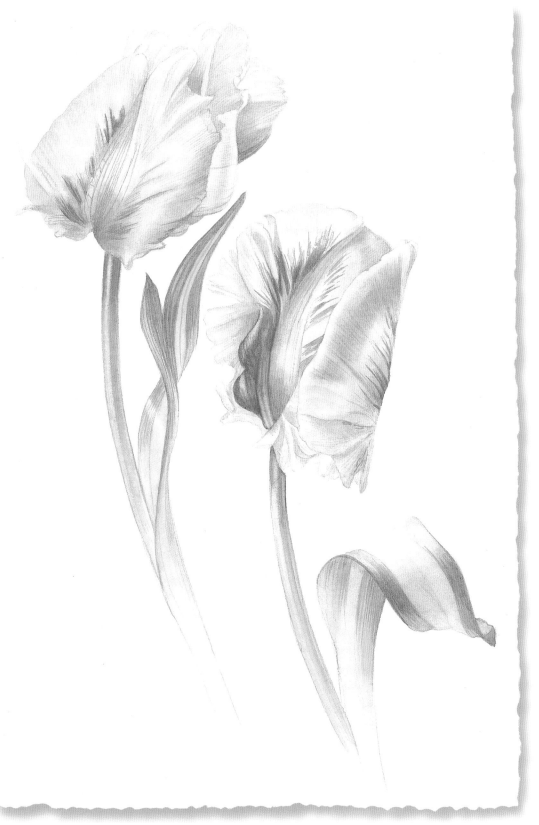

Mid-tone mixes (see page 143).

White and Green Parrot Tulips

Be confident with your shadows, but practise first or you may ruin your painting. Light your subject well to manage the depth of your shadows.

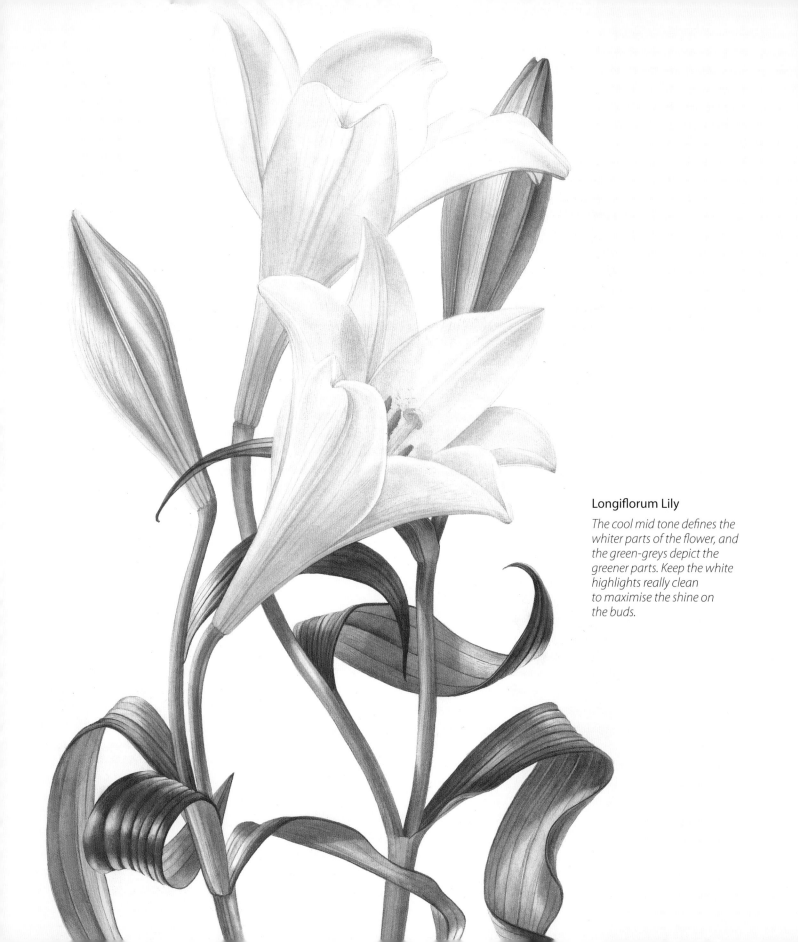

Longiflorum Lily

The cool mid tone defines the whiter parts of the flower, and the green-greys depict the greener parts. Keep the white highlights really clean to maximise the shine on the buds.

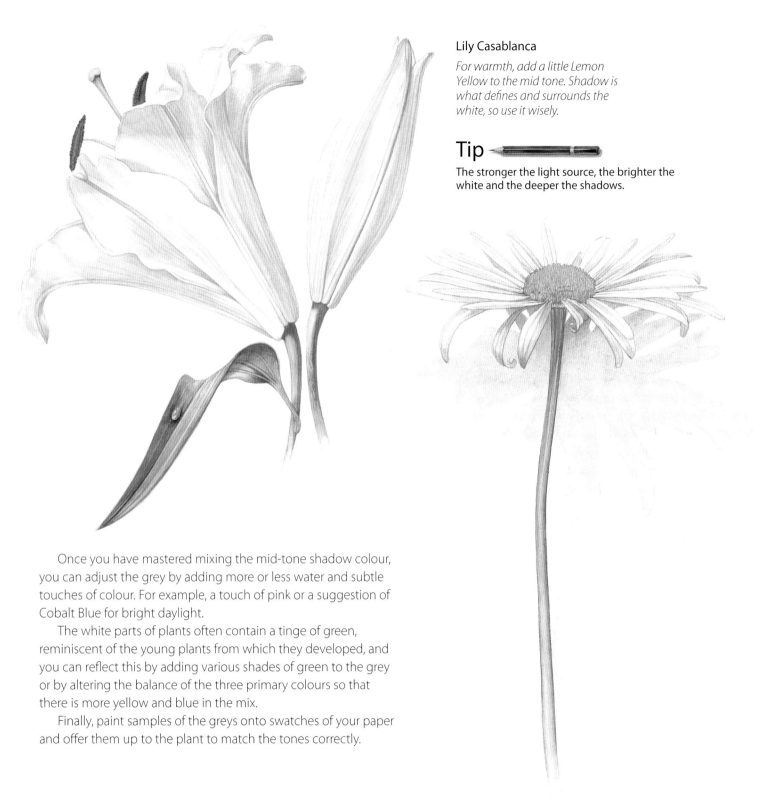

Lily Casablanca

For warmth, add a little Lemon Yellow to the mid tone. Shadow is what defines and surrounds the white, so use it wisely.

Tip

The stronger the light source, the brighter the white and the deeper the shadows.

Once you have mastered mixing the mid-tone shadow colour, you can adjust the grey by adding more or less water and subtle touches of colour. For example, a touch of pink or a suggestion of Cobalt Blue for bright daylight.

The white parts of plants often contain a tinge of green, reminiscent of the young plants from which they developed, and you can reflect this by adding various shades of green to the grey or by altering the balance of the three primary colours so that there is more yellow and blue in the mix.

Finally, paint samples of the greys onto swatches of your paper and offer them up to the plant to match the tones correctly.

Daisy

For cooler whites add a touch of Cobalt Blue to the mid-tone mix.

Mixing browns

Mixing browns is great fun and is a good way to perfect your colour-mixing skills. With my colour palette I can mix a huge variety of brown tones, which means I don't need to keep a tube of pre-mixed brown in my set.

Simply mix together the three primary colours red, yellow and a little blue, and brown will result. Alternatively, if you mix two opposite colours together, for example red and green or yellow and purple, you will achieve a brown.

To make a Raw Sienna, add some reds or pinks to the mix, or glaze over the mix with a red wash at the end.

Dry sycamore leaf.

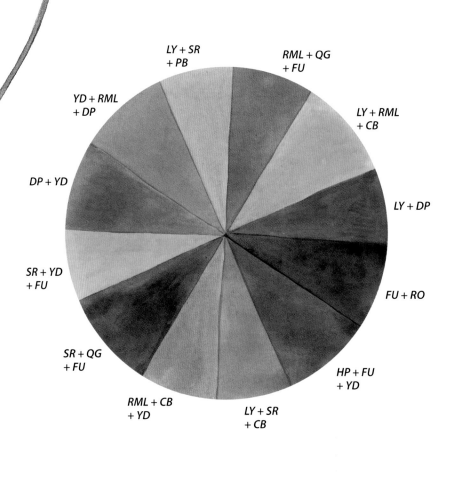

LY + SR
+ PB

RML + QG
+ FU

YD + RML
+ DP

LY + RML
+ CB

DP + YD

LY + DP

SR + YD
+ FU

FU + RO

SR + QG
+ FU

HP + FU
+ YD

RML + CB
+ YD

LY + SR
+ CB

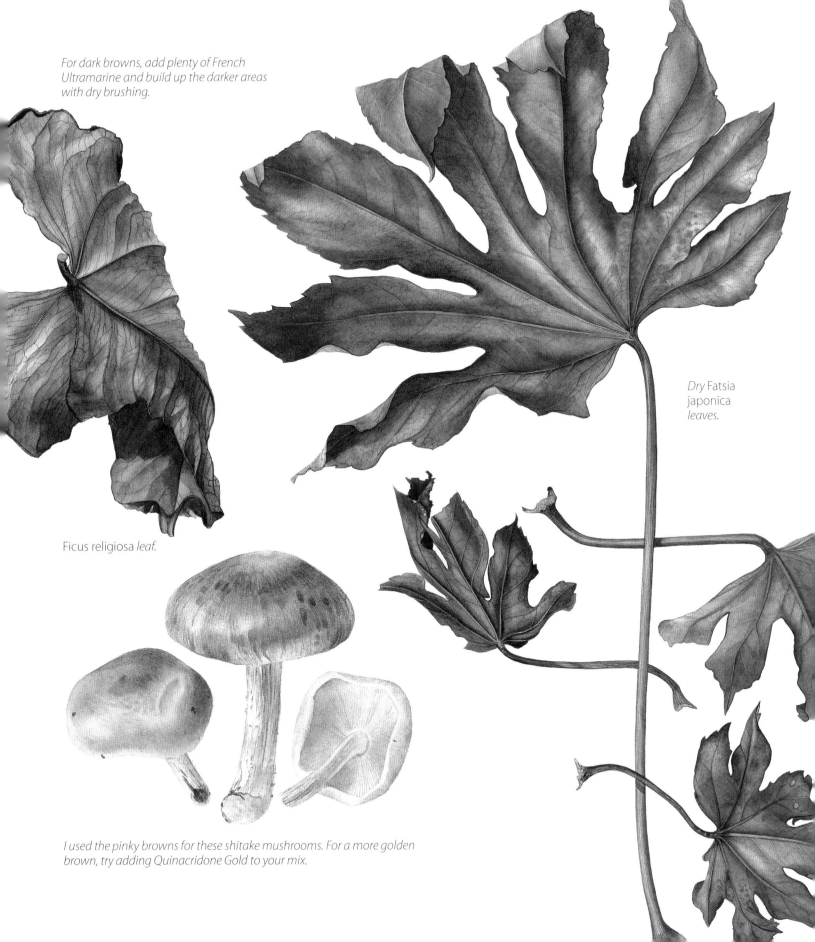

For dark browns, add plenty of French Ultramarine and build up the darker areas with dry brushing.

Dry Fatsia japonica *leaves.*

Ficus religiosa *leaf.*

I used the pinky browns for these shitake mushrooms. For a more golden brown, try adding Quinacridone Gold to your mix.

Composition

Composing a picture is an art in itself. It is something that can come naturally or that you have to practise and perfect, and rules abound on what and what not to do. Most of my paintings come from an idea I have for a particular shape or design to which I then add the plants. This is not the usual way to compose a botanical painting, so my advice is that if you are heading down the traditional route, keep your compositions simple and well balanced.

Composing a painting doesn't have to be difficult. Start by thinking of an overall shape for your painting; one that suits the form of the subject and that will fit nicely on your paper, be it square, portrait or landscape. The size of your painting will be dictated by the size of the plant. Offer the plant up to the paper and if it looks too big then use a larger sheet of paper.

Consider the natural growth habit and characteristics of the plant. Decide what type of design would suit this plant by answering the following questions:

- Is the plant stiff or floppy, twisty or formal, heavy or transparent?
- Does the plant climb, ramble or cascade?
- Are the stems always straight or do they curve?
- What is the shape and nature of the leaves?
- Do the leaves and flowers appear on the plant at the same time or do they follow on from each other?
- If you are including more than one type of plant in your painting, think about the types of plants that sit well together, for example in terms of colour and shape. Remember that sometimes a clash of colour or contrasting shapes can create drama and add interest to your painting.

Look carefully at the plant and take note of the veining and patterning. Turn the plant around until you find the most aesthetic and informative angle from which to paint it. You may need two or even three views of the plant to depict how the plant grows and changes. Think about how to arrange the different views together on the paper and sketch out your ideas. Alternatively, think about showing different elements of the plant and how you would position them on the paper.

You will also need to consider the reference material for your painting. Do you have time to paint from life and, if not, will you need photographs as a back-up? You might prefer to paint only from photographs, without referring to the real plant.

In this painting of hellebores, the composition is based around two overlapping triangles, with three main elements in each triangle. It is softened with smaller elements such as buds and stems.

Opposite:
Zantedeschia and Bamboo

In this painting, the bamboo and the flowers are equally balanced. The little flashes of negative shapes push the eye line towards the network of crossing stems, which is the focus of the painting. The dynamic stem placements then sweep your eye back up to each flower in turn. There are three of the main green goddess flowers, and three pink, five white and four black calla lilies, which have been placed non-symmetrically to work with the design.

Balance

This is a term used to describe the aesthetic arrangement of weight in the picture design. It is something you learn to observe, but there are a few tricks to help you. These are listed in the checklist below.

Creating balance

1 Sketch the design and shade in the tones of the elements. Prop up the sketch and stand well back. You will notice if there are any large gaps or too much dark or light in certain areas. Look out for a good selection of large and small shapes.
2 Hold the sketch up to a mirror. Reversing the image will help you see if there is too much of one element or another.
3 Draw up several sketches of the plant or plants you are painting. Familiarity with your subject will help you see a design more clearly.

Tip

Planning a painting is paramount. There are times when happy accidents occur and a poorly planned painting becomes a masterpiece, but what usually happens is that it results in compromise.

Position

Placing the plant on the page is very important. Putting your subject in the middle of the paper creates a 'target' and your eye remains stuck in the centre of the painting. This can work if you are painting only one element, but if you are adding other elements then your finished arrangement will not have the dynamics required to be a successful composition.

You also need to decide at what angle to draw the plants. Try sketching them from different angles, as shown in the sketch on the left, to help you decide which view shows off the plant to its best advantage as well as being aesthetically pleasing to the eye.

Line

The line of a painting is best described as the journey of the eye across the painting and how your eyes are led from element to element. The aim is to make the line of the design guide the eye subtly to each point of interest within the painting without any dead ends.

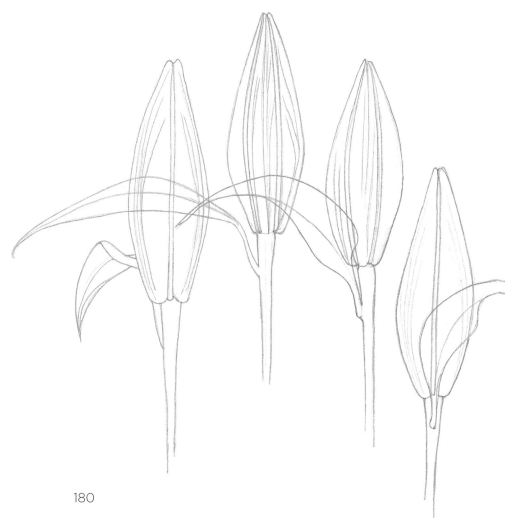

Shape or design

It is sometimes beneficial to use geometric patterns or a basic overall shape to guide the placement of the plants in your composition. Odd groups of threes or fives are often easier to balance, but even numbers of plants can be balanced with the addition of another element of even weight.

Tip

Group the main features of the design in odd-numbered groups such as threes or fives. This will add interest and avoid too much symmetry, which can sometimes stop the eye from dancing around the painting.

Black Iris

In this arrangement I have eight main flowers and six buds. I turned the stems around to find the best angle and placed them in order of increasing height from left to right. The leaves create weight in the lower right corner to balance the dark flowers at the top. I like to think this is a modern composition but still traditional at heart.

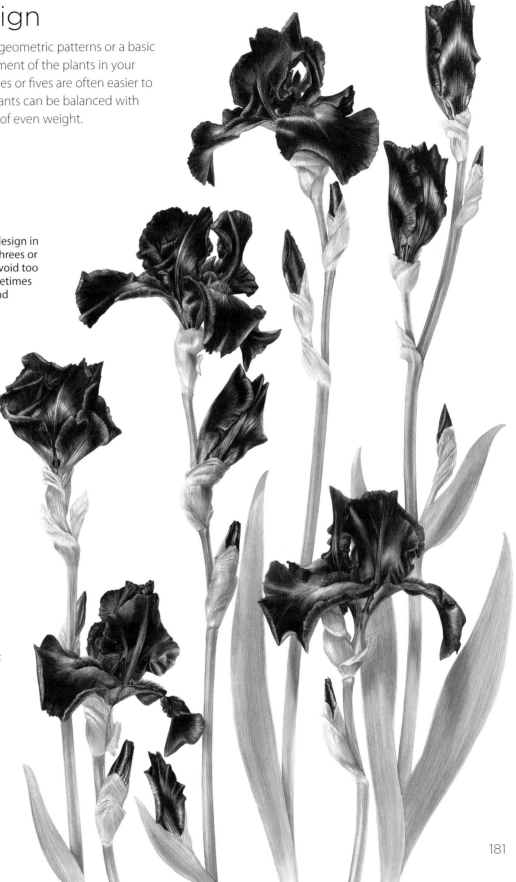

Traditional or modern

I am not very keen on categorising compositions as either traditional or modern. Anything you create today is, in my view, a modern interpretation even if it is in a traditional style, as the execution of the work is inevitably touched or inspired by current influences.

I like to group botanical work into either illustrations or paintings. The aim of a botanical illustration is to depict a plant in order to aid the scientific study of the subject, and it should be as clear and as well laid out as possible. Any alterations in size or magnification should be noted next to or on the piece.

With a botanical painting, you retain the botanical realism but the composition can be as aesthetically pleasing or imaginative as you desire. Your plants, although perfectly represented, can be laid out in a beautiful and flamboyant composition. As long as you are accurate, the plants can be resized larger or smaller than life.

I would categorise my style as botanical painting: I love to play with composition but also love to paint the plants as accurately as possible.

Tip

Keep a sketchbook of ideas with you all the time so that when an idea for a composition comes into your head you can quickly sketch it down. You'll find this an invaluable source of inspiration for when you are sitting with a blank piece of paper in front of you.

Below:
Finding Love

In this painting the top flowers are placed in an arc and the middle three are in a triangle. Within the design, three pairs of flowers are coupled by a twisted leaf while the four remaining flowers lay between the paired flowers. A leaf heart is centrally placed. The inclusion of patterns within patterns forces you to find new meanings on each viewing.

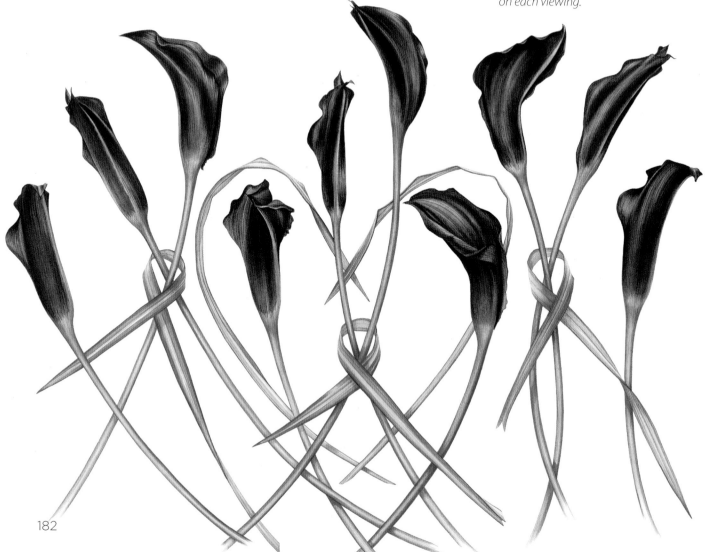

Space

This refers to the space taken up by the plants; the spaces in between the plants; and the spaces in between the design and the edge of the paper. Negative space is the gaps in between the elements on the page, and in my opinion the shapes of these should be as balanced as the plants themselves and be interesting in their own right.

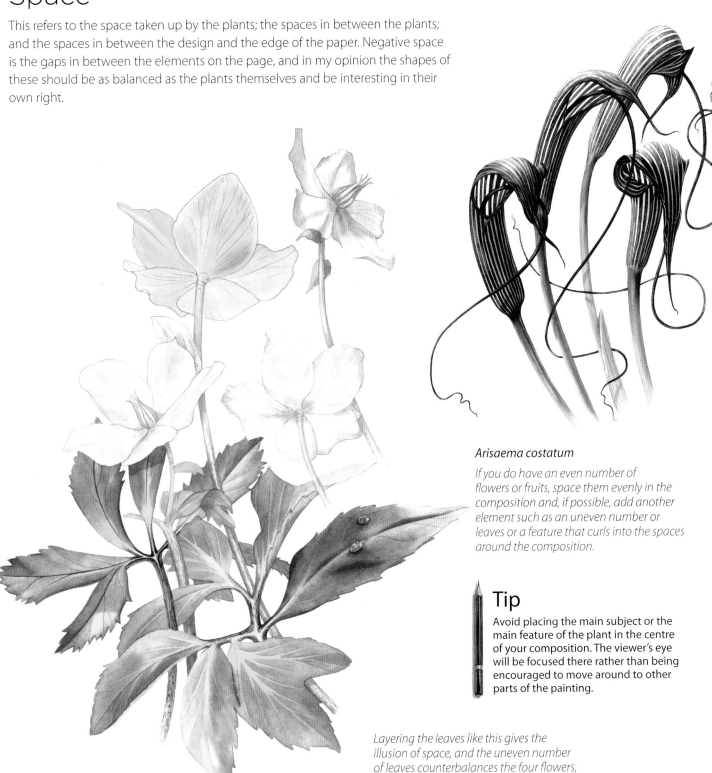

Arisaema costatum

If you do have an even number of flowers or fruits, space them evenly in the composition and, if possible, add another element such as an uneven number or leaves or a feature that curls into the spaces around the composition.

Tip

Avoid placing the main subject or the main feature of the plant in the centre of your composition. The viewer's eye will be focused there rather than being encouraged to move around to other parts of the painting.

Layering the leaves like this gives the illusion of space, and the uneven number of leaves counterbalances the four flowers, that are created in paint and pencil tone.

Have fun with your compositions and don't be constrained by the 'rules'. In the painting below I have arranged the apples in a spiral, starting in the centre with a red apple. As I worked outwards, I gradually added more green apples, ending eventually with completely green apples at the edges of the spiral. Note the increasing depths of the cast shadows as the apples get further from the light source.

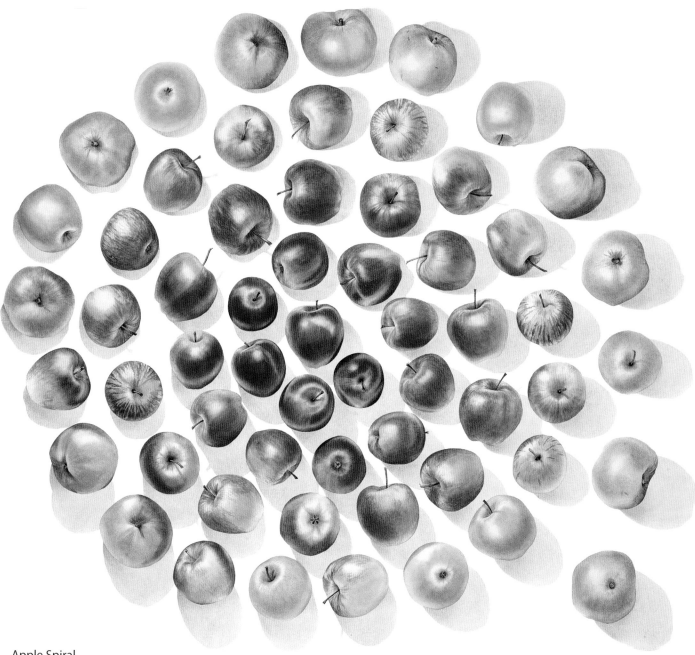

Apple Spiral

Inject an element of fun into your compositions. These are not only botanically correct, but create an overall shape that gives the composition a modern twist.

Weighting

The painting should sit well within its frame, and the space at the base of the paper should be slightly deeper than the space at the top. This weight of space can be reflected in the design. Finer, paler elements are better towards the top of the painting and heavier elements towards the bottom. Don't think of this as a strict rule as the weighting will also depend on the plant itself. A tumbling rose, for example, might be best depicted falling from the top of the painting, and trailing away and becoming lighter towards the bottom.

Below and left: in these examples I have taken the idea of building a composition around a shape even further. I have drawn a basic teacup shape and then added flowers in and around it. I found balancing the stems, flowers and leaves around the cup shape the most challenging yet rewarding part of this painting.

By playing around with composition, you will discover new ways to balance your paintings and draw the viewer's eye to different areas.

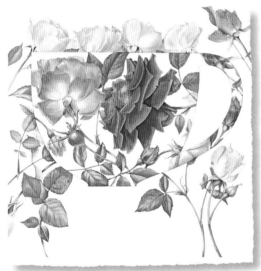

Tea Rose

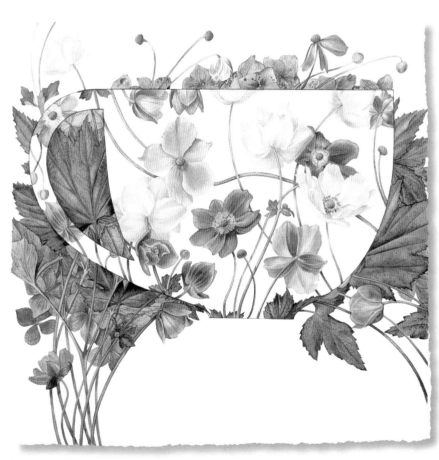

Anemone Tea

Stretching and finishing

Presenting your work well is essential. You will have spent many hours perfecting your paintings and they need to be mounted and framed beautifully. If you present your paintings poorly, it suggests to people that you don't value them; therefore they are unlikely to value them either. Be proud of what you have achieved and spend time and effort on the presentation of your work.

Stretching paper

Stretching paper can be used either to prevent cockling or to flatten a piece of paper that has cockled. I rarely stretch the paper before I paint. I don't use very much water in my painting, so the paper usually remains smooth and flat. I also like to keep the paper free from restraints so that I can move it around as I work. This allows me to position the paper so that I am working with the natural curve of my hand. I also tend to use 640gsm (300lb) paper, which is very heavy and does not require stretching to keep it flat. If your painting has cockled, you can stretch the finished painting quite easily, or even stretch the paper part-way through a painting if the cockling is troublesome – there is no need to do it beforehand.

What is cockling?

When you paint on lighter-weight paper, the areas that are painted on tend to expand and contract, causing the paper to wrinkle and pucker. This makes it difficult to paint on, and makes framing problematic.

Flattening a painting when the paper has cockled

1 Turn the image face down on a clean, thick bath towel.

2 Soak the back of the painting with water applied with a sponge. The towel will stop the water from seeping round onto the finished painting.

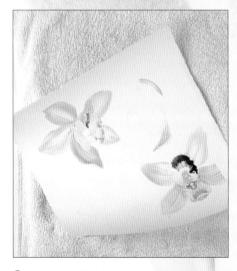

3 Turn the painting back over and leave to dry. This will cause the painting to cockle dramatically, but don't panic! This is meant to happen.

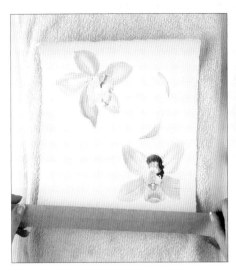

4 While it is drying, measure out the gummed tape. You will need four pieces, one for each side, each 4cm (1½in) longer than the paper.

5 When completely dry, turn the painting over and dampen the back of it again.

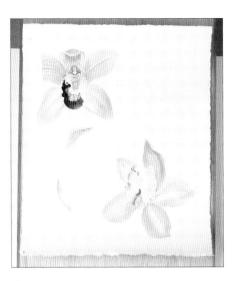

6 While it is still wet, remove the towel and lay the painting face up on the board.

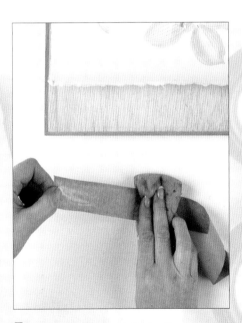

7 While the back of the painting is still wet, dampen the first length of tape by laying a damp sponge at one end and pulling it through.

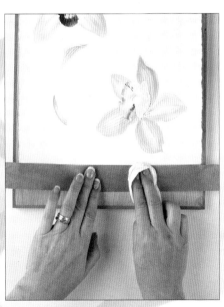

8 Lay it centrally along the edge of the painting and smooth it down from the centre outwards using a piece of paper towel. Cover at least 2cm (¾in) of the edge of the painting.

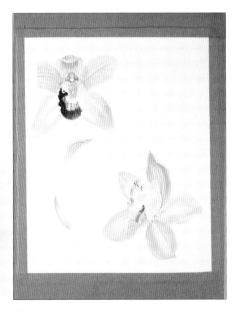

9 Attach the remaining strips and leave to dry. Only remove the painting when you are certain both the tape and the paint are dry. Leave overnight, if possible. To remove it, use a scalpel blade to cut the tape at the edge of the painting. Don't attempt to tear the painting from the board. The part of the tape remaining on the board can be soaked off later.

Creating a deckle edge

I use my deckle ruler to give my paintings a decorative, torn edge. This gives my float-mounted paintings (in which the edge of the painting remains visible behind the glass in the frame) an attractive finish. If using a deckle edge, remember to leave ample space around your composition to allow for part of the edge to be torn away.

1 Lay the deckle ruler along the edge of the painting.

2 Hold the ruler firmly in place (you will not want it to slip!) and tear the edge away. Always tear the surplus paper by pulling it towards the ruler.

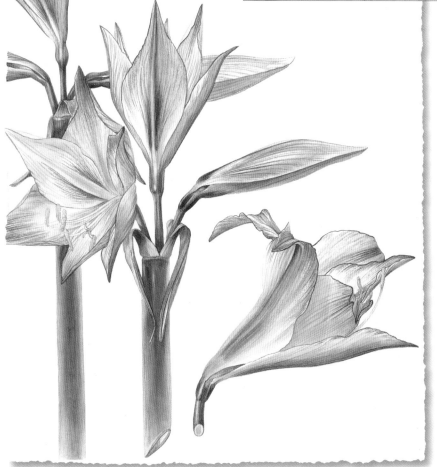

3 The finished edge. Repeat round each side of the painting.

Using a half mount

When you have completed your painting, a good way to find out how large your mount window should be is to use two old mounts that have had one side removed. This will allow you to overlap them on the image to find the perfect mount size.

You can even use the half mounts to help you choose the best crop for a painting. For example, to remove a damaged or superfluous part of the painting or to create a design suitable for a greetings card.

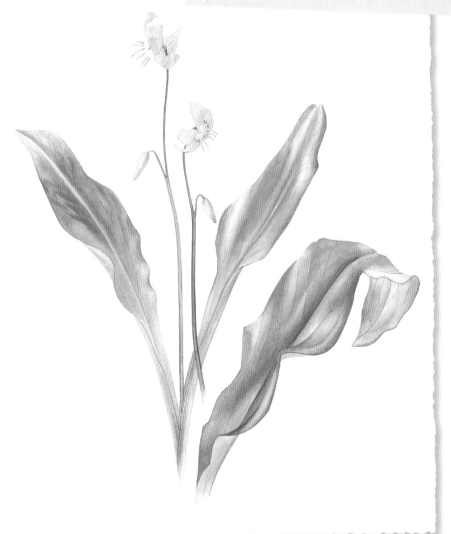

The cropped painting, shown above and top left, has a good amount of white space left around the subject. The crop shown bottom left could be used on a greetings card or postcard.

Glossary

Drop I use this term to describe the action of letting paint fall gently from the brush. When the paper is wet, hold the loaded brush close to the wet paper and allow the paint to be drawn onto it in a small area. Done quickly, this will result in a soft, spotty texture; done slowly, it will allow the paint to settle and spread evenly.

Ferrule The metal part of the brush.

Glaze A thin wash of water or pale colour, used either at the start of a painting or as a finishing technique. Used to transform or enrich parts of a painting.

Hue Hue is another name for colour, as defined by its dominant wavelength, for example red, blue or yellow. If the name of a paint colour includes the word 'hue', for example Cadmium Red Hue, it denotes that it is the closest colour to that name. However, in my experience it may not be the strongest blend of pigment in that colour choice.

Opaque Opaque paints cover and can hide what is beneath them. They are commonly avoided by watercolourists as they can hide the paper and make it hard to maintain the light in a painting. However, I have not always found this to be the case so always experiment and discover what colours work best for you.

Primary colours In painting there are three primary colours: red, blue and yellow. A mix of other colours can't make primary colours; they are the base colours used to create all the other colours on the colour spectrum or wheel.

Secondary colours These are the colours created by mixing two primary colours together: yellow and blue to make green, red and blue to make purple and red and yellow to make orange. The relative amounts of each primary in the mix will result in variations of the secondary colour, for example more blue than yellow will make a darker blue-green; less blue and you will get a more yellow-green.

Shade Shade is the change in a colour through the subtraction of light, as it descends into shadow. It is usually achieved by the addition of black. As mentioned elsewhere in this book, I avoid using black paint, instead shading the colour with deeper tones to achieve an accurate depiction of the colour in shade. Lighter shades can be created with the addition of other colours as well as water to create the effect of colour flooded with light.

Sweep The usual definition of sweep is to brush away, but it can also describe long, dramatic brushstrokes made on the surface of your painting, often lifting the brush away from the paper just before the end of the movement.

Tertiary colours Tertiary colours are colour mixes other than primary or secondary colours and are usually created by mixing together all three primaries. Tertiary colours are usually deeper and earthier.

Tint A tint is a hint of a colour; usually achieved by the addition of white or additional water to increase the lightness of the colour.

Tone Tone, also known as value, is the lightness or darkness of a colour. Tonal range is the lightest to the darkest depiction of a colour. A tonal wash would take a colour through its full range from light to dark. In watercolour, this would mean adding water to the colour; then gradually adding more of the pigment.

Transparent A transparent paint allows you to see through it, although this will depend on how thickly it is applied. It can be quite difficult to build up layers of transparent colours as the layering is easily disturbed.

Wash A flat layer of colour; or a tonal wash from dark to pale laid flat over the paper, as for a sky.

Index

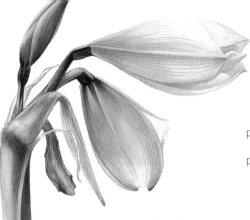

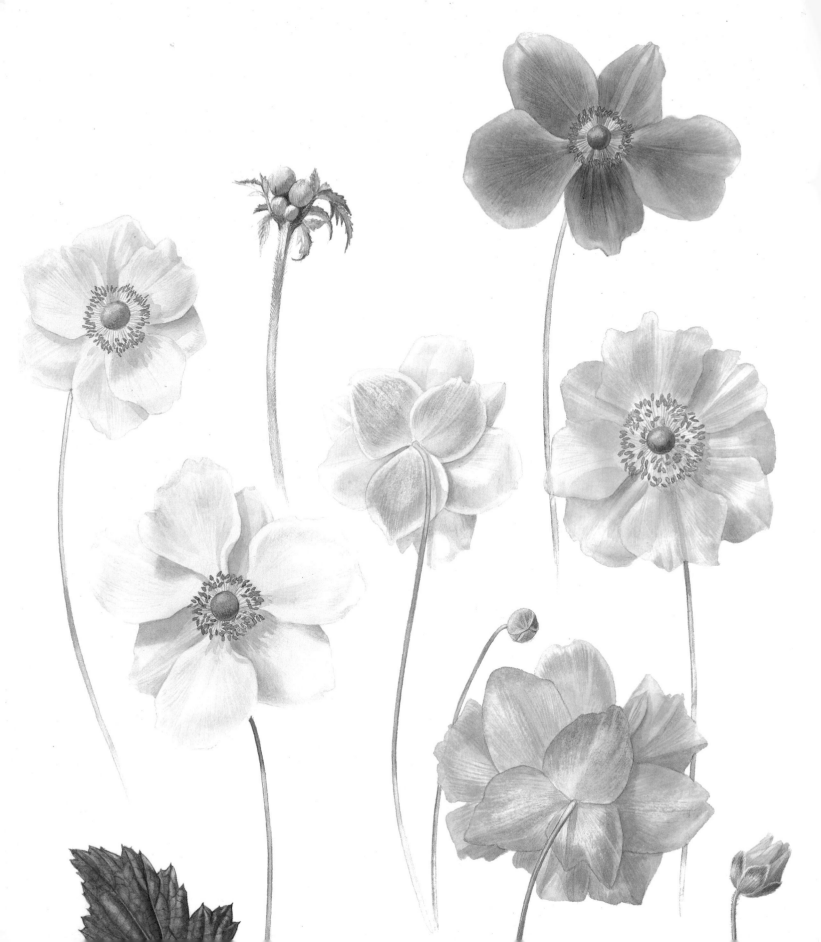